Living in the Hills: Impromptu Verses
I close my brushwood door in solitude
And face the vast sky as late sunlight falls.
The pine trees: cranes are nesting all around.
My wicker gate: a visitor seldom calls.
The tender bamboo's dusted with fresh powder.
Red lotuses strip off their former bloom.
Lamps shine out at the ford, and everywhere
The water-chestnut pickers wander home.
- Wang Wei

CHINA
REMEMBERED

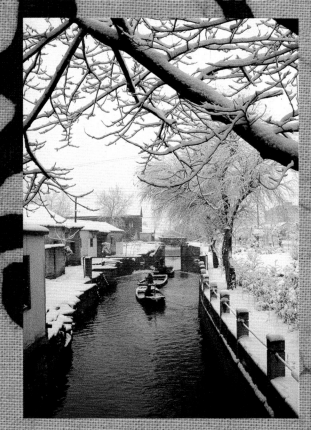

A RARE COLLECTION
OF PHOTOGRAPHS FROM
A FORGOTTEN TIME

by yasuto kitahara

HDi

HARPER
DESIGN
international

An imprint of Harper Collins *Publishers*

CHINA REMEMBERED

Copyright © 2003 by PAGE ONE PUBLISHING PRIVATE LIMITED

First published in SIngapore by
Page One Publishing Private Limited
20 Kaki Bukit View
Kaki Bukit Techpark II
Singapore 415956
Tel: (65) 6742-2088
Fax: (65) 6744-2088
enquiries@pageonebookshop.com

First published in the USA in 2003 by
Harper Design International,
An imprint of HaperCollins*Publishers*
10 East 53rd Street
New York, NY 10022
Tel: (212) 207-7000
Fax: (212) 207-7654
HarperDesign@harpercollins.com
www.harpercollins.com

Distributed in Asia by
Page One Publishing Private Limited
20 Kaki Bukit View
Kaki Bukit Techpark II
Singapore 415956
Tel: (65) 6742-2088
Fax: (65) 6744-2088
enquiries@pageonebookshop.com

Distributed throughout the world (except Asia) by:
Harper Collins International
10 East 53rd Street
New York, NY 10022
Tel: (212) 207-7000
Fax: (212) 207-7654

HarperCollins books may be purchased for educational, business, or sales promotional use. For
information, please write: Special Markets Department, HarperCollins Publishers Inc., 10 East 53rd Street,
New York, NY 10022.

Author: Yasuto Kitahara
Photographer: Yasuto Kitahara
Translators: Tan Meng Wee, Keiko Takanashi and Barry Steban
Calligrapher: Tan Kay Ngee

Designers: Wong Chai Yen, Sharn Selina Lim and Seow Soo Shya
Sub-Editors: Ang Hwee Chuin and Narelle Yabuka
Art Director: Jacinta Neoh
Editorial Director: Kelley Cheng
Colour Separation: Colourscan Co Pte Ltd
Printer: KHL Printing Co Pte Ltd
Publisher: Page One Publishing Private Limited

Printed in Singapore, 2003

ISBN: 0-06-059847-6

Library of Congress Control Number: 2003111175

CONTENTS

REMEMBERING CHINA

FOREWORD

China is a vast land that stretches eastward from the Himalayas for some 250 million acres and a country whose population exceeds 1.26 billion people. Its land area is some 3.7 million square miles—which is approximately one fifteenth of the total area of all the continents of the world added together. Its size is equivalent to that of the whole of Europe and 26 times that of Japan, making it the fourth largest country in the world after Russia, Canada, and the United States.

China is a vast country whose climatic conditions, natural features and built forms are very diverse. Apart from the distinctive building forms in each region, building materials also vary from region to region. For example, there are regions where houses are made of sun-dried bricks, and others where homes are simply caves enveloped in yellow earth. China is truly a country of infinite variety, where there are always new and unexpected things to discover.

On 25 October 1999, I visited China's administrative capital, Beijing, with the students of Shibuya Makuhari Japanese School in Singapore. When we arrived, we were appalled to find that the road from the airport was lined with skyscrapers. As with every big city, Beijing was filled with a lot of people and traffic. It felt almost as if we were in Europe or America.

At the time, the excitement of the October 1 National Day celebrations commemorating the fiftieth anniversary of the founding of the People's Republic of China still had not died down. There were also tourists everywhere—both from other parts of the world and other provinces of China. At the time, Beijing was not the only city in China that was undergoing drastic changes and experiencing the gradual rejection of significant cultural elements. The evolution of China could also be felt in other cities such as Shanghai and Tianjin. While this rapid development was worthy of admiration, it felt to me that a part of China had somehow been lost in the process.

The famous district of Wang Fujing, which used to be lined with Chinese seal shops and bookstores, had been transformed into an upscale shopping district lined with brand-name boutiques. One no longer saw the life that filled the alleyways of Wang Fujing, which had left a deep impression on me when I first visited China twenty-five years ago with children playing jump rope and peddlers selling food and daily necessities on their carts—things that once gave Beijing its special character. Even the *sihetang* (which literally means four-sided halls in Chinese as it encloses an open courtyard in the center) where the majority of Beijing residents lived a good part of their lives were no longer in sight, except in the specially preserved heritage districts. I told the students that I felt like Urashima Taro*.

As with most cities that were developing fast, the cultural heritage of Beijing seemed to be slowly fading. But the rural population of China, as at the end of 1998, still constituted some 70% of the Chinese population. Over a period of twenty-five years, I observed that while the cities had changed radically, the drastic development was not paralleled in the countryside, which still maintained the strong characteristics of Chinese culture, traditions and practices.

I happen to be a geographer, and my life has been intertwined with geography for a long time. Being a geography teacher, my trips to China began when I first travelled there to scout for teaching materials. With that purpose in mind, I began taking a lot of slides in order to show my students, but after a few trips, I became intrigued with the country as I became really interested in the way the Chinese live. So I began taking a lot of other slides beyond pure geography. I began photographing life in China.

I am extremely delighted that finally I can share some of these images and my experiences through this book, which documents my multiple visits to China, witnessing the evolution of what I believe will be a great nation one day.

Yasuto Kitahara
June 2002

*Urashima Taro is a legendary Japanese hero, who was carried by a sea turtle to the palace of the Dragon King at the bottom of the sea. After three years of luxury in the palace, he returned to his village to find that a whole generation had passed on land and the village had become a totally different world.

INTRODUCTION

之昆弟之子傳曰何以期也以公妾之昆弟之子傳曰何以期也報之也公妾

傳曰弟何以期也婦之事舅姑等何以期也妾之期也妾之子何以期也

後者服斬妾為之則小君也父卒為何以期也妾之子傳曰何以期也

服也母傳母長子祖父母何以傳長子祖父母何以服君之父母妻

故祖父母何以期也為君之父何以期也為君之父何以期也

服弟也從服也姑姊妹故祖父母服齊衰三月何以服齊衰三月

也從人也姑姊妹傳曰大夫去君之父母妻長子傳曰大夫為舊君

通人無主者謂其姑姊妹其宗也傳曰大夫為舊君何以服

居...夫之君也傳居也大夫去君之父母妻不敢以舊君...

夫者其妻也未嫁者其父母者其成人而父母傳曰嫁者其父母

父母傳之未嫁者未嫁者其祖父母曾祖父子嫁者未嫁者曾祖

子嫁者未嫁者女子嫁者大夫之妻為大夫之妻為舊君何以降

也大夫不敢降其祖父母也齊衰三月傳曰何以齊衰三月

眾人傳曰何以齊衰三月母傳曰何以齊衰三月過大夫之妻

絕也曾祖父母為母傳曰何以母妻如眾人傳曰何以過大夫先

乎言其以道去君而猶未乎言其以道去君而猶未母妻先

言與臣同也何以大夫之謂之庶乎言其以道去君而母妻

其宗廟故服齊衰三月故服齊衰三月之庶母妻

齊衰三月也大夫為舊君何以服齊衰三月也大夫為舊君

序 INTRODUCTION

The difference in longitude from the easternmost tip of Heilongjiang Province and the westernmost tip of the Xinjiang Uigur Autonomous Region is about 60 degrees. The two regions are separated by a distance of about 3,225 miles with a time difference of over four hours.

When the morning light shines in full brilliance over the Ussuri River, which forms the border with Russia in the Northeast, the sky is still pitch black and filled with stars over the Pamir Plateau in the West.

While snowflakes fall over Heilongjiang, Hainan Island in the south feels like the peak of summer. From the northernmost tip of Heilongjiang to the Nansha archipelago far down in the south, the difference in latitude is about fifty degrees, over a distance of 3,420 miles that stretches from the frigid zone to the tropics.

To illustrate the diversity of culture and practices in China, there is a saying that goes "Boats in the South; Horses in the North." The rivers to the south of the Qinling Mountains and the Huai River maintain a relatively steady quantity of water flow throughout the year. They rarely freeze, so they can be used for transportation all year-round. Moreover, in this region, vegetation flourishes. The water is clear as there is relatively little silt in the rivers. There are also many lakes and marshes, which have been connected for some time to make navigation easy. Due to these climatic differences, transportation by boat has long dominated in the south, whereas in the north people depended largely upon horses.

There is another saying in China that goes "Mild in the South; Salty in the North; Sour in the East; and Hot in the West." This is said with reference to the characteristic cuisines of the different regions. Types of cuisine develop in close connection with the climate of that particular region where the cuisine is conceived. Cantonese food is comparatively plain, lacking in strong and spicy flavors, with the emphasis tending towards sweetness. Beijing, being in a cold climate, presents a cuisine that tends to be on the salty side. Shanghainese cuisine, on the other hand, tends to be sour, while Sichuan cuisine, to help fend off the oppressive summer heat, is hot and spicy.

All these differences in geography and culinary preferences are only small examples of the variety of life in China. There is still so much more to China that this book alone certainly does not suffice.

RIGHT:
The Xia River People living near the front gate of the Labuleng temple

FOLLOWING PAGES pp. 6-7
Images of a parade celebrating the 11th National People's Congress in Shanghai

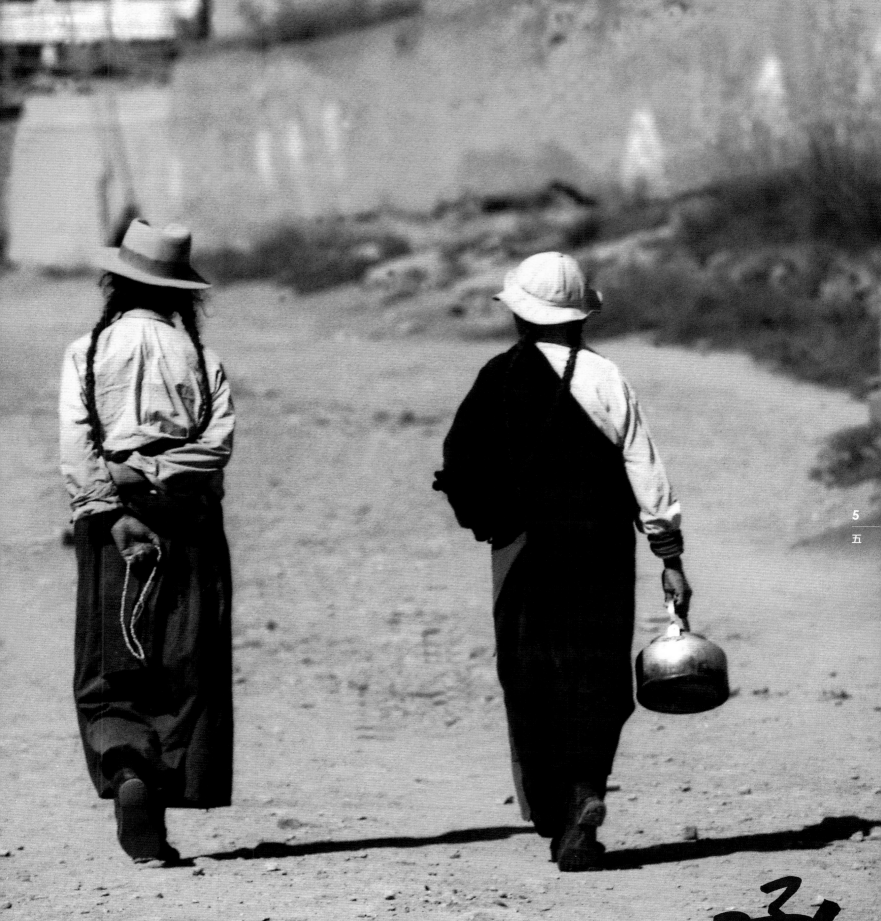

承

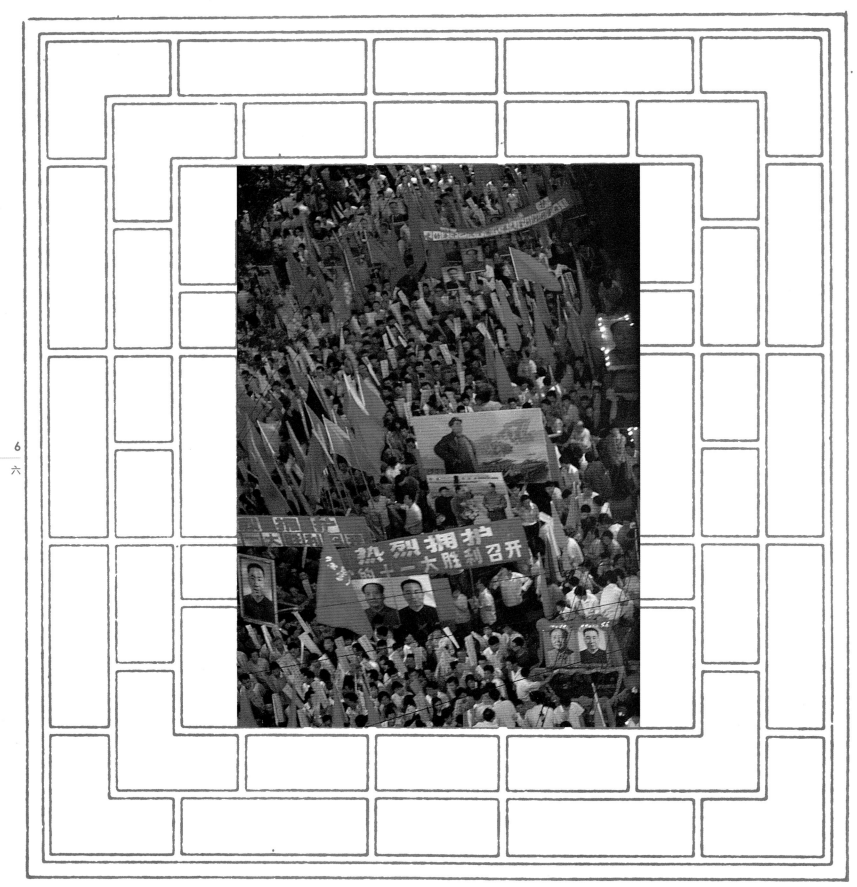

人人为我

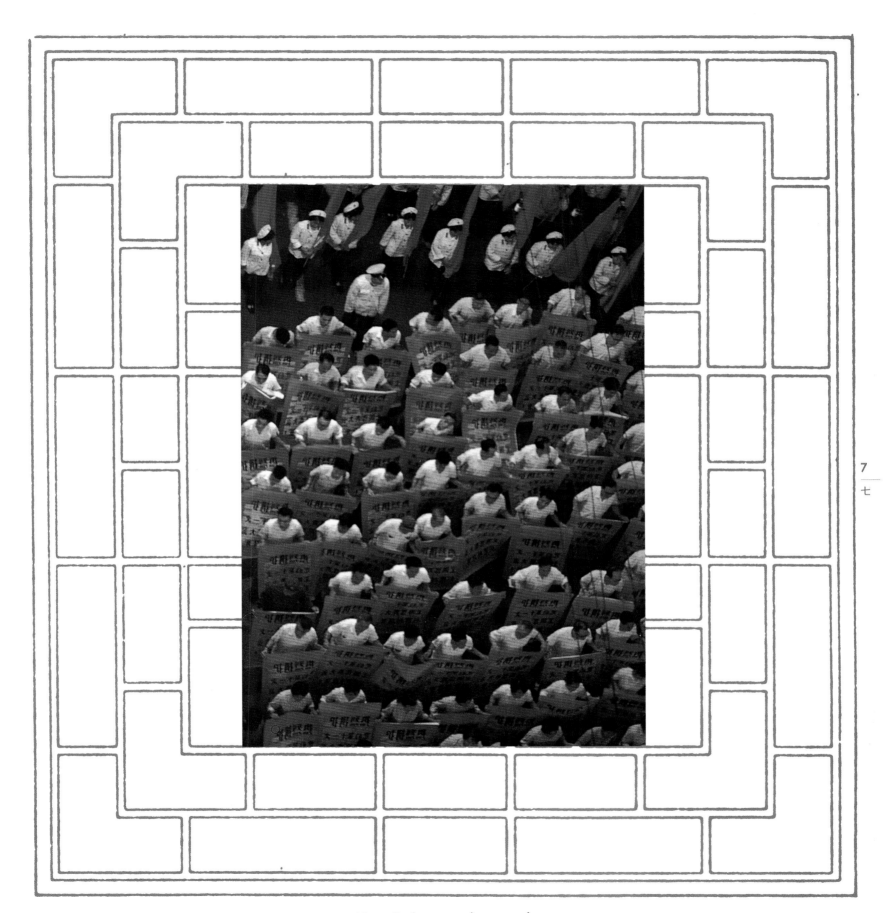

我为人人

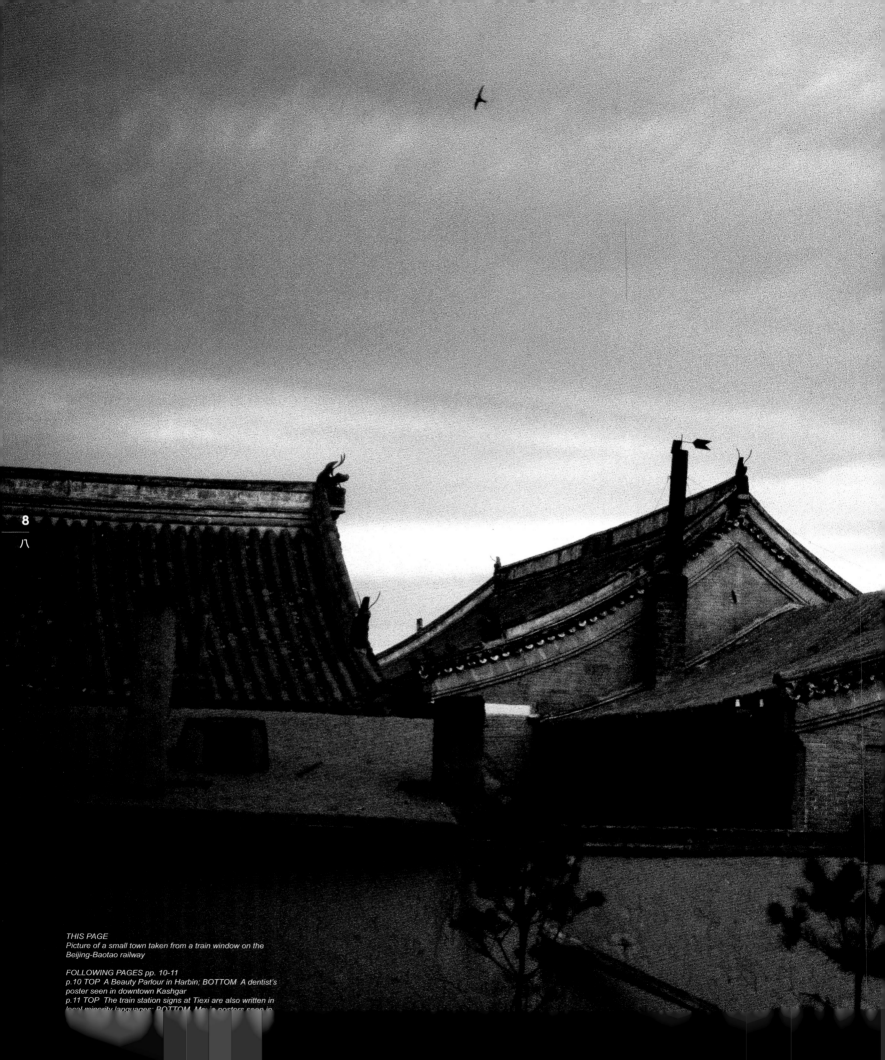

8
八

THIS PAGE
Picture of a small town taken from a train window on the
Beijing-Baotao railway

FOLLOWING PAGES pp. 10-11
p.10 TOP A Beauty Parlour in Harbin; BOTTOM A dentist's
poster seen in downtown Kashgar
p.11 TOP The train station signs at Tiexi are also written in
local minority languages; BOTTOM Mao's posters seen in

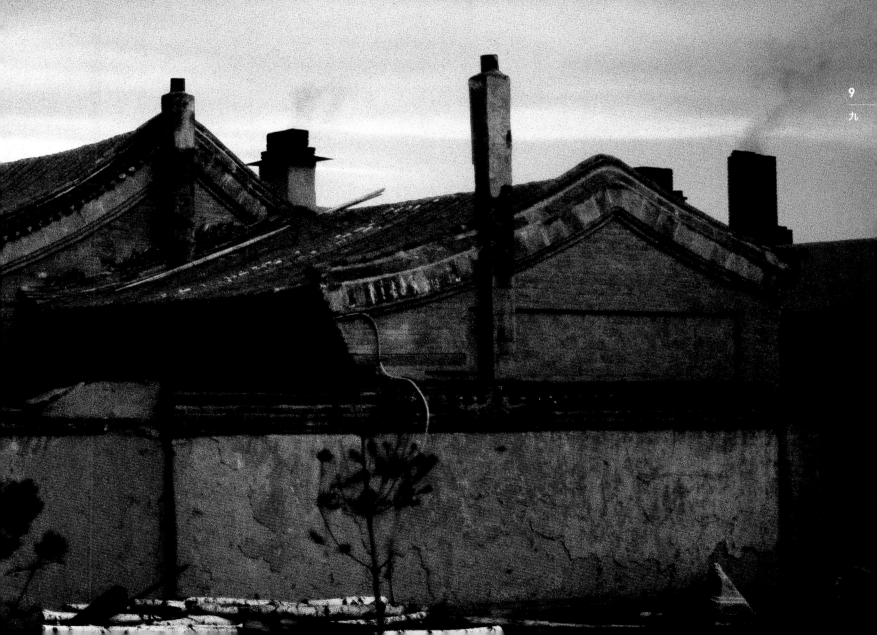

A Quartrain
Under the late sun, the scene is beautiful,
The Spring breeze bears the fragrance of flowers and grass
The mud has thawed, and swallows fly around,
On the warm sand, mandarin ducks are sleeping
- Du Fu

絕句

遲日江山麗

春風花草香

泥融飛燕子

沙暖睡鴛鴦

- 杜甫

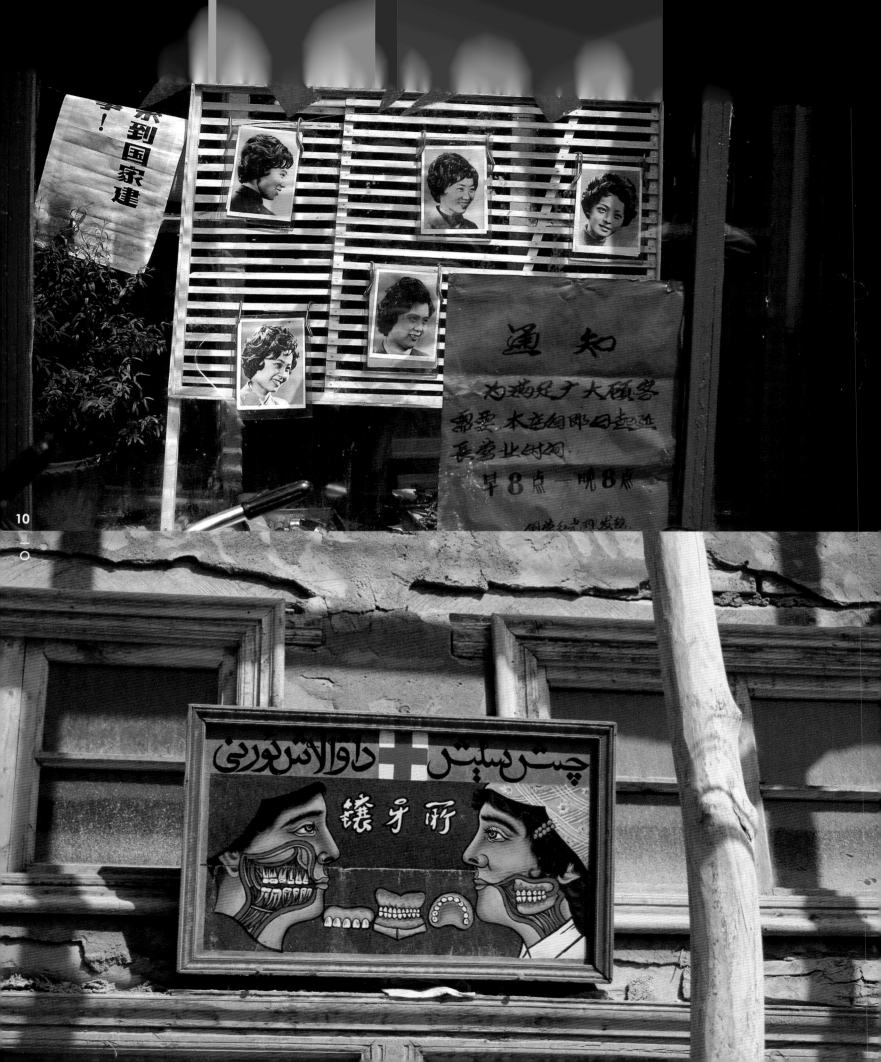

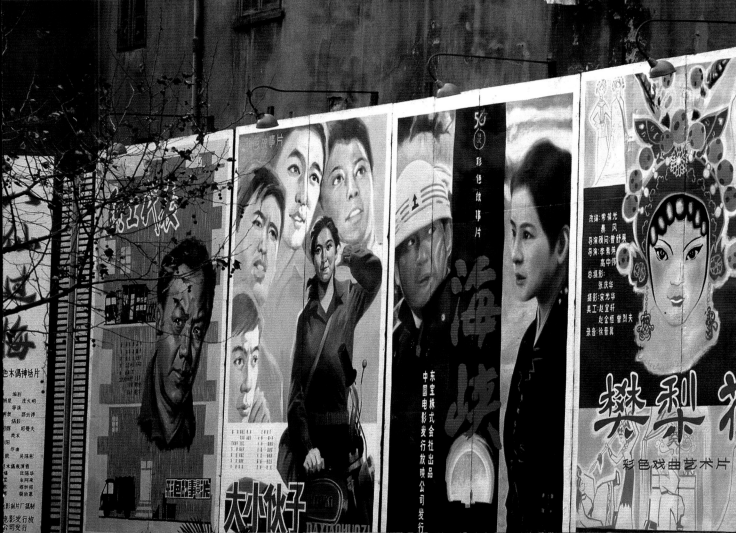

chapter one
PEOPLE

When one thinks of Chinese society, one thinks of strong family ties, like filial piety, ancestor worship, bonding of ethnic groups, etc. In China, however, with the implementation of the one-child policy in January 1979, there has been a predominance of the nuclear family, as well as significant changes occurring in family relationships. This policy has resulted in an increasingly aging society and a struggle for more independence among the younger generation, which is going against the Chinese tradition of maintaining strong family ties.

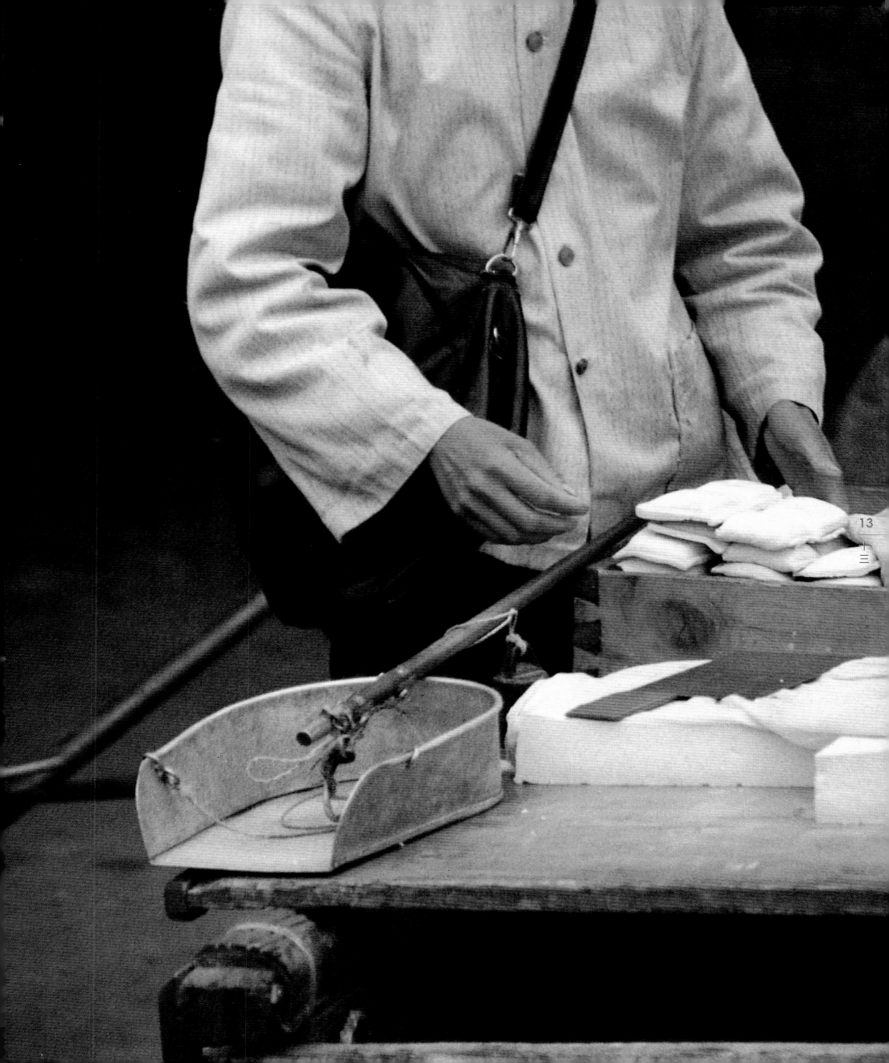

PEOPLE

work . leisure . family

China has long been known for the size of its agricultural workforce and for the assiduousness in their work. The South is known for the cultivation of rice while the North is known for harvesting wheat. Among China's population of 1.26 billion people, the percentage of the population engaged in agriculture is 50% (as of 1998).

When I visited China for the first time in 1976, there were posters everywhere advocating—"In Agriculture, Learn from Dazhai" and "In Industry, Learn from Daqing." I visited Dazhai in 1978. Under Mao Zedong's directives, large-scale collective communities for agricultural production called "communes" were set up throughout the country. The one in Dazhai village, in particular, was directed by Mao Zedong personally. Through the investment of machinery and labor, the barren earth of the village—in the yellow soil region—had been transformed into beautiful terraced fields planted with flourishing corn and other crops. Moreover, reservoirs were built, irrigation systems were set up, facilities for the cultivation of vegetables and the raising of farm animals were constructed, and collective residences were developed. Because of the nationwide campaign, there were a lot of visiting farmers from Guangdong and Sichuan Provinces who went there to learn from the "model village." Subsequently, in the 1982 constitution, a production responsibility system was introduced in order to raise the peasants' enthusiasm for production, and the people's communes were disbanded.

As the production responsibility system became established, specialized farming families (*zhuanyehu*) began to appear, i.e. farmers who specialized in raising livestock, cultivating vegetables or fruit, or in the transportation or construction industries. Among these *zhuanyehu*, successful families began to appear with annual incomes of over ten thousand yuan. These are called *wanyuanhu*.

With the appearance of such *wanyuanhu*, a growing number of people from the rural areas began to travel abroad or within China. Dazhai village is in the wheat cultivation region. In this region, generally, wheat is cut using sickles, and the threshing is done on communal ground by means of foot-operated husking machines, or by sifting them with poles pulled by oxen. The separation of the good grains from the bad is done either with the aid of machines or by manual labor. The grains are subsequently dried by spreading them out on top of mats laid out along the roads, from which peasants will then pack the dried grains into bags that same evening. This trading of the harvested wheat is conducted on the same roads where the grains are threshed.

In the southern rice-cultivation regions, there has not been much effort to introduce technology. From the preparation of the rice seedlings to the weeding of the fields and application of fertilizer, and finally the harvesting of the mature rice—the whole cycle is essentially carried out through human labor. The slogan "In Industry, Learn from Daqing" was most widespread in 1960, and Daqing became the greatest oil field in China. A petrochemical complex has also been built there. Under the inspiration of the Daqing work spirit of "self-reliance, hard work and persistence," the "Learn from Daqing" movement spread throughout the country.

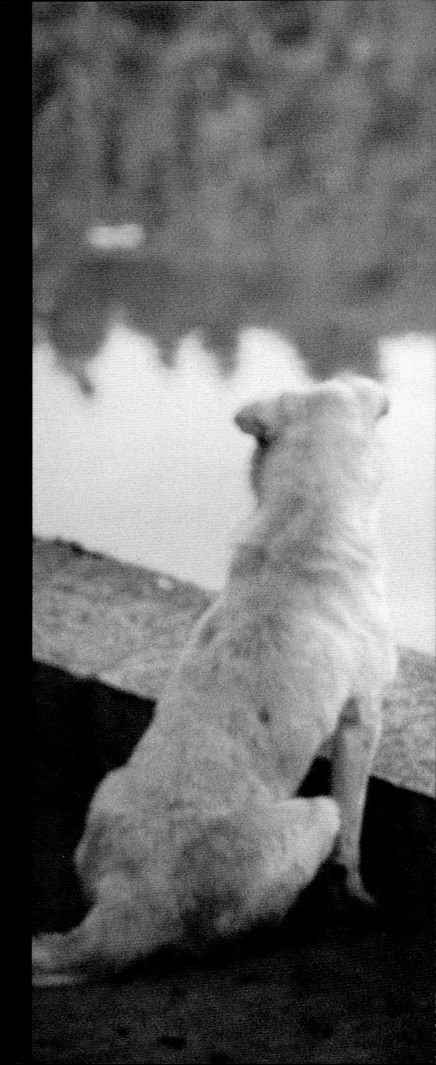

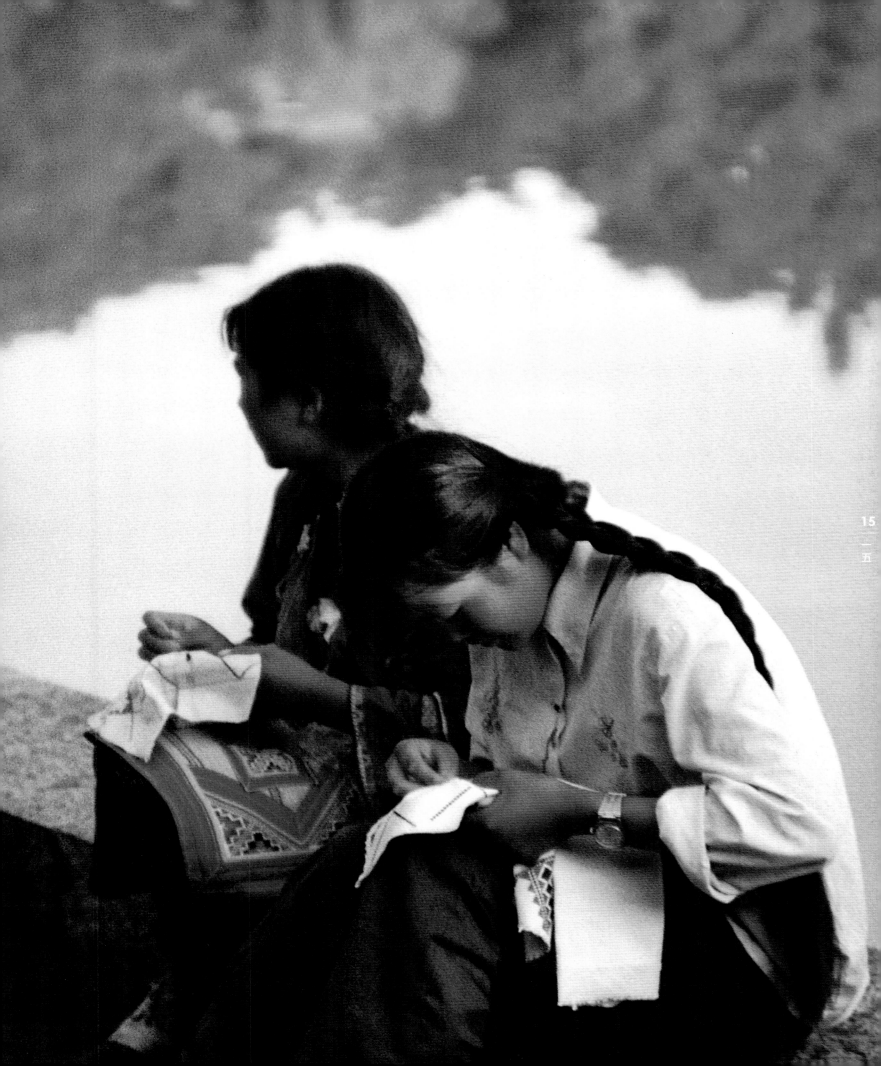

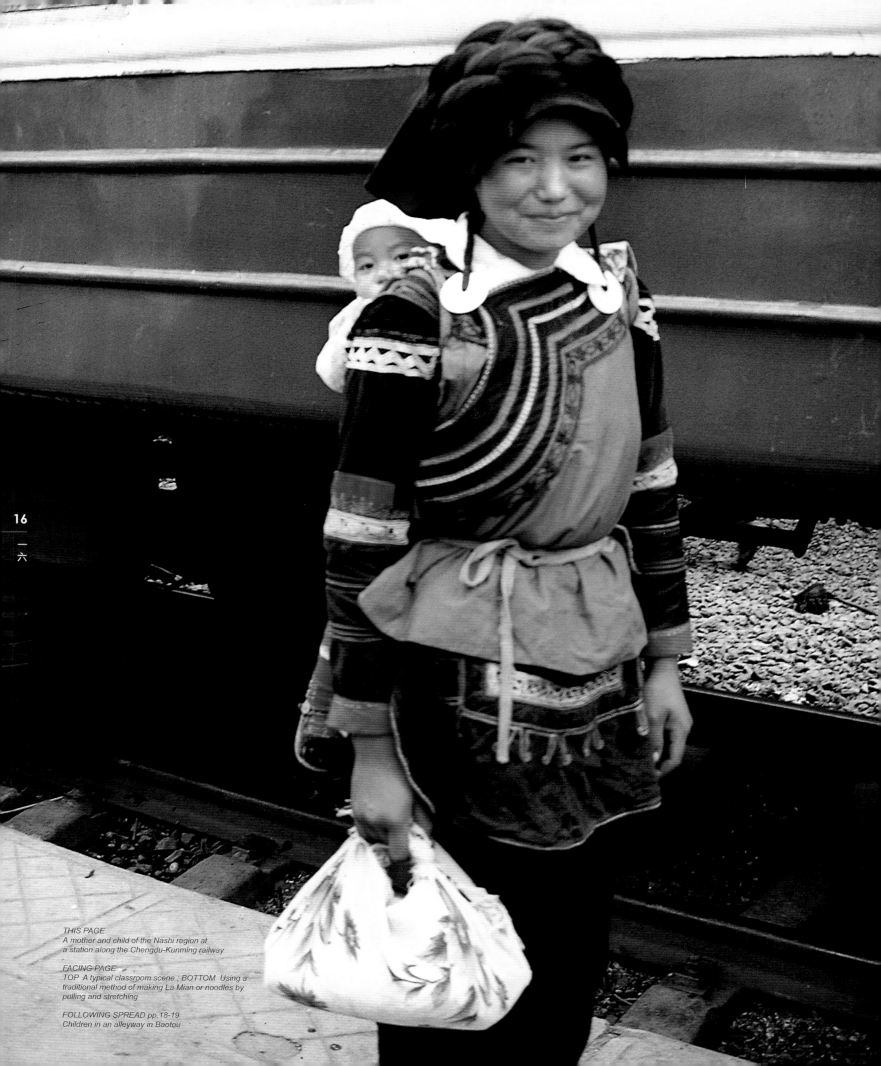

THIS PAGE
A mother and child of the Nashi region at
a station along the Chengdu-Kunming railway

FACING PAGE
TOP A typical classroom scene ; BOTTOM Using a
traditional method of making La Mian or noodles by
pulling and stretching

FOLLOWING SPREAD pp.18-19
Children in an alleyway in Baotou

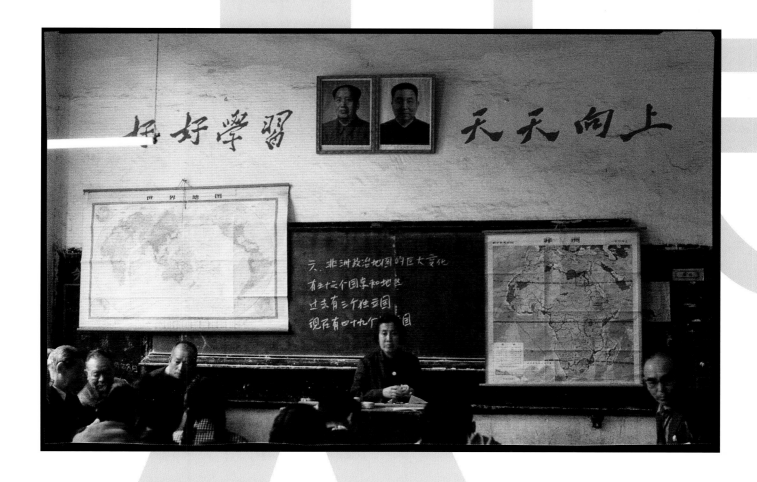

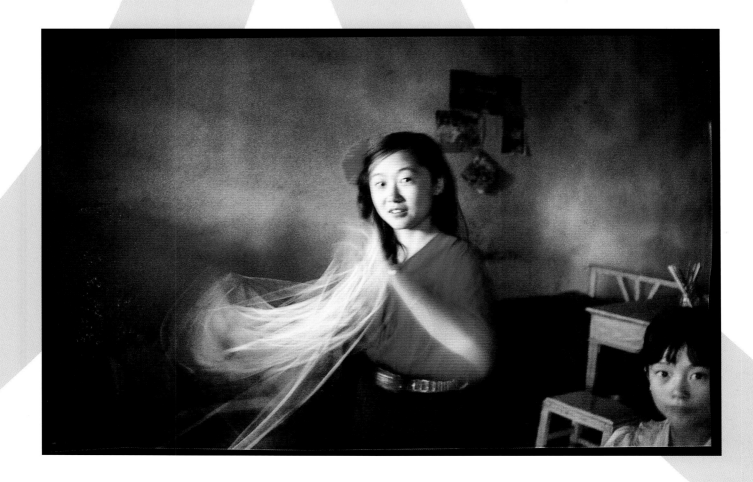

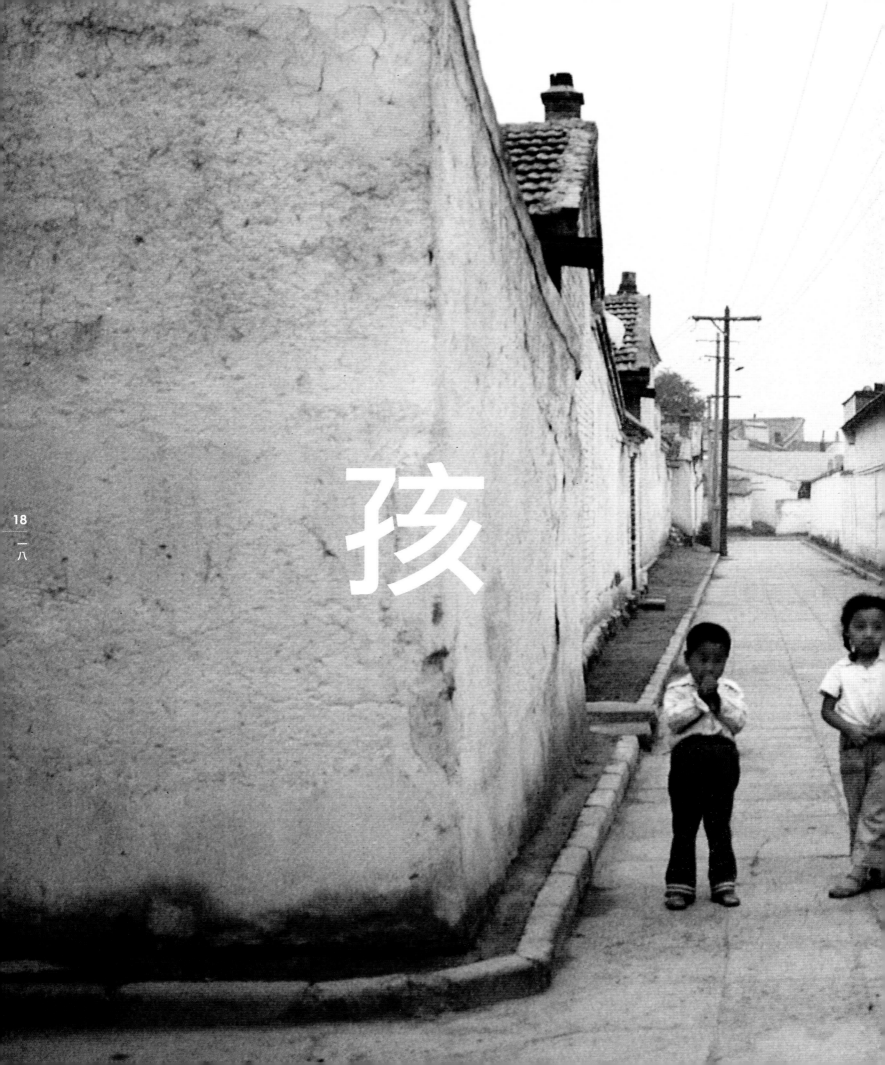

孩

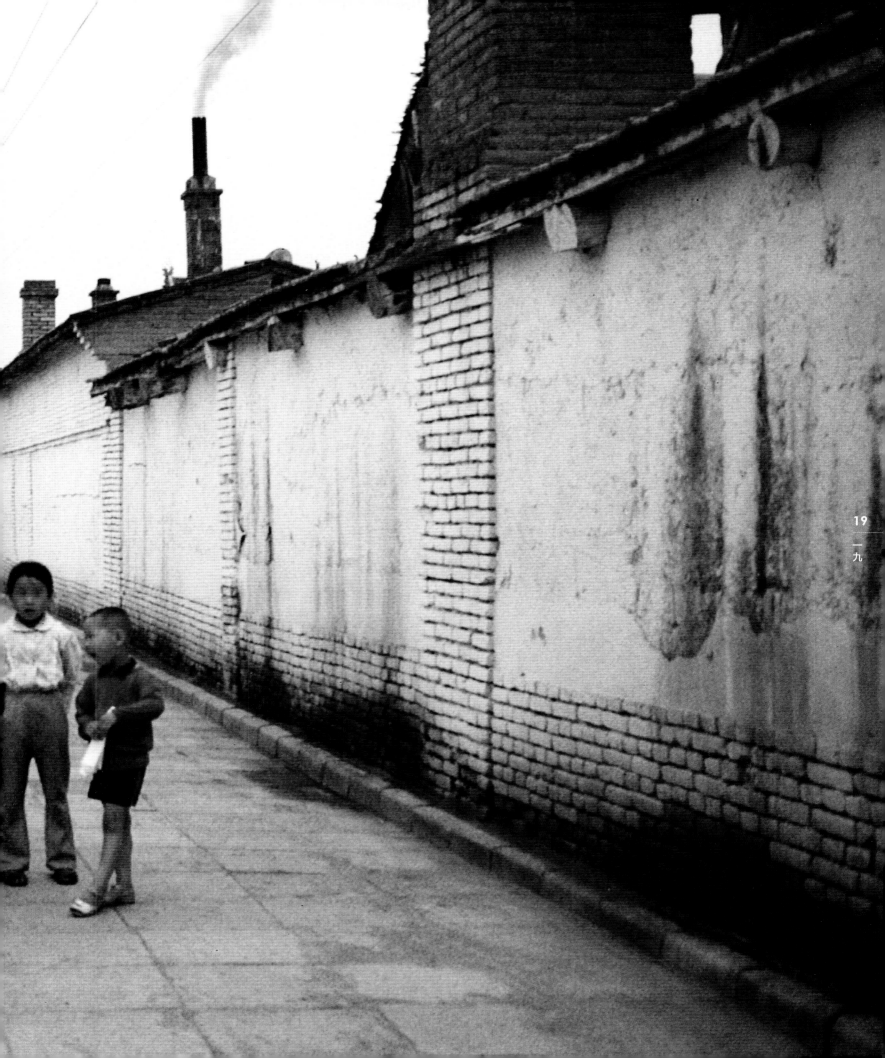

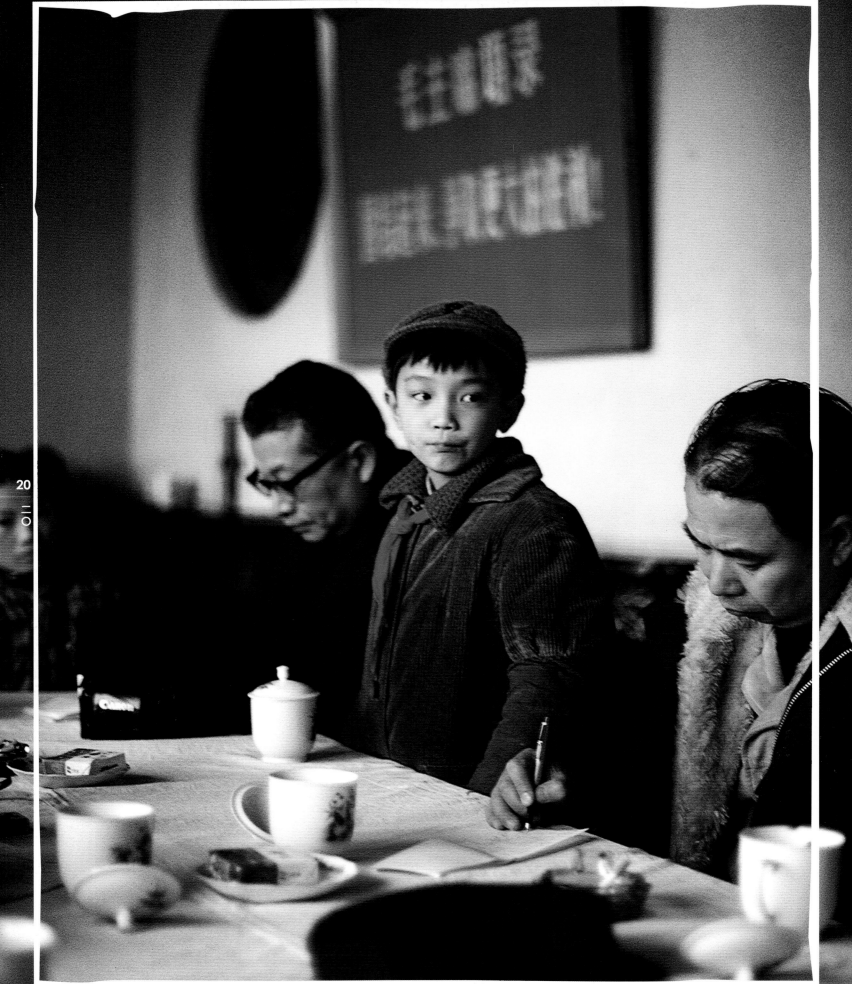

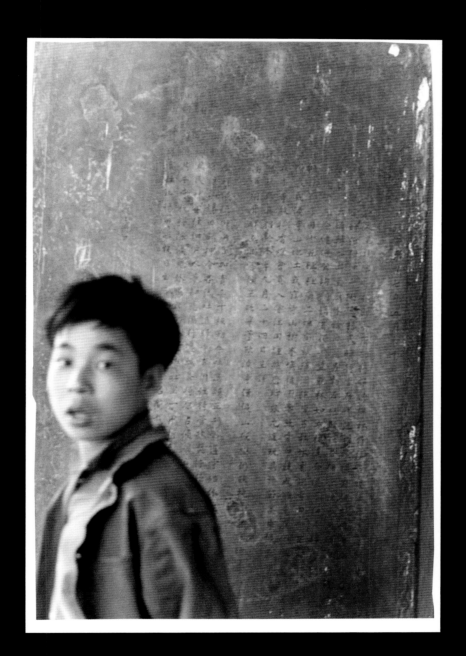

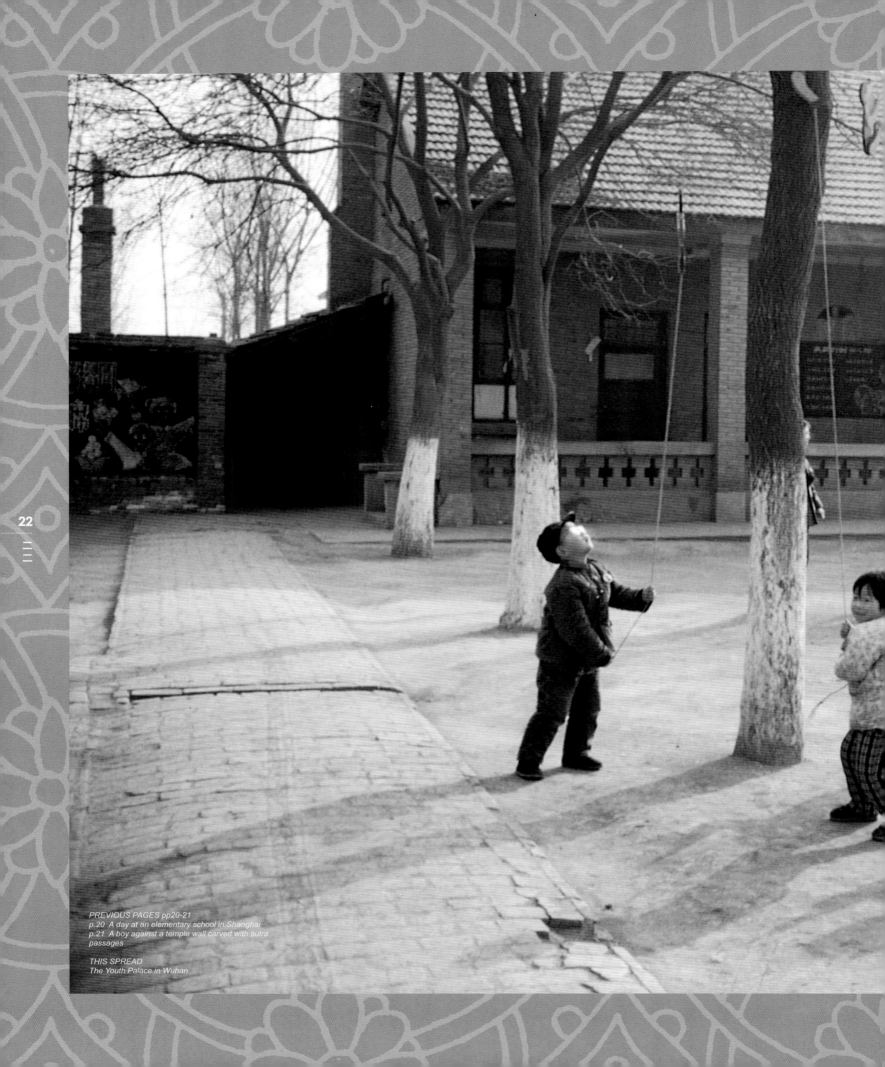

22

PREVIOUS PAGES pp20-21
p.20 A day at an elementary school in Shanghai
p.21 A boy against a temple wall carved with sutra
passages

THIS SPREAD
The Youth Palace in Wuhan

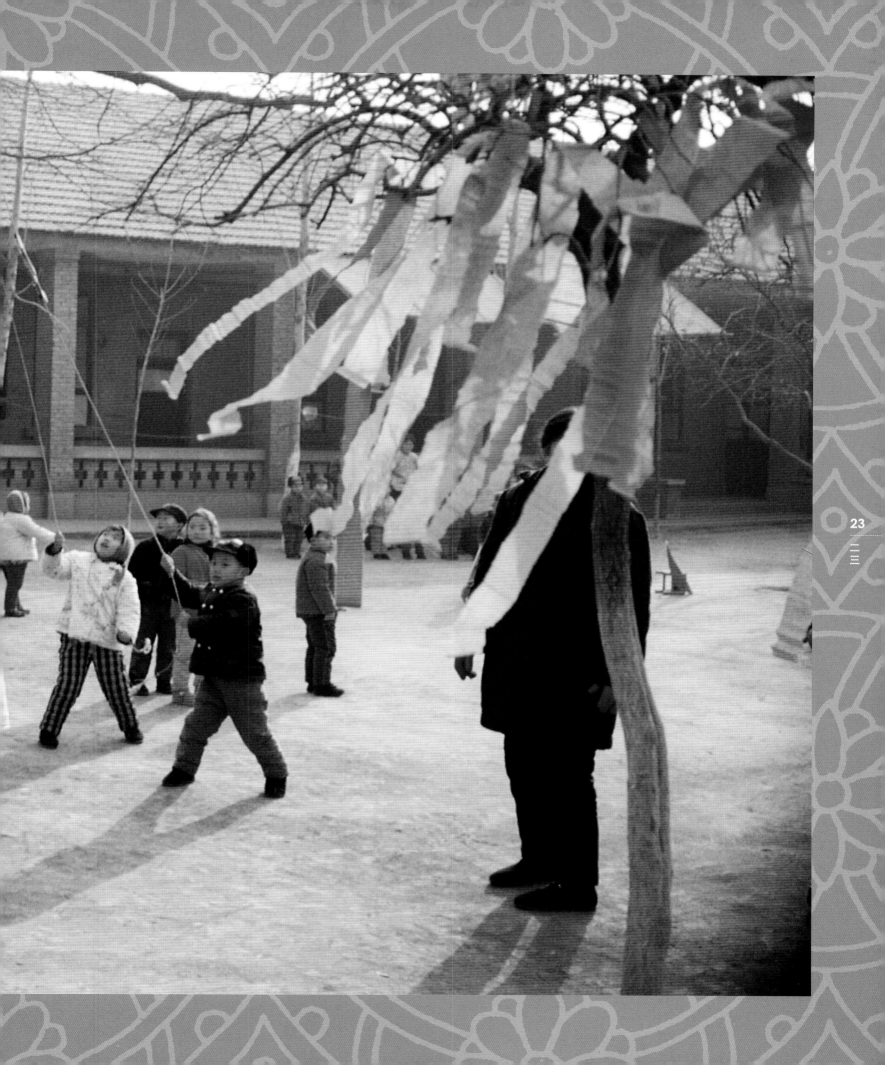

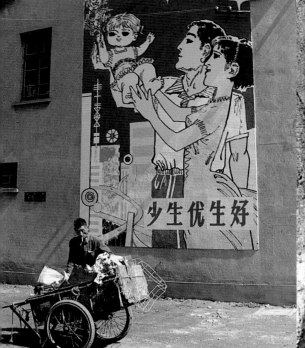

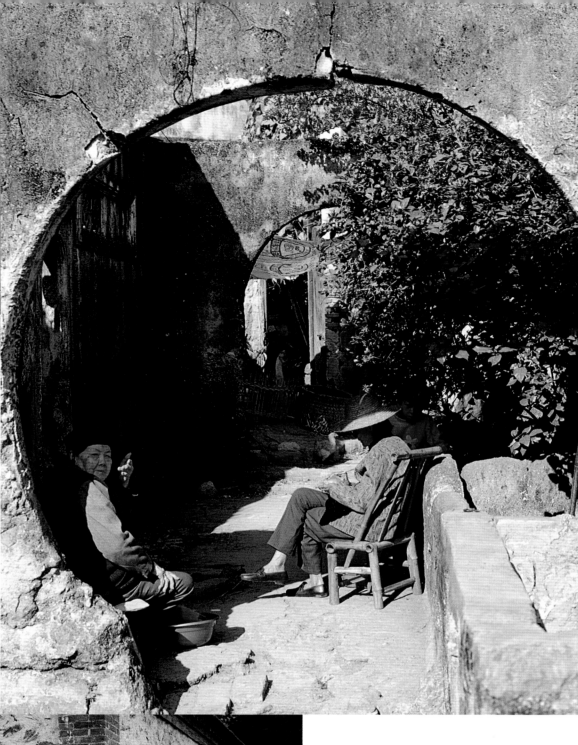

消 閑

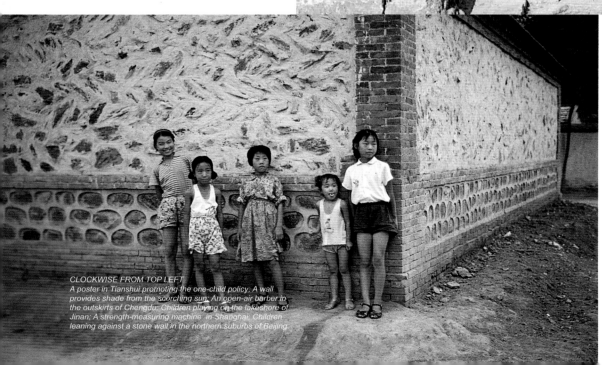

CLOCKWISE FROM TOP LEFT
A poster in Tianshui promoting the one-child policy; A wall
provides shade from the scorching sun; An open-air barber in
the outskirts of Chengdu; Children playing on the lakeshore of
Jinan; A strength-measuring machine in Shanghai; Children
leaning against a stone wall in the northern suburbs of Beijing

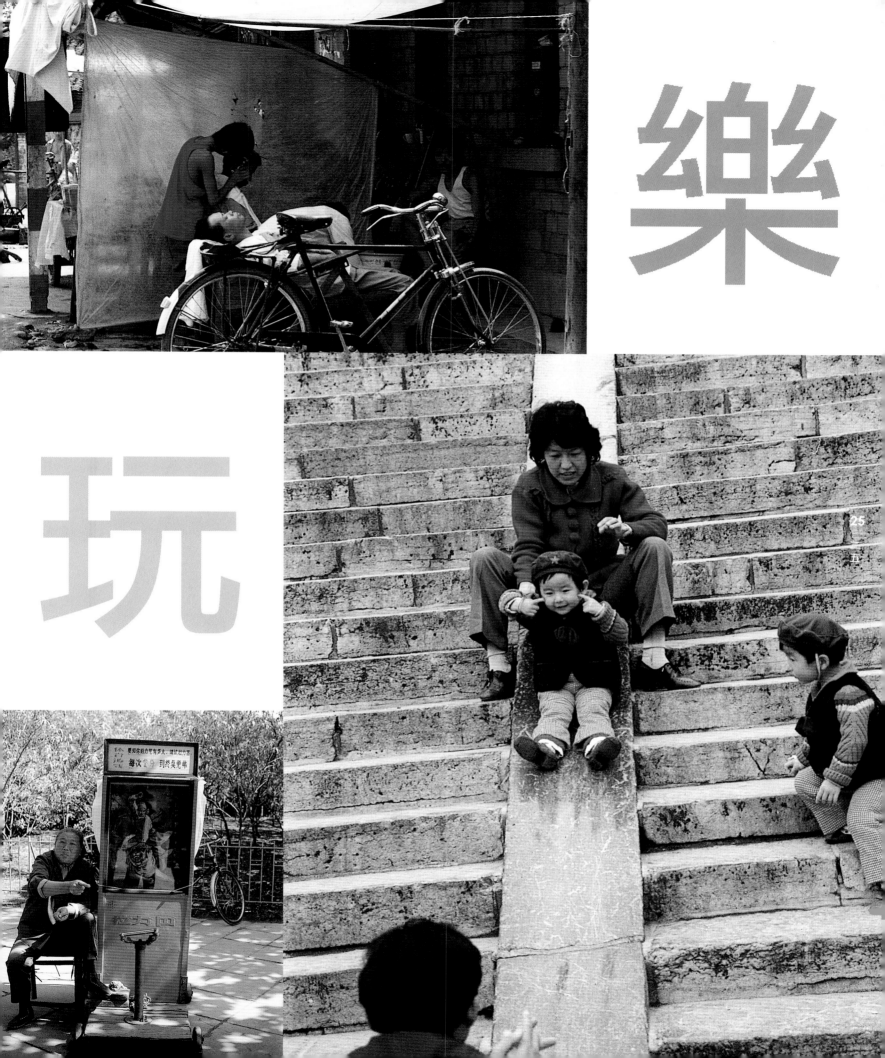

樂

玩

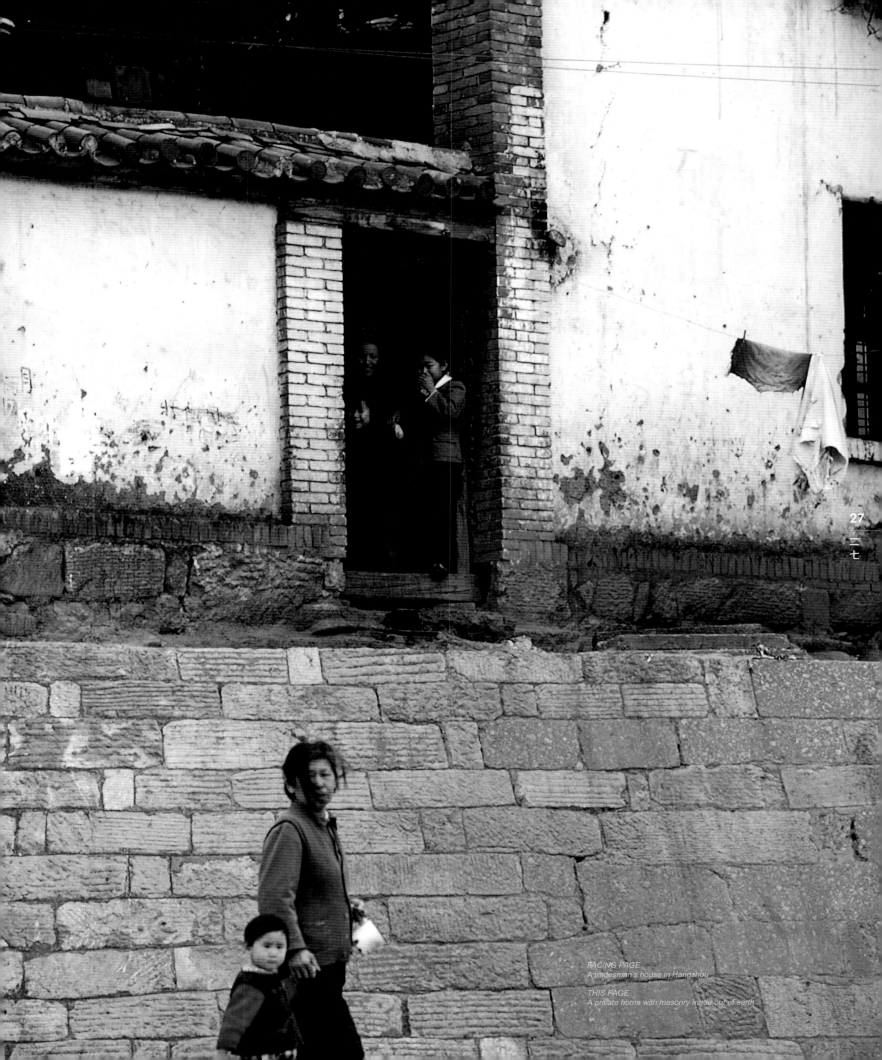

27
二十
七

WORK

The Silk Road is the name of an ancient trade route coined by a German geographer, Ferdinand Freiherr von Richthofen. Though the trade route was never known as the Silk Road historically, it was the most important connection between the Orient and the West before the discovery of the sea route to India. This route starts in the old capitals of Luoyang and Xian and reaches the Yellow River at Lanzhou, following along the Gansu Corridor across the continents. In a town called Hotan, which is situated along the Silk Road, the making of silk and silk woven products is carried out as a cottage industry. In Turfan, women wearing silk clothing are a common sight, especially in the silk factories, where the workers work on their silk reeling machines clad in delicate silk clothes.

Trades in the villages of China are often directly related to what the regions produce or breed, and the whole village specializes in the trade. For example, sheep-raising is very widespread in the Uigur Autonomous Region of Xinjiang, and hence, there is an abundance of carpet factories. And in the Northeast in Changchun and Lanzhou, fine wood carving is a specialty. The factories produce a variety of ornamental carvings both for local consumption and export.

The famous Shaoxing wine is produced in the city of Shaoxing in central China. China's most famous fermented-grain wines include white wine, made in Gaoliang, Maotai from Guizhou, fen wine from Shanxi, and Shaoxing wine. Shaoxing is also a major producer of bamboo and hence there are also many bamboo factories there that produce bamboo chairs, bamboo poles, and crafts made of bamboo. These products are transported mostly by traditional means of transport such as horse-drawn carts, human-drawn carts, bicycle-wagons, bicycles, and occasionally lorries.

THIS SPREAD
Laborers on a truck in Chengdu E'mei

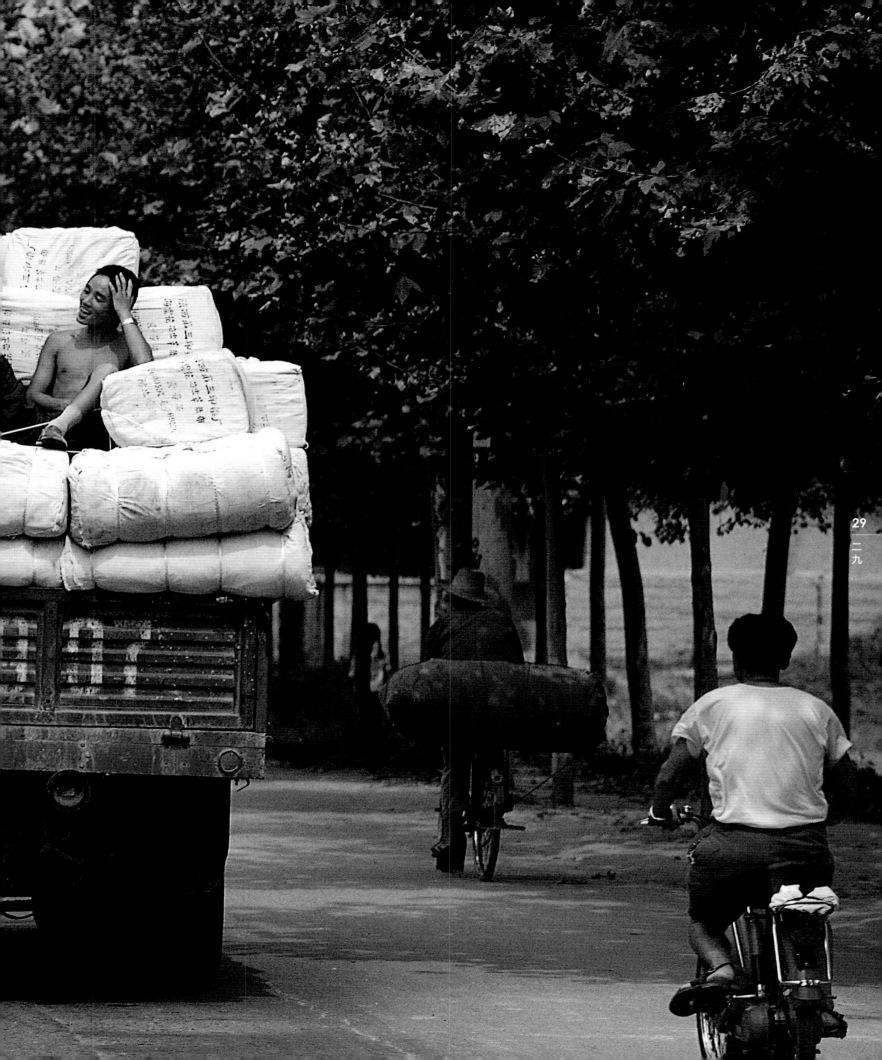

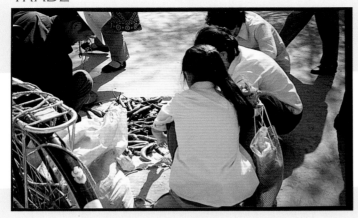
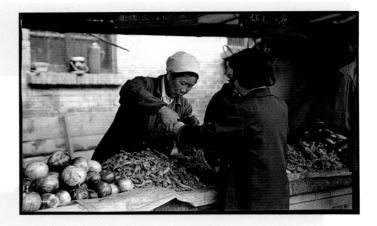
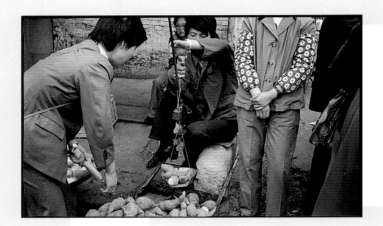
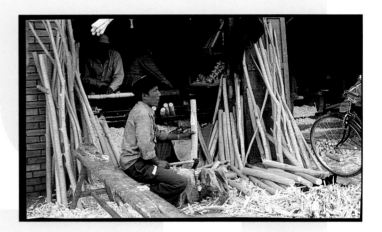
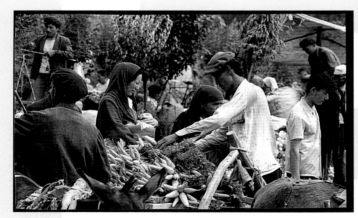
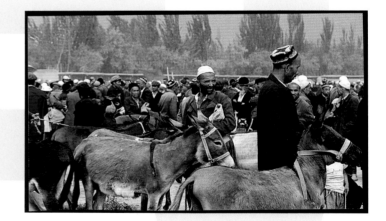

THIS PAGE (CLOCKWISE FROM TOP LEFT)
A green grocer selling cucumbers in Lanzhou ; A green grocer selling vegetables in Lanzhou;
Processing lumber; Livestock transactions at a bazaar in Kashgar; A grocer's shop in Kashgar;
A green grocer selling potatoes in Lanzhou

Markets in different parts of China have different characteristics. When I first went to Beijing, I visited the Xidan vegetable market. Housed within a large building, the stalls selling vegetables and poultry were lined side by side with their items all spread out in front of the stall. The array of things was really colorful and the overall display was really attractive. Fish and meats were hung at eye-level, or displayed on platforms, and customers could easily pick out what they wanted. When I visited the market at the Chongwen Gate subsequently, I realized that not all markets were the same. Here, the produce was all displayed within glass cases. In another region, the market was a series of simple shops with makeshift roofs, shielding the hawkers from the scorching sun. The Uigur bazaar that I had visited was conducted under the open sky. The markets of the Han people, in Lanzhou, Hangzhou, as with Beijing, were set up inside large buildings. This seems to reflect some sort of cultural difference between the different ethnic groups.

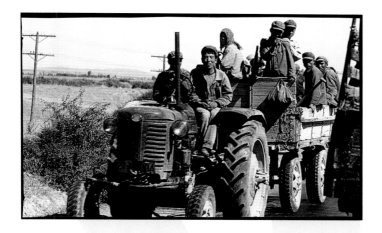

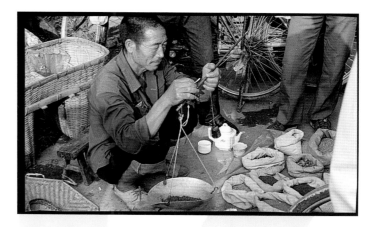

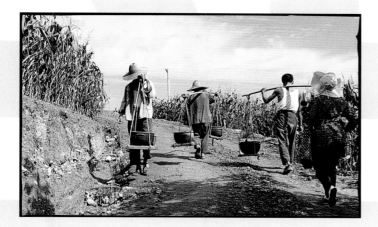

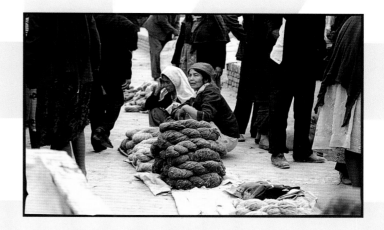

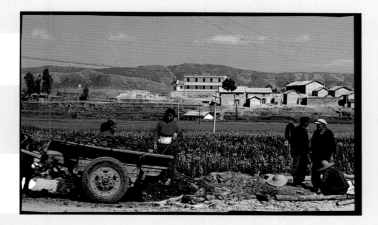

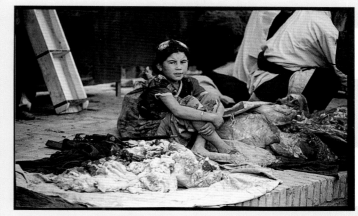

THIS PAGE (CLOCKWISE FROM TOP LEFT)
Trucks, in the suburbs of Lanzhou,used for transporting crops also transport people; Selling spice by measure in the suburbs of Qufu; A stall in a bazaar in Kashgar selling wool yarn; Meat on sale at a Sunday bazaar in Kashgar; Vegetable cultivation in the outskirts of the city of Kunming; Farmers carrying fertilizers in Dazhai

In these markets, one can find practically everything, including things that one would not have imagined. Amidst the usual vegetables, meat, hats, wool, mats, cotton, cotton yarn, silk thread and cloth, one could also buy sheep heads, internal organs of various animals, lumber, gates, doors for entrances, skins, and so on and so forth. And everywhere, there were live animals such as cows, horses, donkeys, sheep and chickens either for sale or barter.

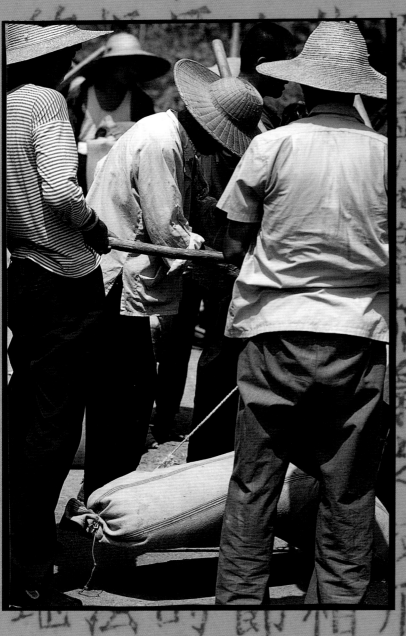

32

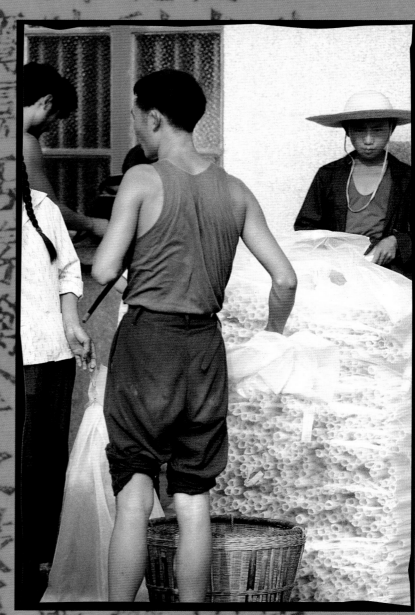

THIS PAGE
LEFT Using the road as a trading ground for wheat
transactions in the outskirts of Xi'an; RIGHT Shops along the
road in E'mei

FACING PAGE
LEFT A craftsperson weaving from bamboo in E'mei, RIGHT
Working on a vase in the shade in Kuge

FOLLOWING SPREAD pp.34-35
Work and life across China

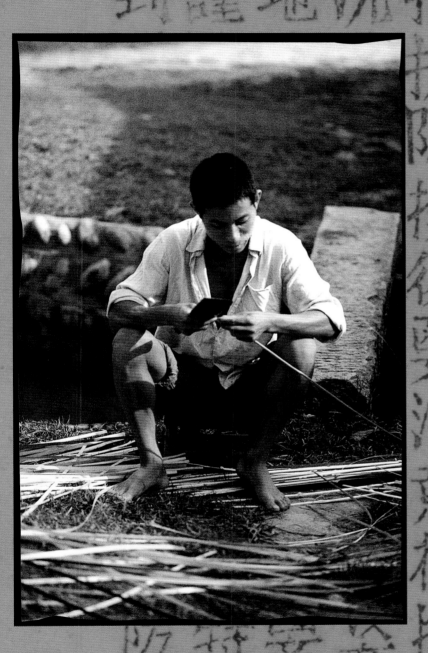

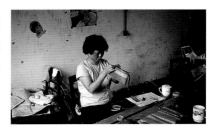
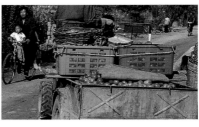
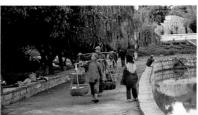
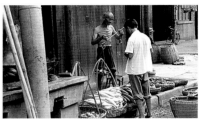
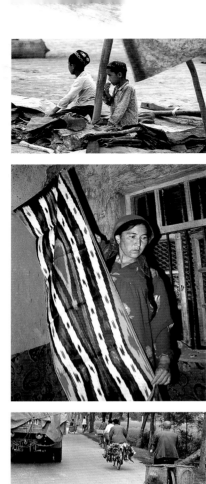
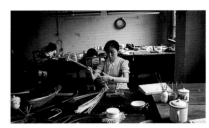
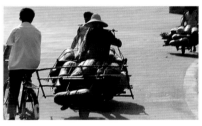
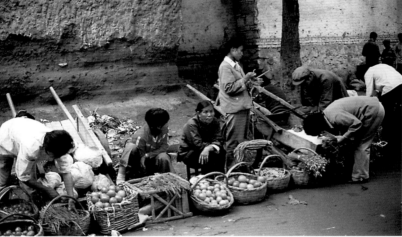
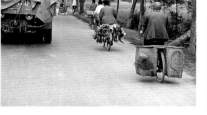
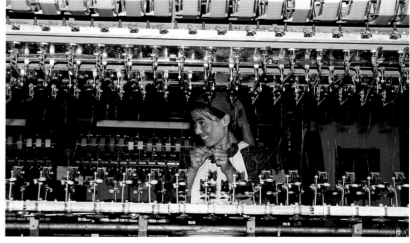

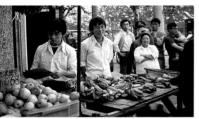

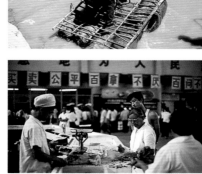
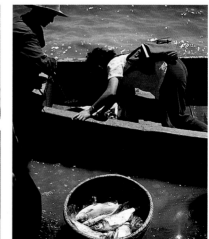

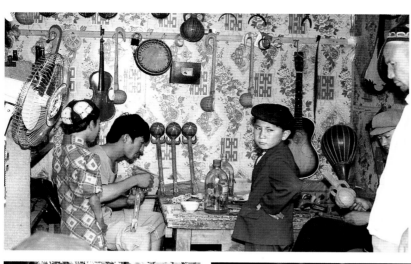
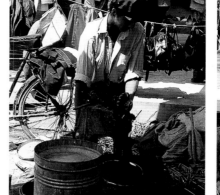
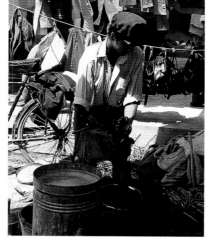

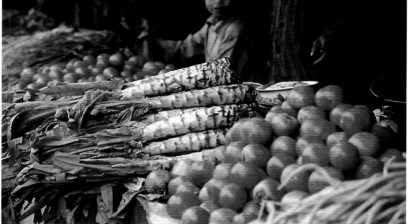

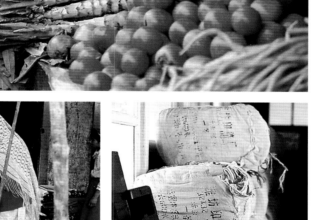

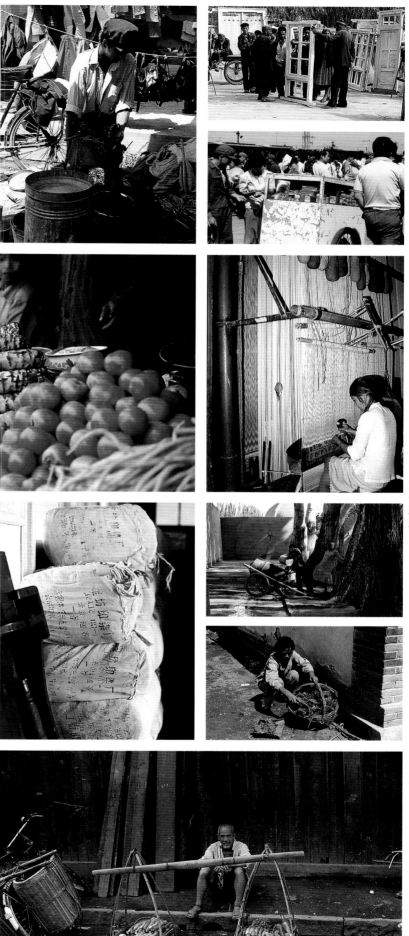

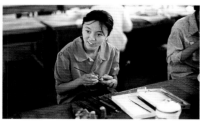
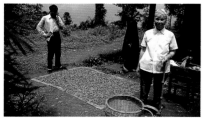
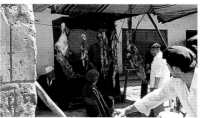
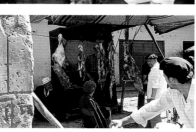

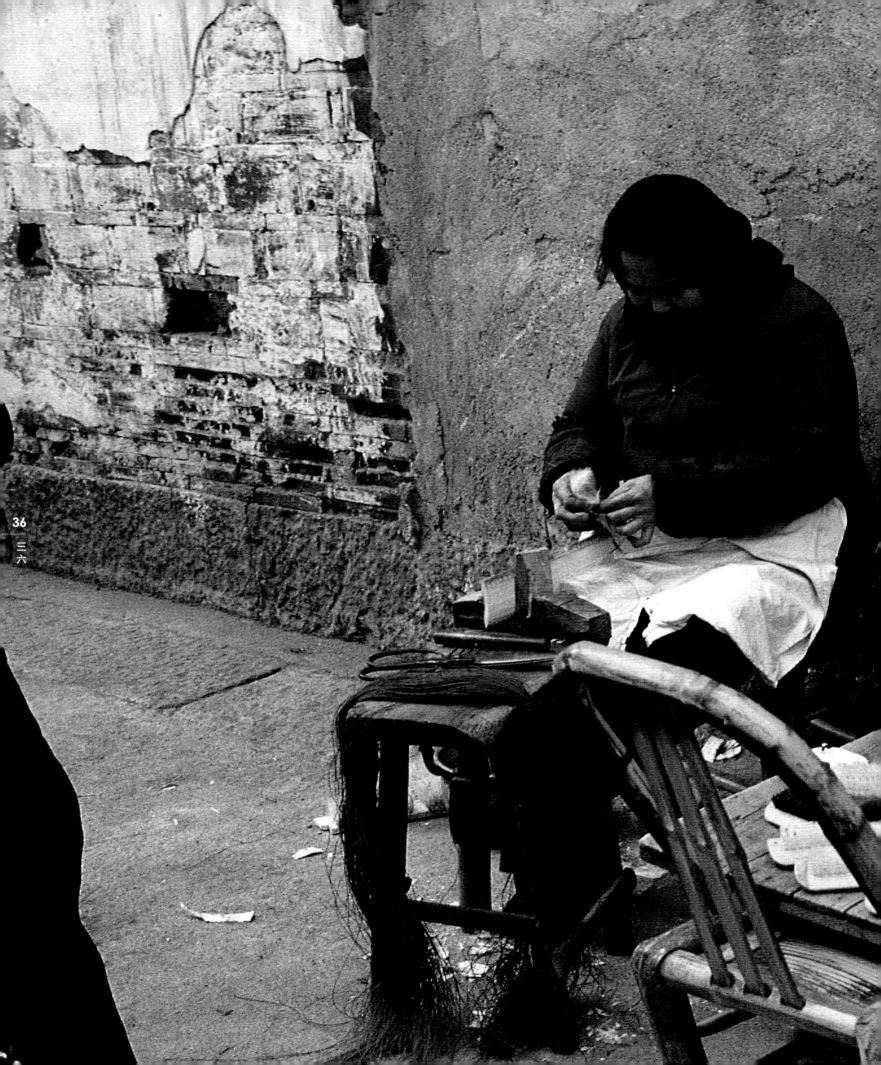

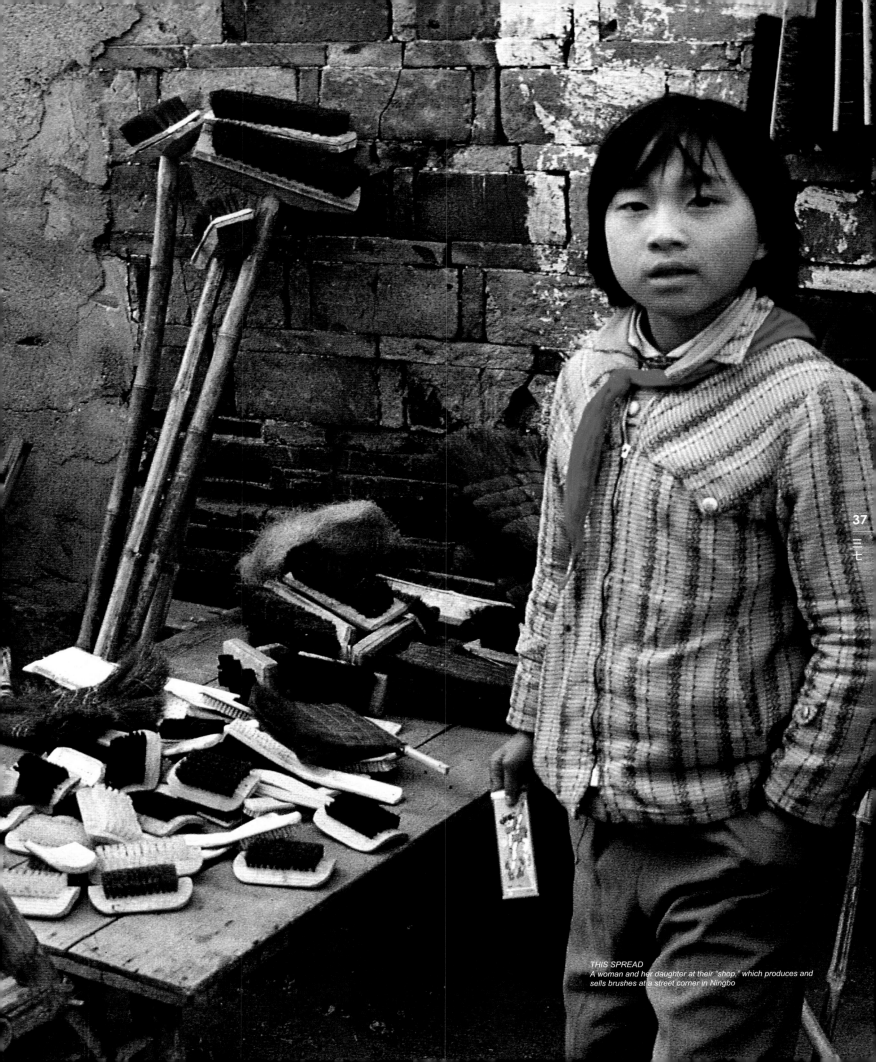

THIS SPREAD
A woman and her daughter at their "shop," which produces and sells brushes at a street corner in Ningbo

THIS SPREAD
The farmers of Sichuan Province taking a short break

FOLLOWING PAGES pp.40-41
p.40 TOP People playing chess in Yining; BOTTOM Visitors from Japan at Lake Kunming
p.41 TOP A grandmother taking a nap; BOTTOM People playing mahjong

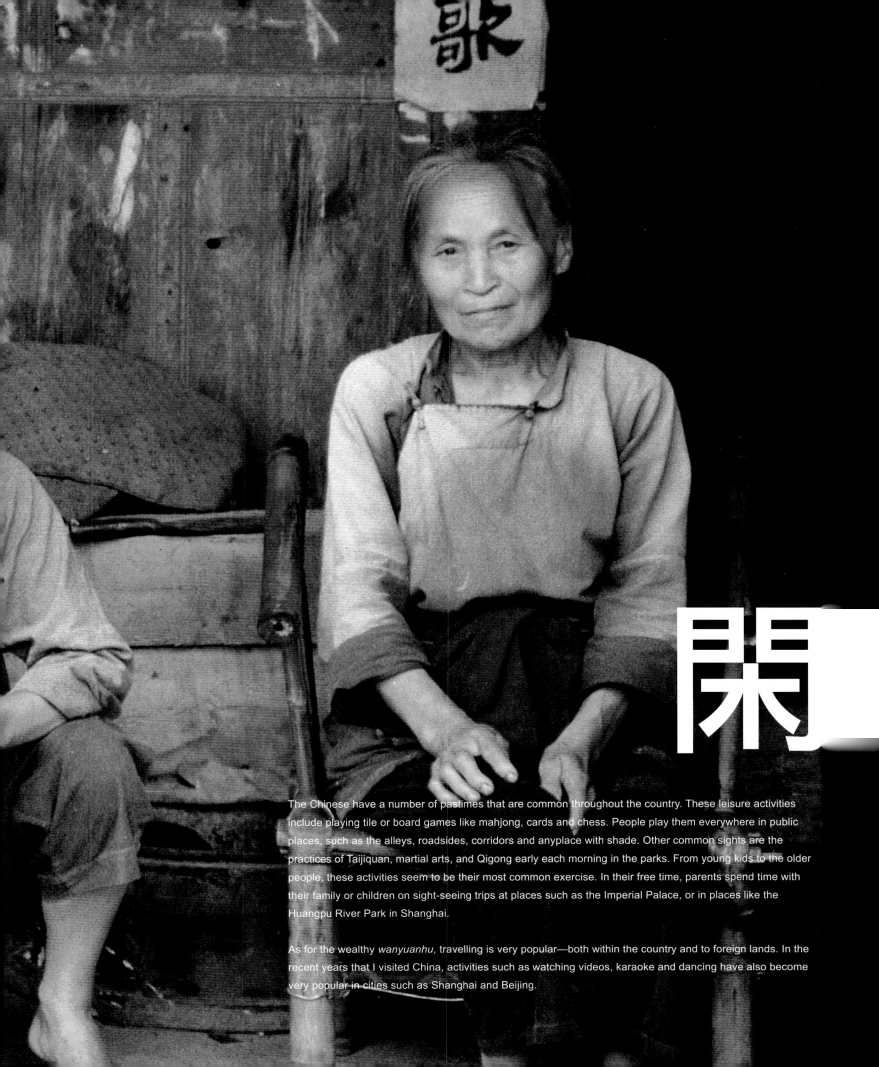

The Chinese have a number of pastimes that are common throughout the country. These leisure activities include playing tile or board games like mahjong, cards and chess. People play them everywhere in public places, such as the alleys, roadsides, corridors and anyplace with shade. Other common sights are the practices of Taijiquan, martial arts, and Qigong early each morning in the parks. From young kids to the older people, these activities seem to be their most common exercise. In their free time, parents spend time with their family or children on sight-seeing trips at places such as the Imperial Palace, or in places like the Huangpu River Park in Shanghai.

As for the wealthy *wanyuanhu*, travelling is very popular—both within the country and to foreign lands. In the recent years that I visited China, activities such as watching videos, karaoke and dancing have also become very popular in cities such as Shanghai and Beijing.

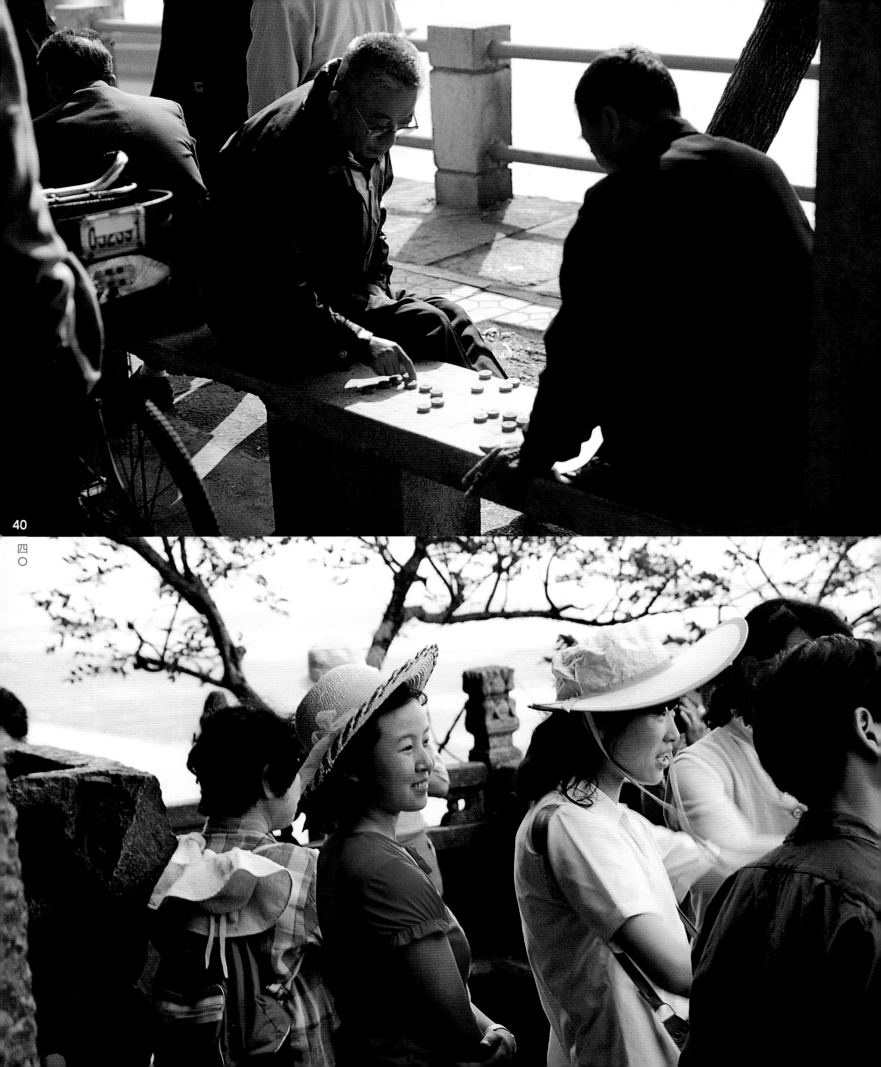

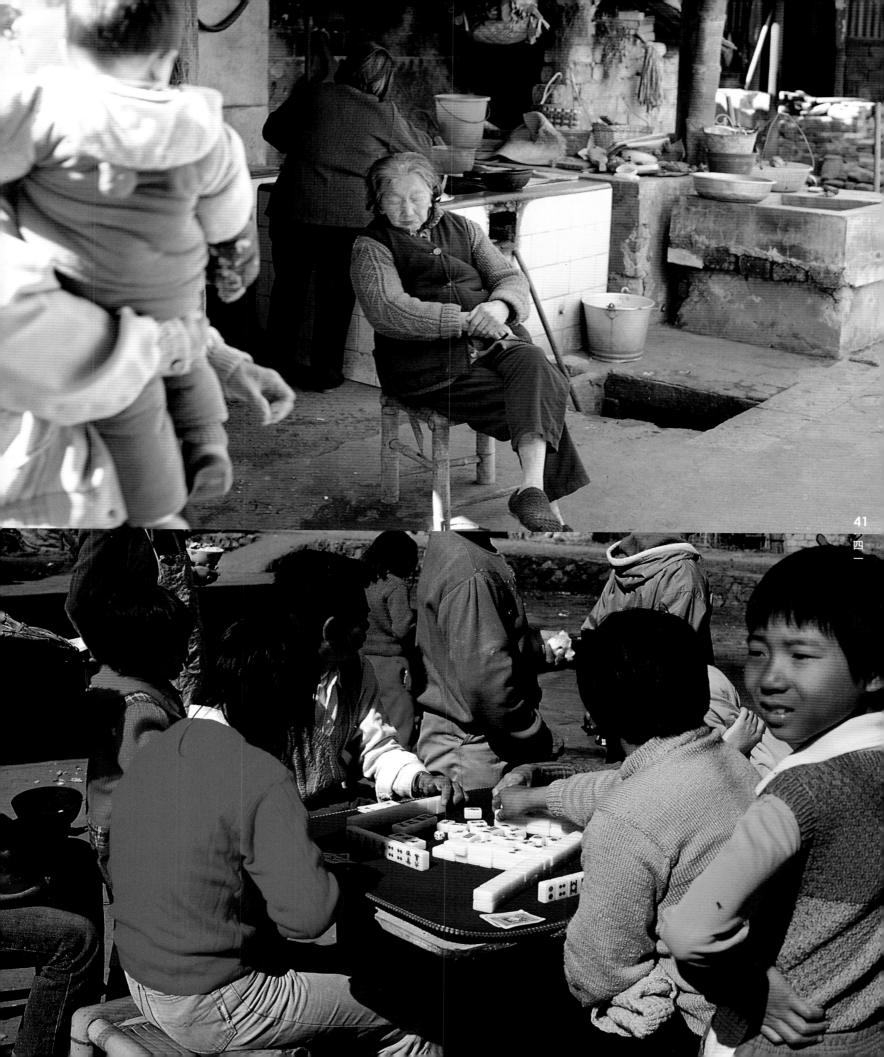

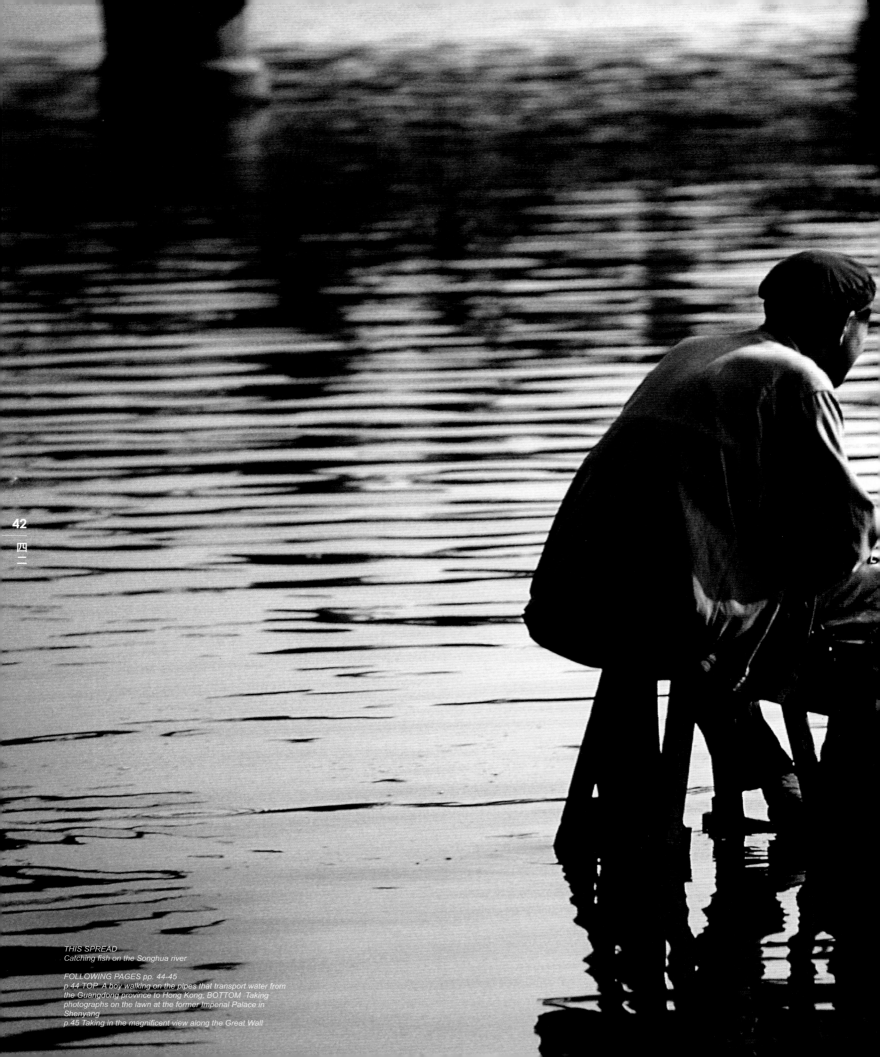

THIS SPREAD
Catching fish on the Songhua river

FOLLOWING PAGES pp. 44-45
p.44 TOP A boy walking on the pipes that transport water from
the Guangdong province to Hong Kong; BOTTOM Taking
photographs on the lawn at the former Imperial Palace in
Shenyang
p.45 Taking in the magnificent view along the Great Wall

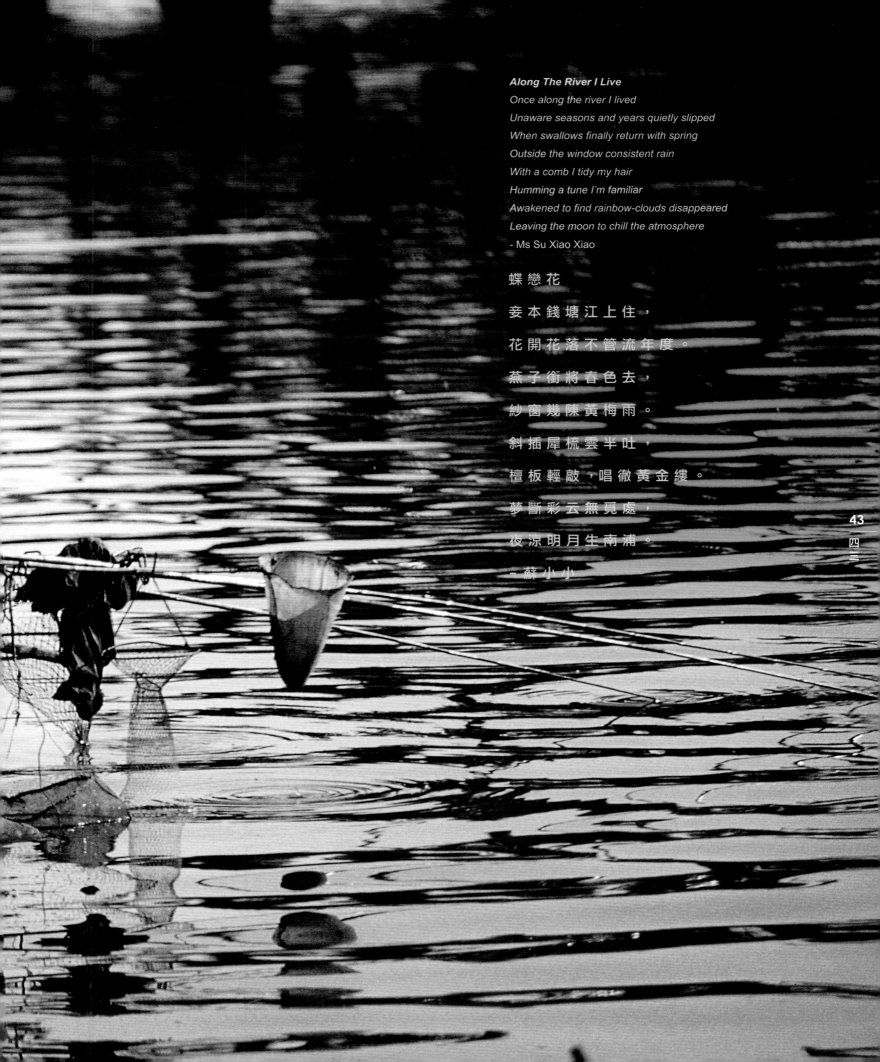

Along The River I Live
Once along the river I lived
Unaware seasons and years quietly slipped
When swallows finally return with spring
Outside the window consistent rain
With a comb I tidy my hair
Humming a tune I'm familiar
Awakened to find rainbow-clouds disappeared
Leaving the moon to chill the atmosphere
- Ms Su Xiao Xiao

蝶 戀 花

妾 本 錢 塘 江 上 住 ，

花 開 花 落 不 管 流 年 度 。

燕 子 銜 將 春 色 去 ，

紗 窗 幾 陳 黃 梅 雨 。

斜 插 犀 梳 雲 半 吐 ，

檀 板 輕 敲 ，唱 徹 黃 金 縷 。

夢 斷 彩 云 無 覓 處 ，

夜 涼 明 月 生 南 浦 。

— 蘇 小 小

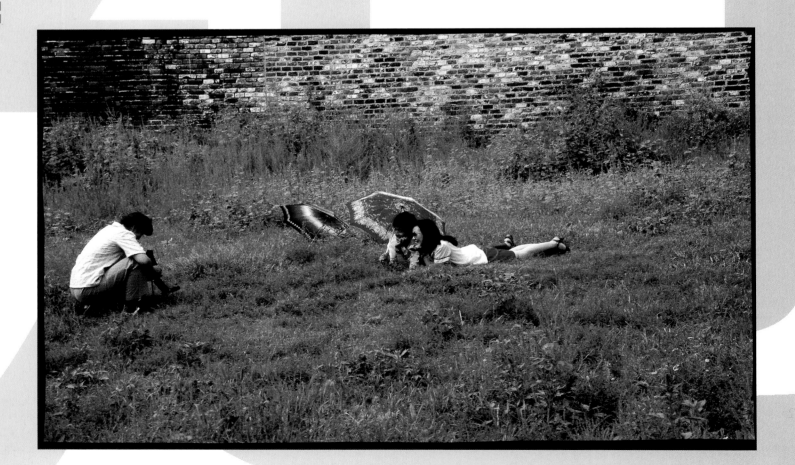

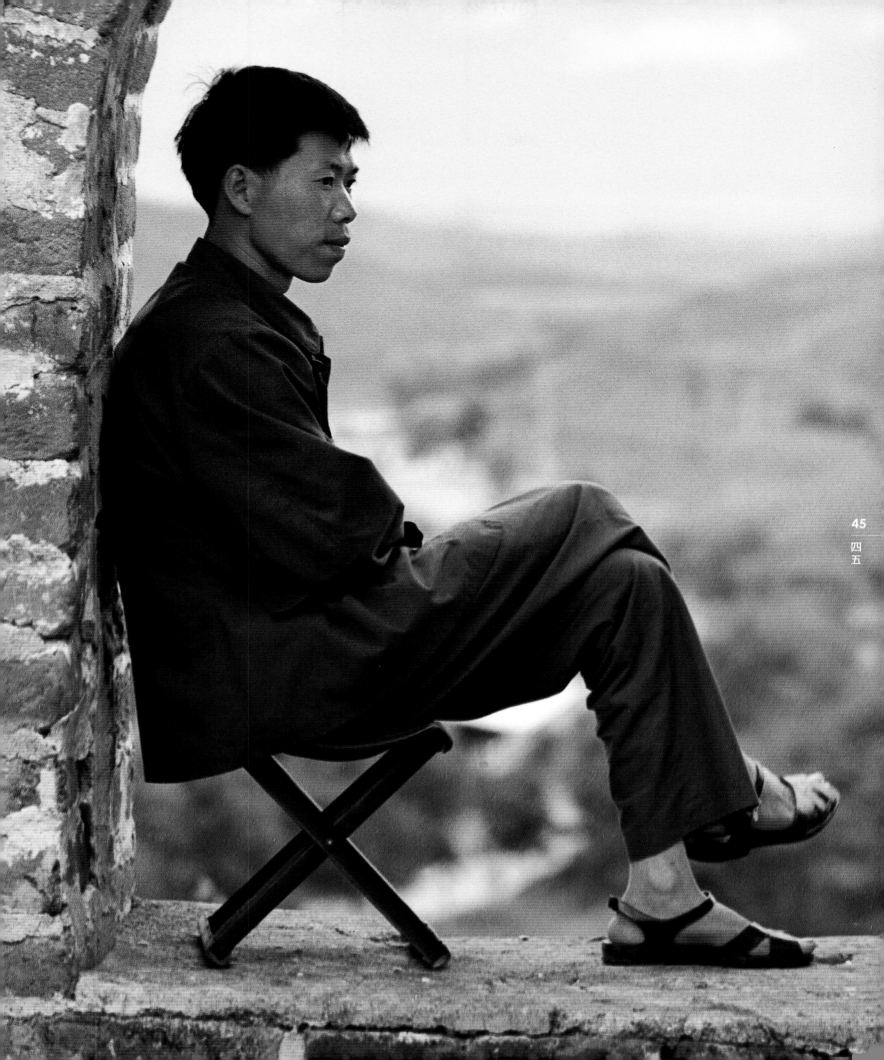

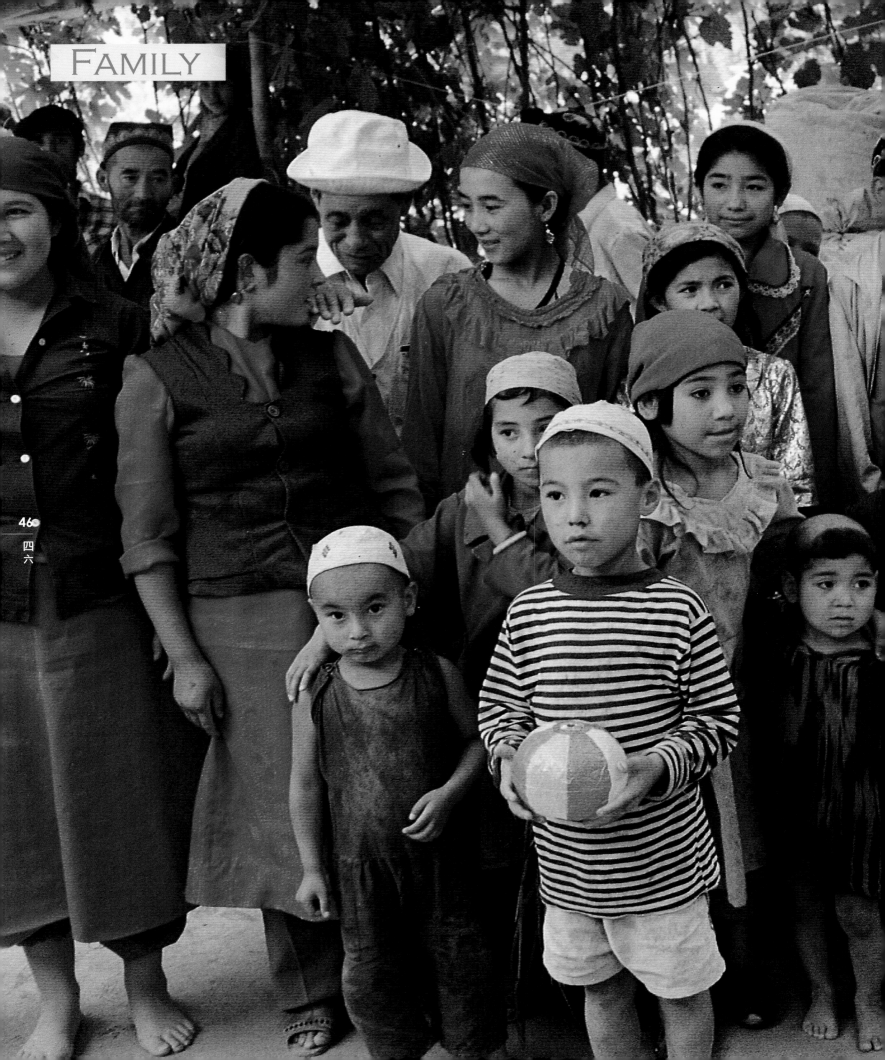

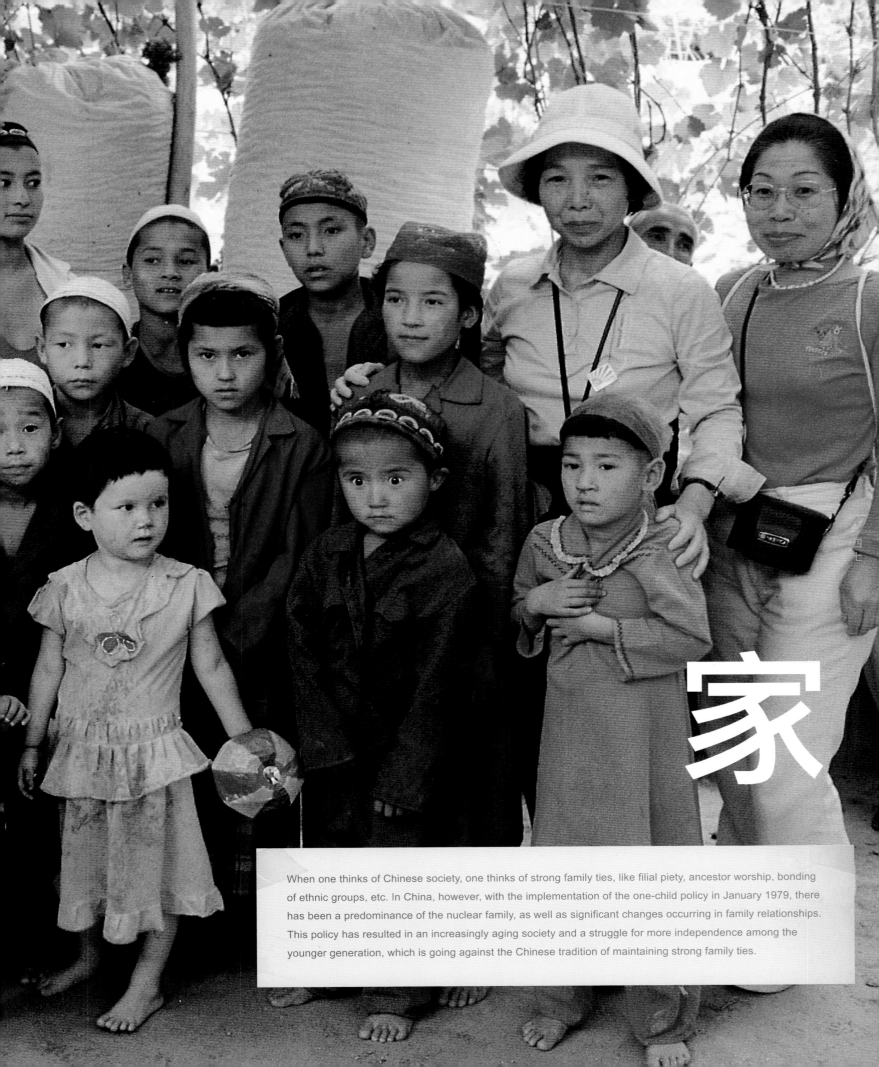

家

When one thinks of Chinese society, one thinks of strong family ties, like filial piety, ancestor worship, bonding of ethnic groups, etc. In China, however, with the implementation of the one-child policy in January 1979, there has been a predominance of the nuclear family, as well as significant changes occurring in family relationships. This policy has resulted in an increasingly aging society and a struggle for more independence among the younger generation, which is going against the Chinese tradition of maintaining strong family ties.

PREVIOUS SPREAD pp.46-47
People of the village of Hetian

THIS PAGE
A family taking a rest on the sidewalk

FACING PAGE
A father and child at the Huangpu River Park in Shanghai

FOLLOWING SPREAD pp.50-51
An old couple before a farmhouse entrance
in the outskirts of Chengdu

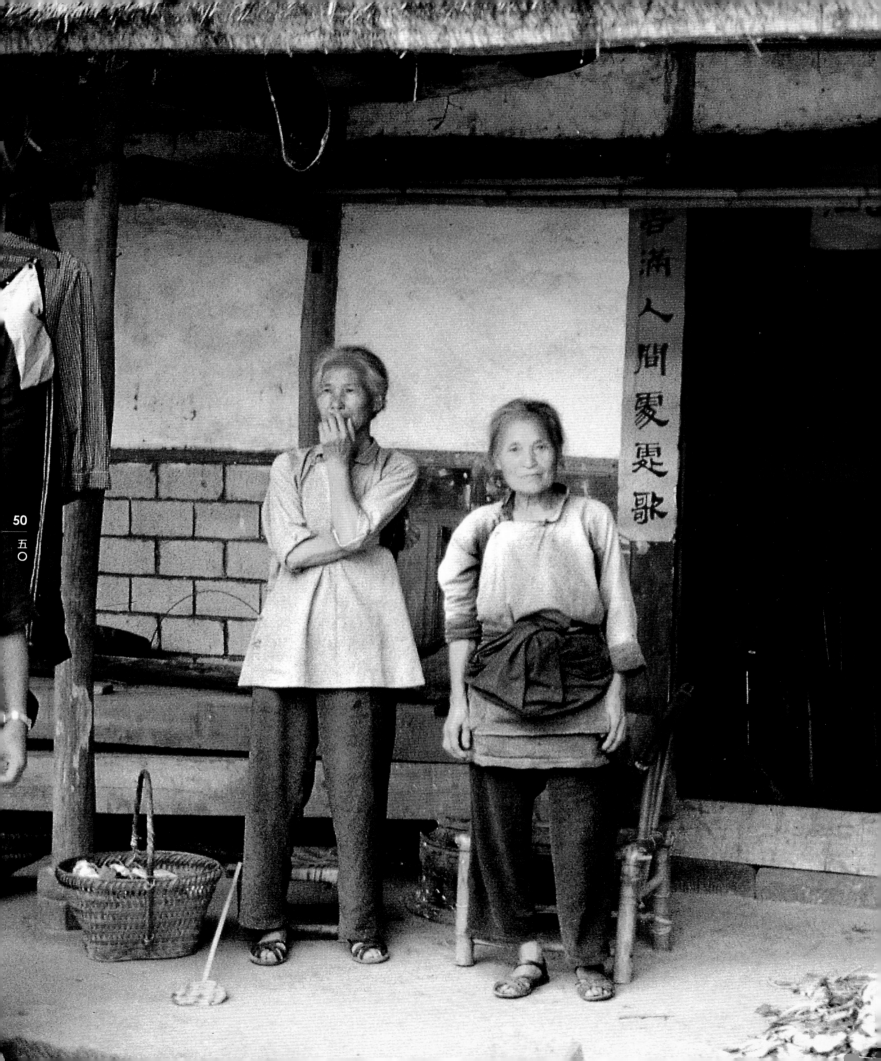

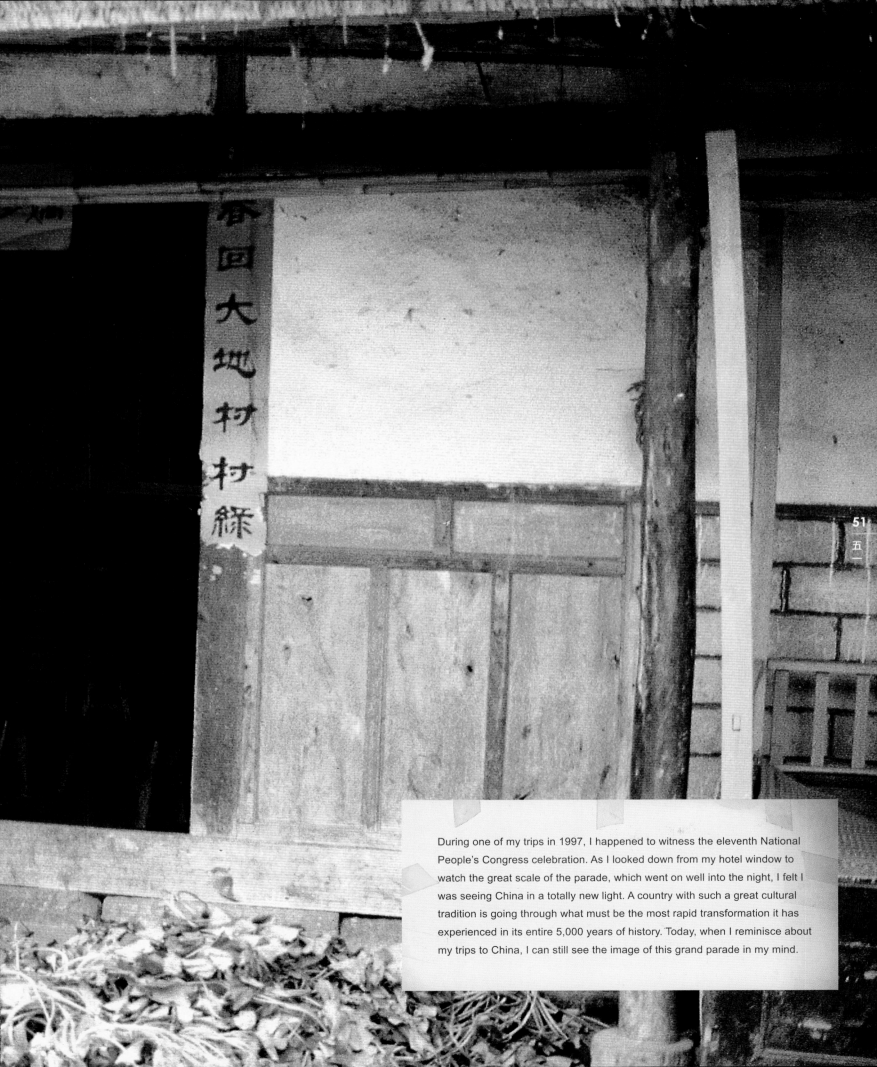

春回大地村村綠

During one of my trips in 1997, I happened to witness the eleventh National People's Congress celebration. As I looked down from my hotel window to watch the great scale of the parade, which went on well into the night, I felt I was seeing China in a totally new light. A country with such a great cultural tradition is going through what must be the most rapid transformation it has experienced in its entire 5,000 years of history. Today, when I reminisce about my trips to China, I can still see the image of this grand parade in my mind.

chapter two

ARCHITECTURE

In Beijing, the siheyuan *was the dominating form of architecture surrounding the Imperial City. It was forbidden for* commoners' residences to be any higher than the lowest buildings in the Imperial City, and hence, the siheyuan *around the Imperial City were all single story buildings. However, it was common to find* siheyuan *of two or more stories in the provinces south of the Yellow River.*

FACING PAGE
A tradesman's house

FOLLOWING SPREAD pp.54-55
View of the entrance of the Forbidden City in Beijing with the huge portriat of the late Mao Zedong from Tiananmen Square in Beijing

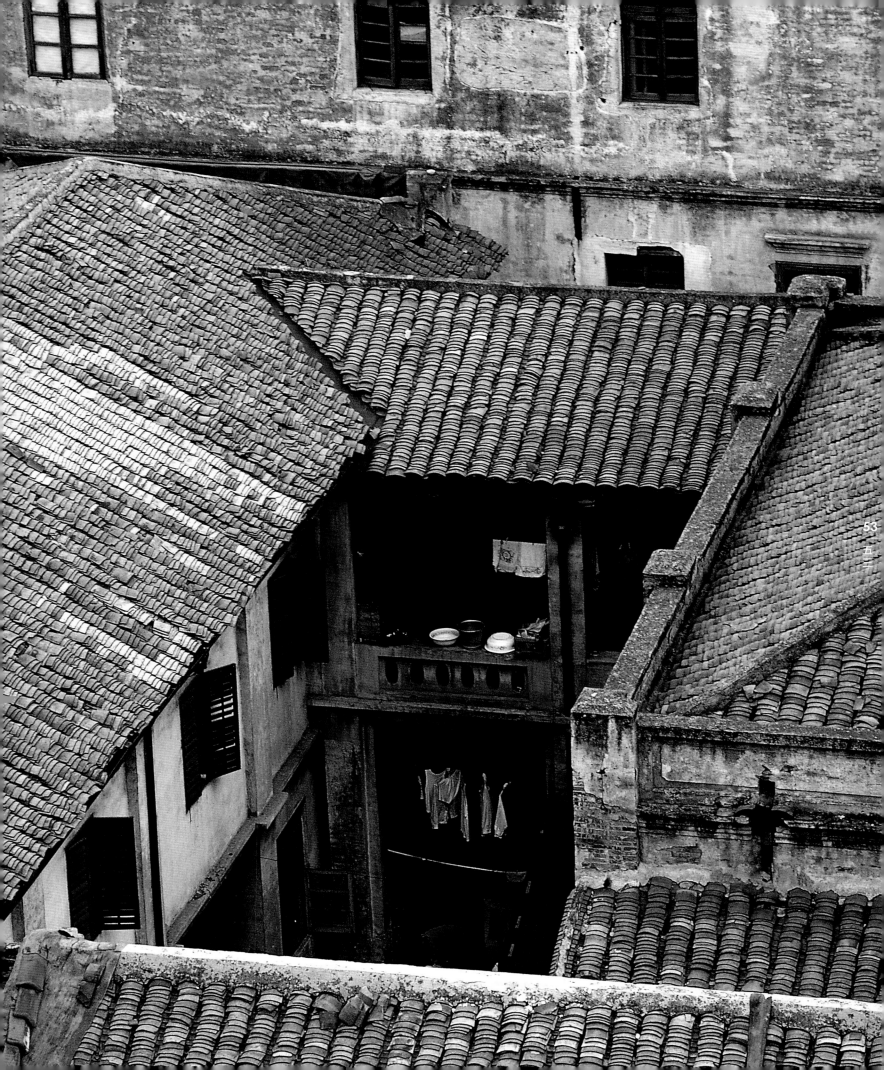

ARCHITECTURE

planning . dwelling . civic

When one visits Japan's ancient Imperial capital in Nara, one longs to see the Chinese Imperial capital that it was modelled after. That Chinese capital is the great city of Chang'an—the capital of the Tang dynasty. The city of Chang'an still exists (now under the name of Xi'an), but it has lost much of its splendor since it ceased to serve as the capital after the Tang dynasty.

However, one is still able to catch a glimpse and experience the grandeur of China's ancient Imperial palace compound at the Forbidden City in Beijing. When I visited the Forbidden City, I stood atop the Jing Mountain Park to admire the grandeur of the Forbidden City with its magnificent architecture, and I was truly amazed by its splendor. The Japanese ancient Imperial Palace in Nara is as splendid, but it is of a smaller scale in comparison.

The Gugong (Former Imperial Palace), the present name of the Forbidden City, contains the largest group of wooden buildings still in existence in China, which can be said to be truly representative of traditional Chinese architecture. Emperor Zhu Li began the construction of the palace compound in the year 1406, and it was completed fourteen years later in 1420. Fourteen Ming emperors and ten Qing emperors ruled China from this palace, known as Zijincheng (Forbidden City), for a total of 491 years. The palace is now a museum—one of the core attractions in Beijing for tourists, from both within China and around the world.

The grounds of the Forbidden City are truly vast in scale, measuring 1051 yards from north to south and 823 yards from east to west, covering a total area of 865,458 square yards. The site contains over 800 buildings, both large and small, and the buildings contain over 9,000 rooms in total. The palace grounds are surrounded by a wall approximately 2.1 miles long and about 10 yards high, with towers on all four corners. The wall itself is then surrounded by a moat called the Huchenghe (City-protecting River) or Tongzihe (Tubular River), which measures 57 yards wide and 2.4 miles long.

Jing (Scenic) Mountain stands at the north of the Forbidden City, serving as a natural protective barrier. To the south flows the Jinshuihe (River of Gold Water). Together, the Jing Mountain and the Jinshuihe provide the ideal conditions for the site to be rendered as palace grounds according to feng shui beliefs.

There are four gates to the compound—the Wu Gate on the south, which is the main gate, the Donghua Gate on the east, the Xihua Gate on the West, and the Shenwu Gate on the north. All the buildings in the Forbidden City are constructed of timber, while the roofs are laid with yellow lapis lazuli tiles and the foundations cast in marble. There are two main architectural components of the Imperial Palace: the *waichao* (Outer Court) and the *neiting* (Inner Court). The outer court centres on the "three great palaces"—the Taihedian (Hall of Great Harmony), Zhonghedian (Hall of Central Harmony), and Baohedian (Hall of Preserving Harmony). Two wing areas are allocated on either side—the Wenhuadian (Hall of Cultural Attainments) and the Wuyingdian (Hall of Martial Courage), where the Emperor performed his public ceremonies.

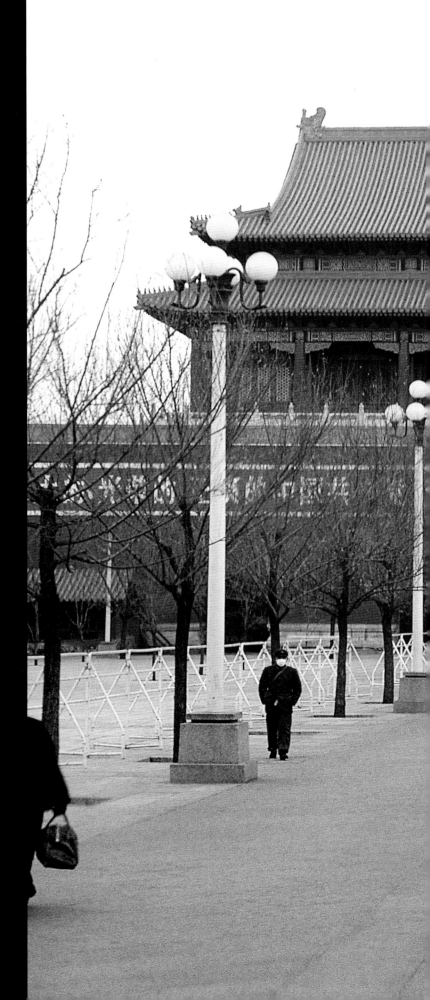

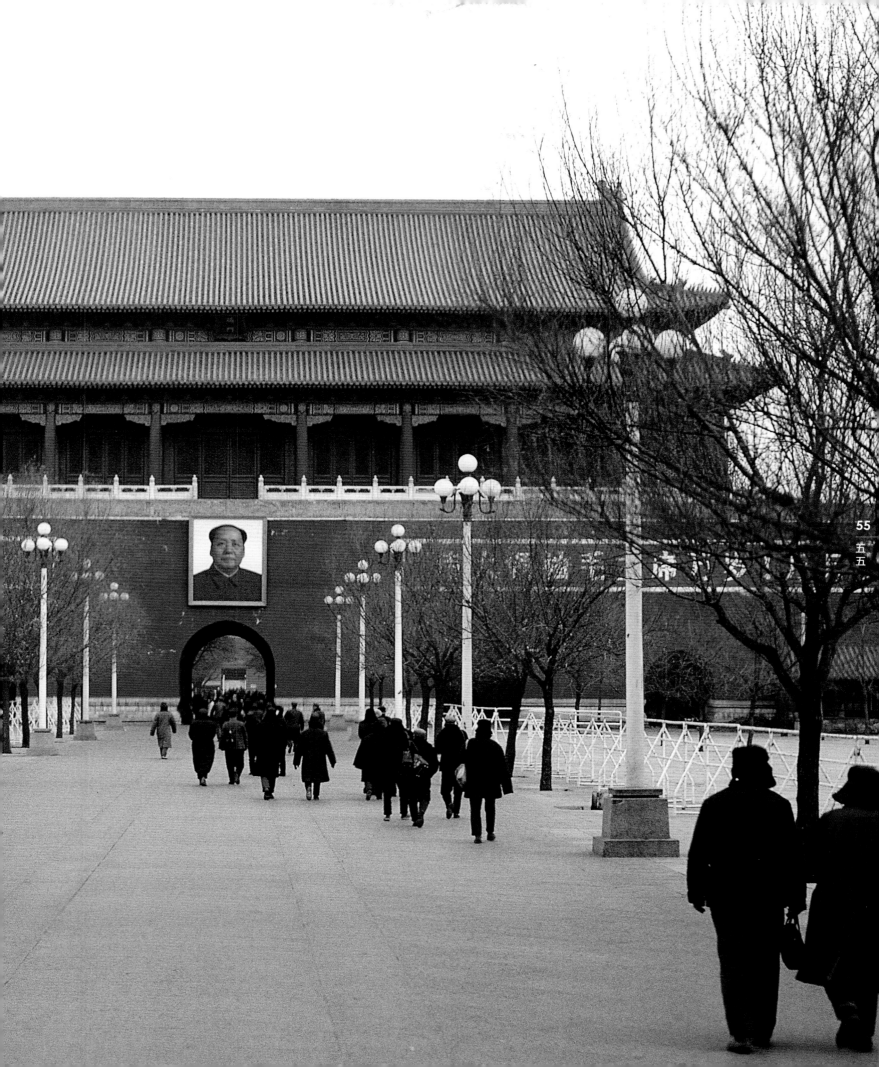

The Inner Court centers on the "three rear palaces"—with the Qianqinggong (Palace of Heavenly Purity) in front, the Kunninggong (Palace of Earthly Tranquillity) at the rear, and the Jiaotaidian (Palace of Prosperous Communion) in between. This signified the symbolic coming together of "Heaven" and "Earth" with the Emperor's ritualistic position in the center and effected by the rites of worship, which he performed in offering to Heaven and Earth. This was also where the Imperial Garden was located. The Emperor and his family conducted their private living in the two wing areas called the "Six Eastern Palaces" and the "Six Western Palaces." It was also in these wing areas that the Emperor attended to the everyday business of governmental affairs. The architectural style of the Outer Court is dignified, ornate, and majestic, expressing the supreme authority of the Emperor and the Imperial Dynasty. The Inner Court, on the other hand, is interspersed with gardens, studies, pavilions and artificial mountains, creating a less formal environment conducive for relaxation.

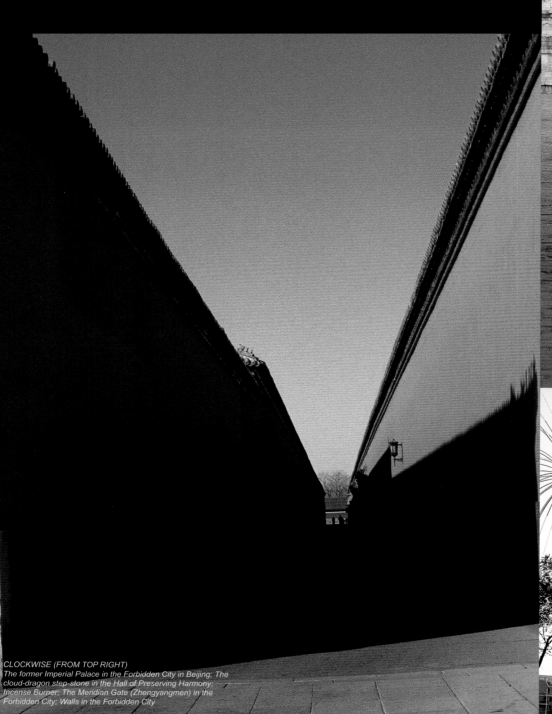

CLOCKWISE (FROM TOP RIGHT)
The former Imperial Palace in the Forbidden City in Beijing; The cloud-dragon step-stone in the Hall of Preserving Harmony; Incense Burner; The Meridian Gate (Zhengyangmen) in the Forbidden City; Walls in the Forbidden City

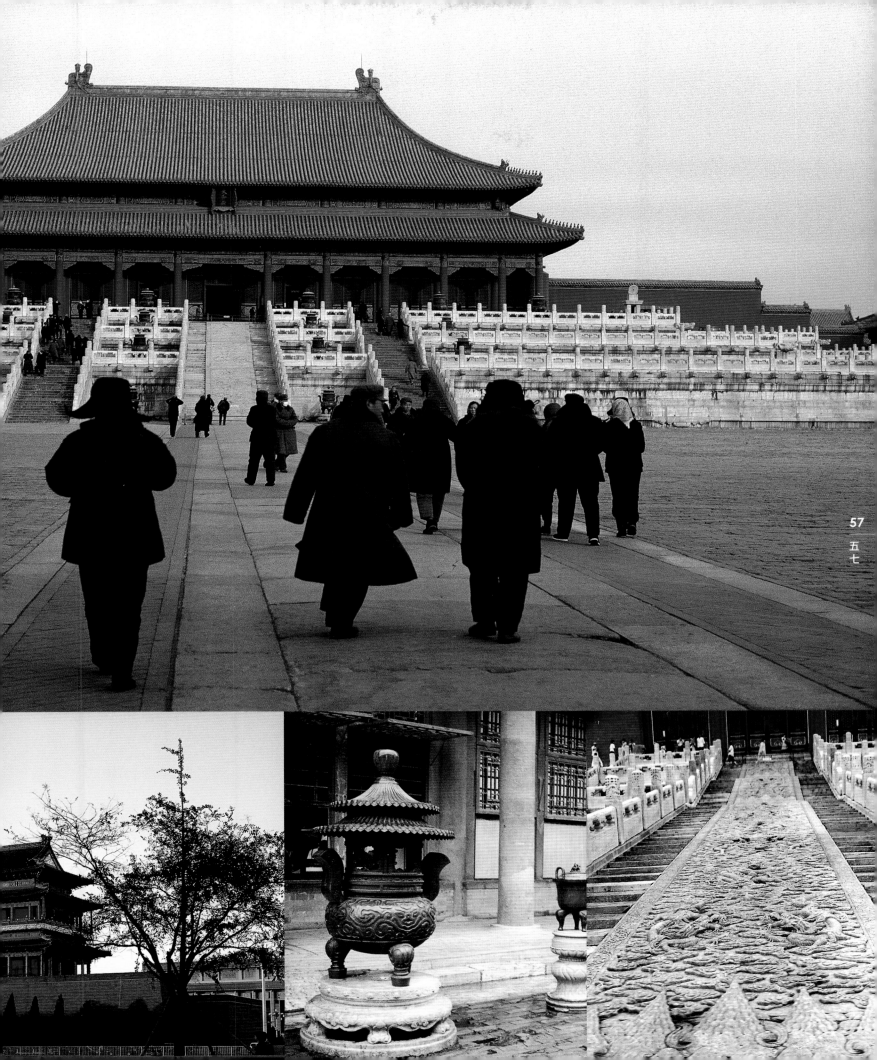

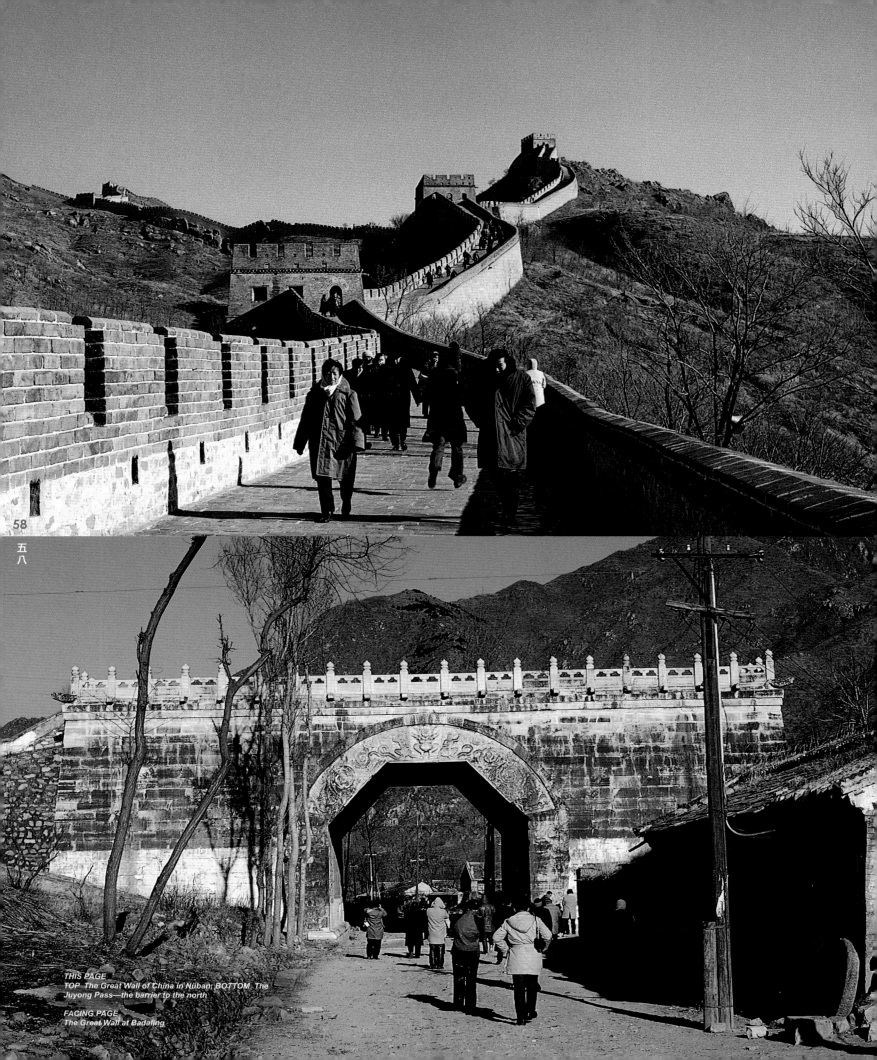

58

五八

Another structure that is considered representative of traditional China is, of course, the Great Wall, known in Chinese as the "Long City of Ten Thousand Miles," or Wanlichangcheng. With its total length of 1,500 miles, the Great Wall is said to be the only man-made structure that is visible from the moon.

Beginning in the East from the "old dragon head" of the Shanhai (Mountain and Sea) Pass in North China, it snakes along the ridges of the northern mountains passing through the Hebei Province, the northernmost part of Beijing, Shanxi Province, Inner Mongolia, and the Ningxia Hui-Nationality Autonomous District, finally ending at the Jiagu Pass in Gansu Province in the west.

The Great Wall at Badaling, north of Beijing, is composed of four elements: barrier stations, platforms, beacon fire platforms and the wall itself. The barrier station at Badaling is called the Juyong Pass, and on the stone walls of the arch-shaped gate of Yuntai (Cloud Platform) are reliefs of Garuda (the mystical bird of Indonesia) and Nagas (snake gods).

On the inner walls, there are reliefs of the Four Heavenly Kings of Buddhism. This site is also famous for Buddhist scriptural passages carved in six different languages: Sanskrit, Tibetan, Mongolian, Uigur (the Xixia language) and Chinese, suggesting that the Wall not only symbolized the perennial attempt to protect the Chinese Empire from foreign invaders, but also the intense degree of interaction that occurred between the Han people and other people in these northern border regions, often through the medium of the great pan-Asian religion of Buddhism.

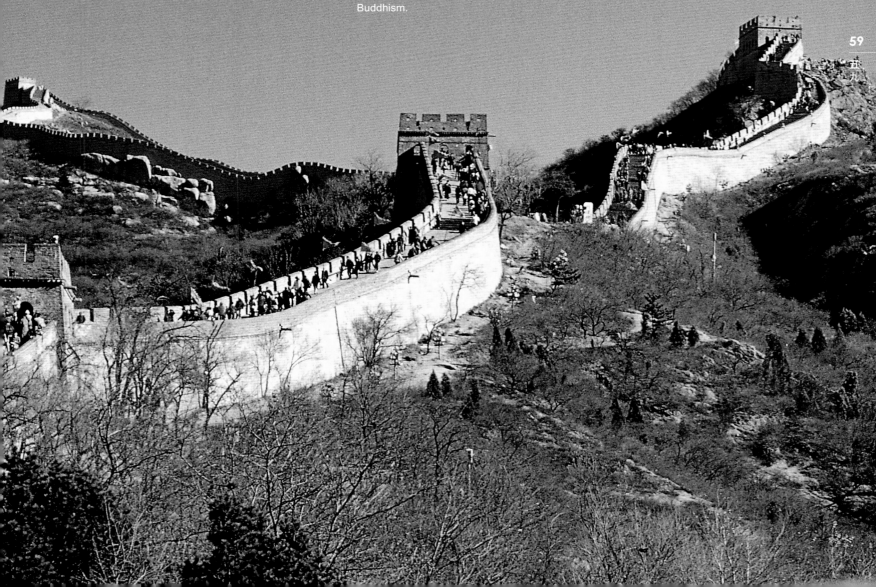

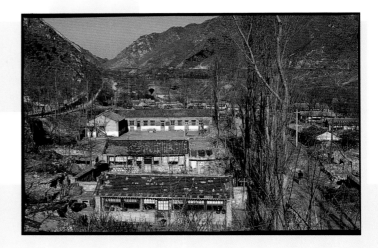

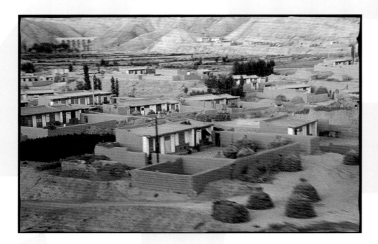

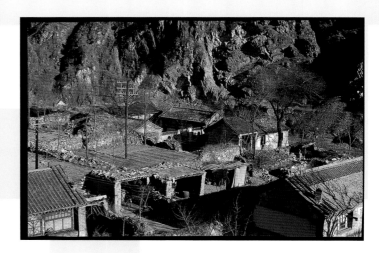

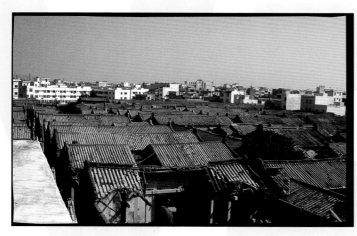

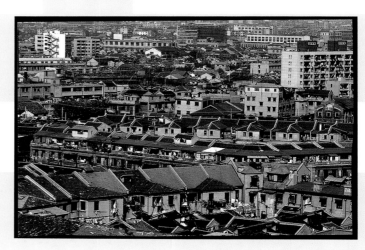

THIS PAGE (CLOCKWISE FROM TOP LEFT)
A colony enclosed by solid walls as seen from a train's window along the Baolan line; A private house seen from the Juyong Pass in the northern suburbs of Beijing; A building at the foot of a mountain in the northern suburbs of Beijing; Tradesmen's quarters in Shanghai; Old town houses against the backdrop of new apartments in the suburbs of Beijing; Private houses with gardens that are enclosed with solid walls, seen from a train's window along the Baolan line

While the residence of the emperor is called the Huangju (Imperial Residence), the dwellings that ordinary people live in are called *minju* (commoners' dwellings). As China has many ethnic groups and different climatic regions, there is of course a great variety of *minju*. There are many well known types: the half-underground dwellings of the northeast; the hipped-roof residences of the Korean minority nationality; the *siheyuan* (courtyard style of residence) of northern China; the *shikumen* (storehouse style of residence) and the *lilong* (lane and alley residences) of Shanghai; the *tulou* (multi-storey earthen houses) of the Hakka people of southern China; the pillbox style of stone dwellings used by the Tibetans; the earthen arched residences of Xinjiang; the *bao* or *yurt* of the Mongolians; and the *yikeyin* (single seal) architectural style of Yunnan province, just to name a few.

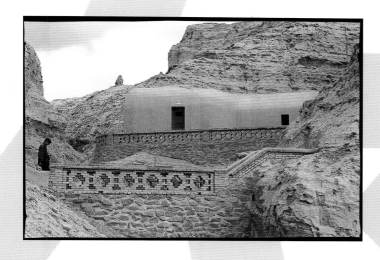

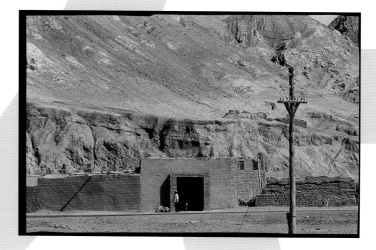

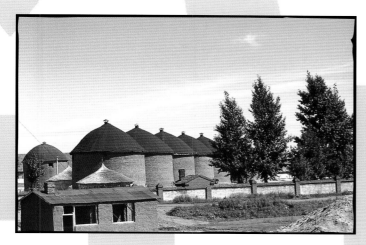

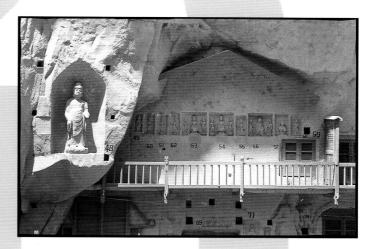

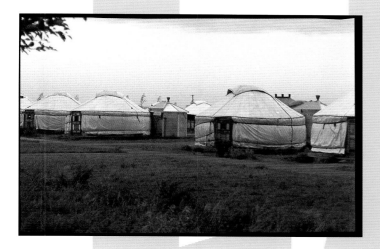

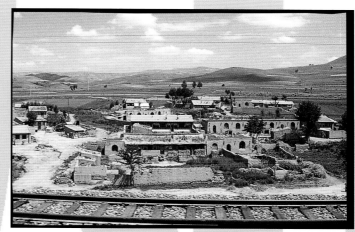

THIS PAGE (CLOCKWISE FROM TOP LEFT)
The Kucha Kuzurgaha Thousand Buddhas Cave; The entrance to a private house situated at the foot of Tienshan; A cave dwelling in a mountain; A mud-house seen from a train's window along the Jingbao line; Tourist bao at the Inner Mongolia Autonomous Region; Brick store-houses seen from a train's window along the Jongha line

The four-sided courtyard (*siheyuan*) type of residence of northern China centers on a square courtyard, with four buildings arranged around it. The main house is situated at the north end, with its entrance facing south. Here, the altar for worshipping the ancestors is located at the front of this house. The houses on the two sides serve as the residences for the master and his wife, while the children live in the eastern and western wing-rooms. The southern wing consists of a storeroom, guest rooms, and the servants' quarters. The four buildings are connected by a passageway with fences on both sides. The courtyard in the center is used for decorative landscapes, raising poultry, and most importantly, as a center for interaction among the people who live in the compound.

策
六三

In Beijing, the *siheyuan* was the dominating form of architecture surrounding the Imperial City. It was forbidden for commoners' residences to be any higher than the lowest buildings in the Imperial City, and hence, the *siheyuan* around the Imperial City were all single-story buildings. However, it was common to find *siheyuan* of two or more stories in the provinces south of the Yellow River.

The *shikumen* house is the traditional style of residence in Shanghai. The frame of the entrance is constructed with a hard stone material such as granite. Besides the main entrance, the only other fenestration on the four external walls is a service entrance. On both sides of the alleyway, the compound buildings are two stories high and are connected to several other buildings. They are called *shikumen* houses because, firstly, the entrances are made of stone (*shi*) and secondly, their shape resembles a storehouse (*ku*). The other type of residence found in Shanghai is called *lilong*. These residences are tenement row houses built on both sides of the numerous alleys found in Shanghai.

In another part of Beijing at the yellow-earth plateau, some 40 million people live in submerged and horizontal caves dug into the sides of mountains. This plateau is bounded by the Taihang Mountains to the east, the Great Wall to the north, the Riyue Mountains to the west, and the Qinling Mountains to the south. It has a total area of some 717,594 square yards. There are three kinds of mountainside cave dwellings—earth-caves, stone-caves, and brick-caves. Earth-caves are created by digging holes into the cliffs of sedimented yellow earth; stone-caves are made by using stones to insulate and strengthen the structure both on the exterior and the interior; and brick-caves are made from baked bricks. These cave dwellings are made possible by the homogeneous accumulation of small particles over a long period of time, which add to the dryness of the sedimented layers of yellow earth and are preserved because of the paucity of precipitation in this region. These dwellings have the advantage of being cool in summer and warm in winter. However, a major disadvantage is that, because the yellow-earth particles are so fine, a dust storm attacks northern China and Beijing every year.

The forefathers of the Hakka province were originally Han people who were driven southward from the middle reaches of the Yellow River because of civil wars. The Hakka *tulou* (earth house) is commonly found in Fujian and Guangdong provinces. Due to their vulnerable position as "foreigners" in these provinces that they settled in, their architectural style is visibly both protective and defensive in nature.

The walls of their dwellings are about 1 yard thick and 13 to 15 yards high. The biggest ones, which are planned in a circular manner, have a circumference of over 75 yards. Large clans of people with same surnames live together in communities and the number of inhabitants in each community can reach as many as 400 or 500. The first story is where the kitchen and pens for the domestic animals are located. The second story is utilized as a storehouse. The third and fourth stories are occupied by bedrooms. All four stories are considered common spaces, though several families would be allocated common sleeping quarters on the third and fourth stories. The shrine for protecting the house is located on the first story, either in the center or at the back of the house directly opposite the front entrance.

The dwellings of the nomadic Mongolians are called *bao*, which may also be known in other languages as *yurt*. A collapsible lattice structure is constructed using around thirty to fifty stretched lengths of timber that are formed into a dome. Sheepskins are stretched over the lattice to make a tent-like "house" that can be unassembled and set up elsewhere. An aperture for admitting light is made in the ceiling. The entrance is about 35 inches wide, and just high enough for people to fit through if they stooped over.

Within the *bao*, there is a case for storing clothing. On top of that is placed a domestic altar of sorts. Key activities such as sleeping, preparation of food, eating, hosting guests and even the slaughtering of sheep are all customarily done inside the *bao*. In recent years the Mongolians have started living in permanent dwellings made of bricks. The location of each permanent dwelling is determined so as to assure that the family has enough prairie area for grazing its horses and sheep, so even the closest neighbors will live several miles away.

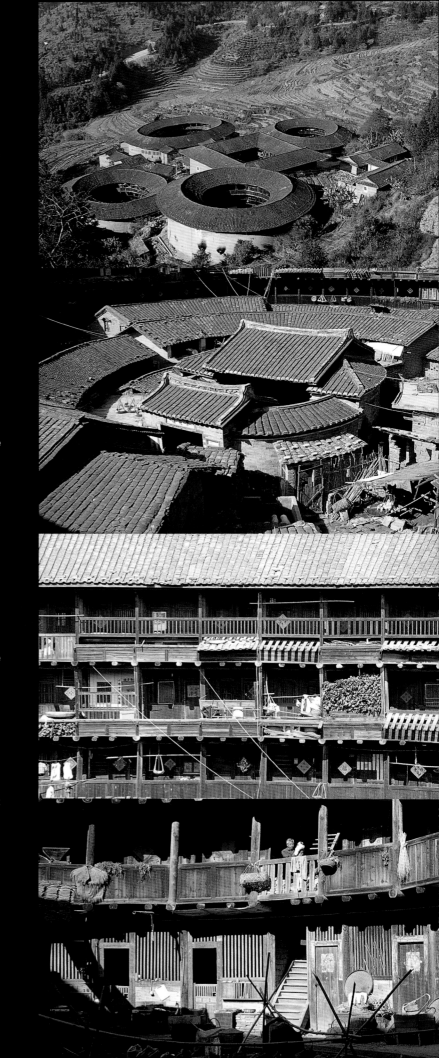

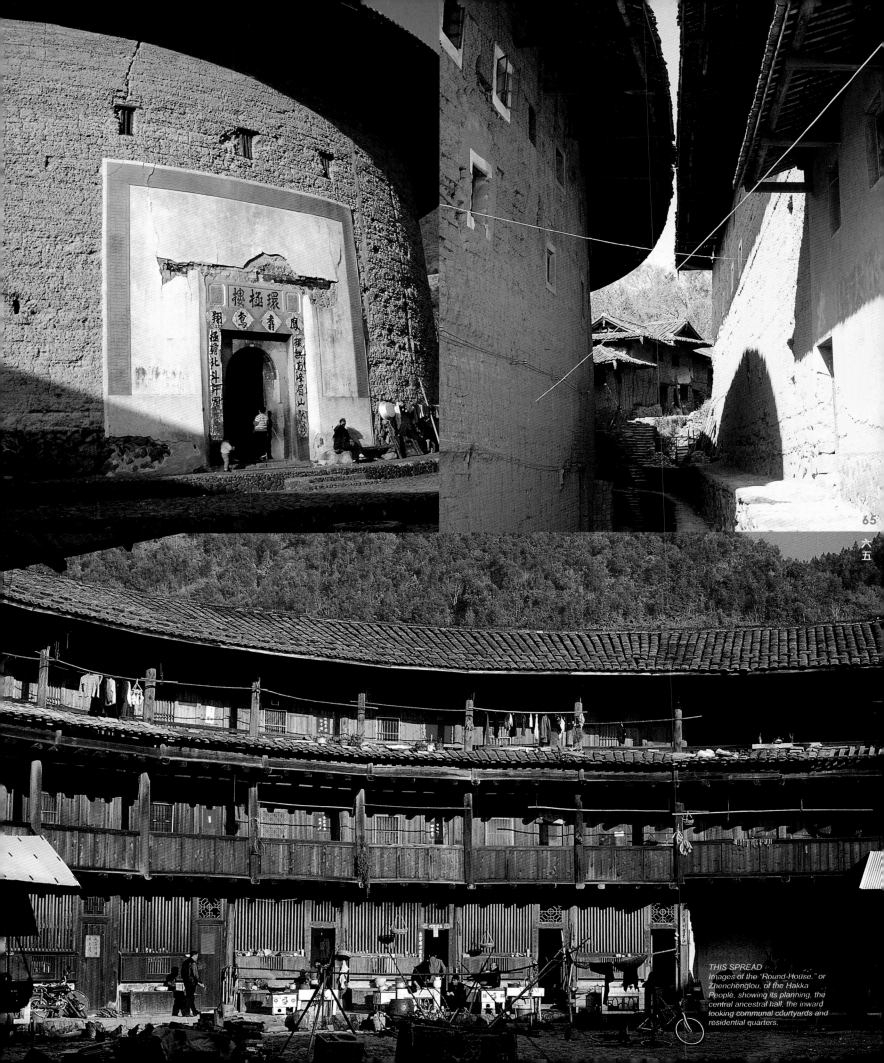

THIS SPREAD
Images of the "Round-House," or
Zhenchénglou, of the Hakka
People, showing its planning, the
central ancestral hall, the inward
looking communal courtyards and
residential quarters.

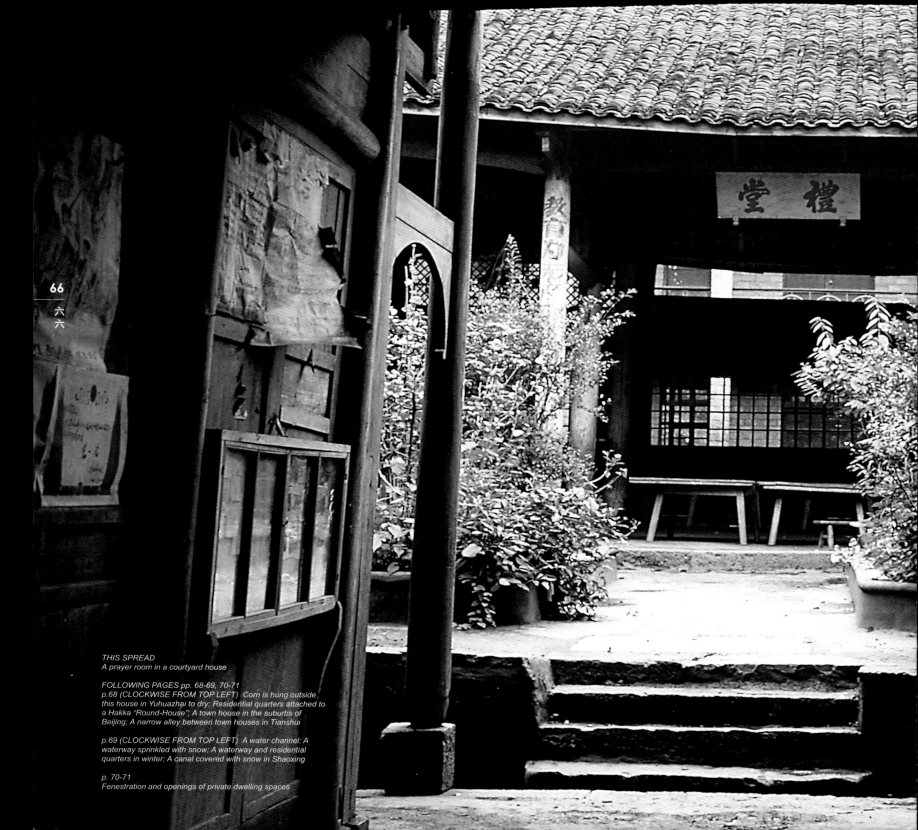

禮堂

THIS SPREAD
A prayer room in a courtyard house

FOLLOWING PAGES pp. 68-69, 70-71
p.68 (CLOCKWISE FROM TOP LEFT) Corn is hung outside this house in Yuhuazhai to dry; Residential quarters attached to a Hakka "Round-House"; A town house in the suburbs of Beijing; A narrow alley between town houses in Tianshui

p.69 (CLOCKWISE FROM TOP LEFT) A water channel; A waterway sprinkled with snow; A waterway and residential quarters in winter; A canal covered with snow in Shaoxing

p. 70-71
Fenestration and openings of private dwelling spaces

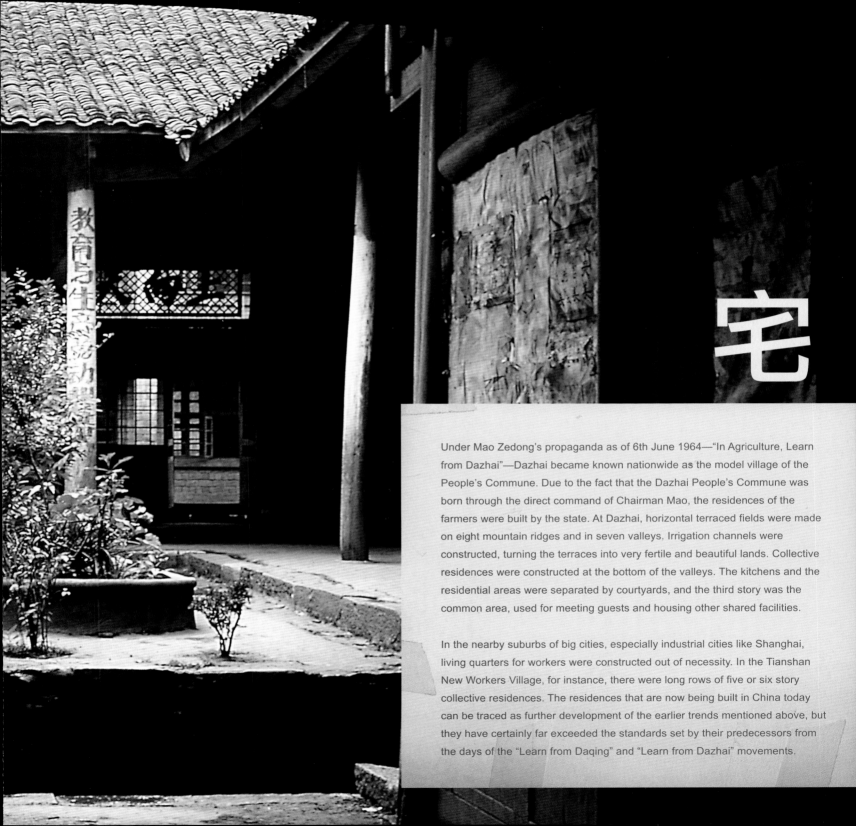

宅

Under Mao Zedong's propaganda as of 6th June 1964—"In Agriculture, Learn from Dazhai"—Dazhai became known nationwide as the model village of the People's Commune. Due to the fact that the Dazhai People's Commune was born through the direct command of Chairman Mao, the residences of the farmers were built by the state. At Dazhai, horizontal terraced fields were made on eight mountain ridges and in seven valleys. Irrigation channels were constructed, turning the terraces into very fertile and beautiful lands. Collective residences were constructed at the bottom of the valleys. The kitchens and the residential areas were separated by courtyards, and the third story was the common area, used for meeting guests and housing other shared facilities.

In the nearby suburbs of big cities, especially industrial cities like Shanghai, living quarters for workers were constructed out of necessity. In the Tianshan New Workers Village, for instance, there were long rows of five or six story collective residences. The residences that are now being built in China today can be traced as further development of the earlier trends mentioned above, but they have certainly far exceeded the standards set by their predecessors from the days of the "Learn from Daqing" and "Learn from Dazhai" movements.

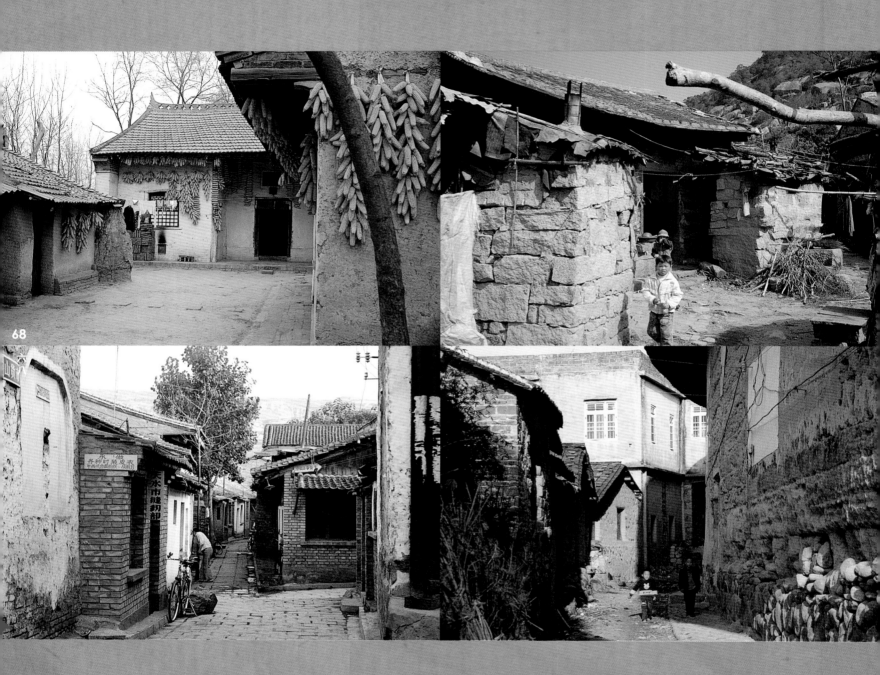

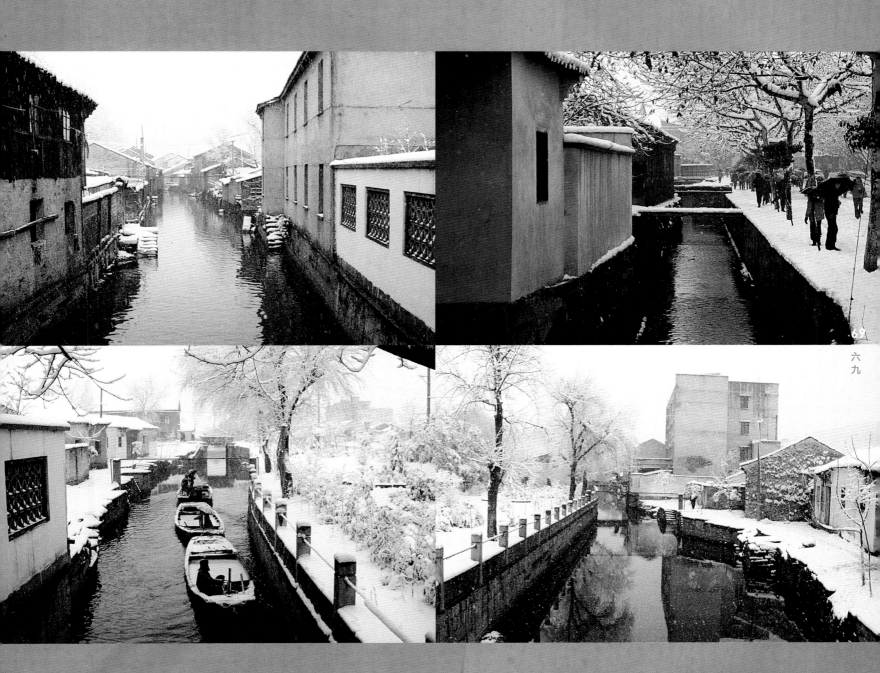

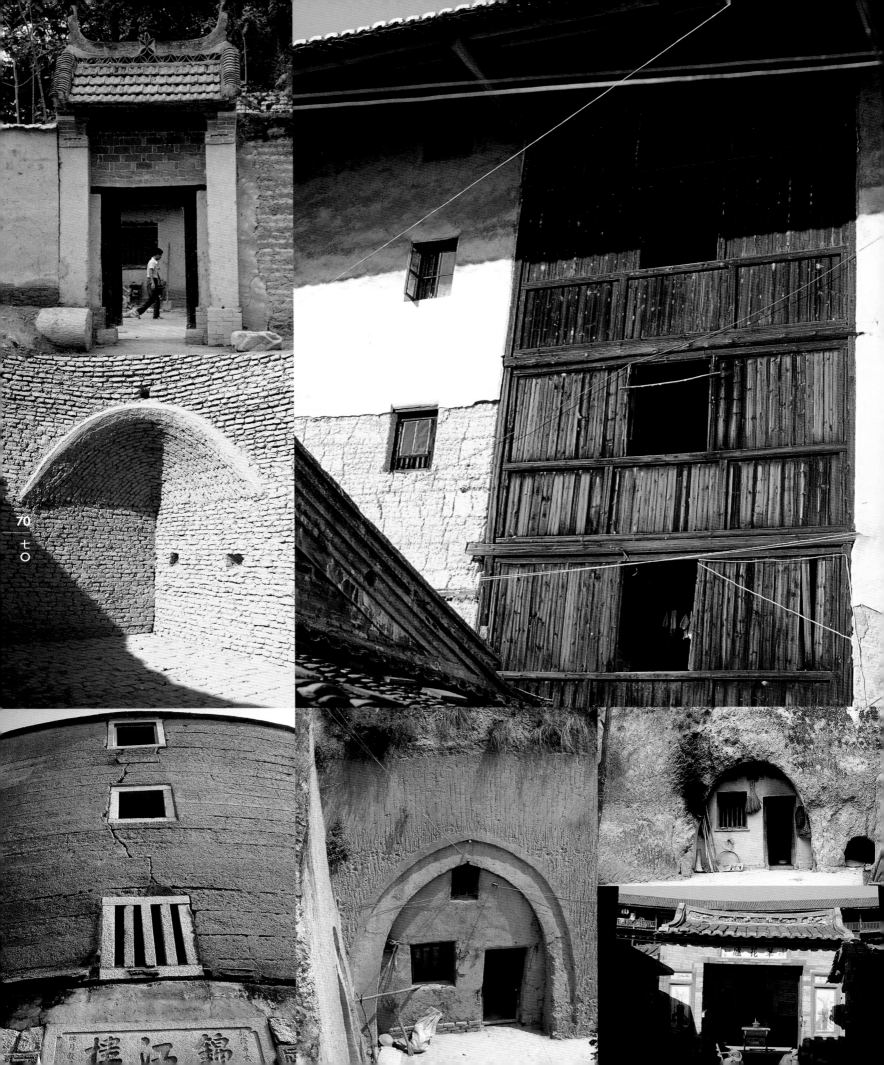

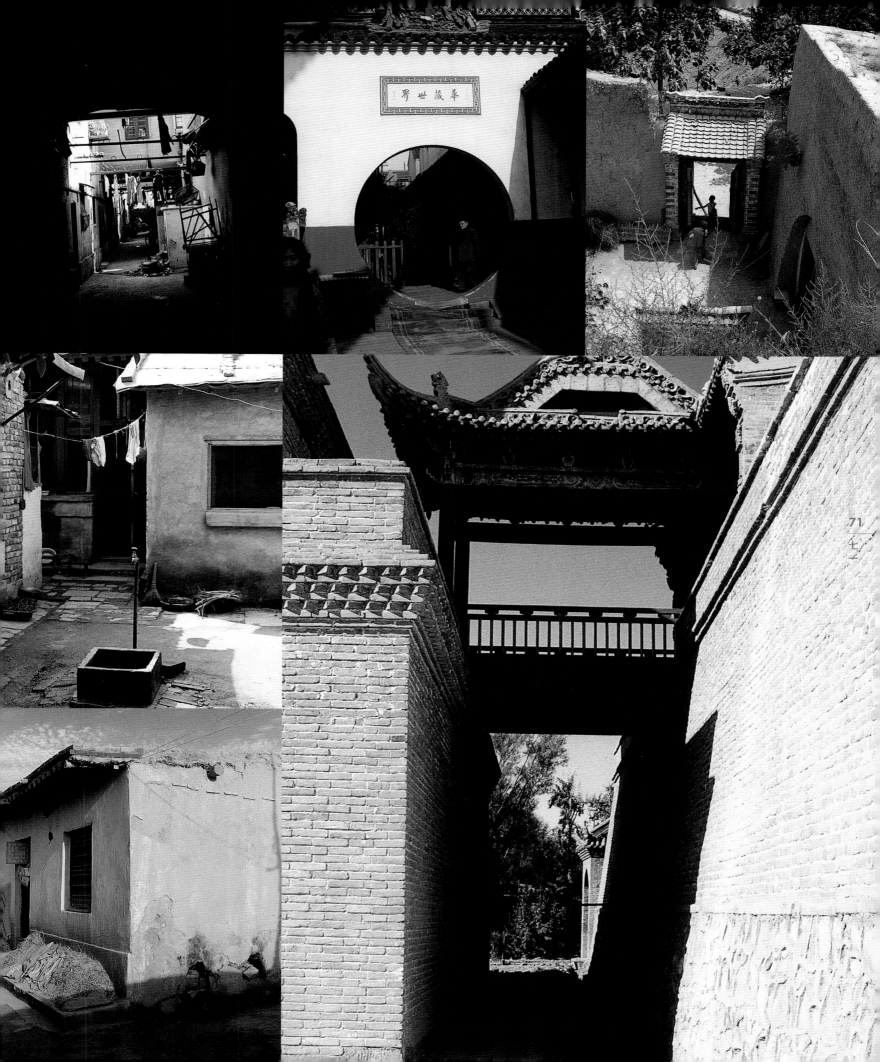

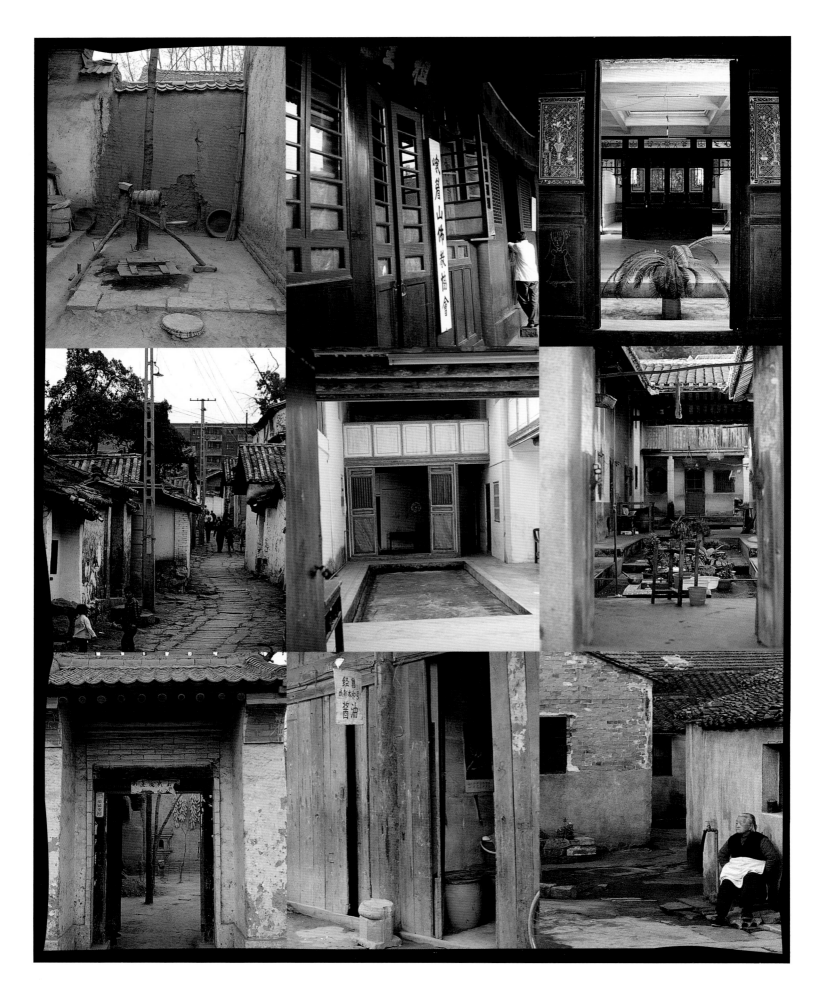

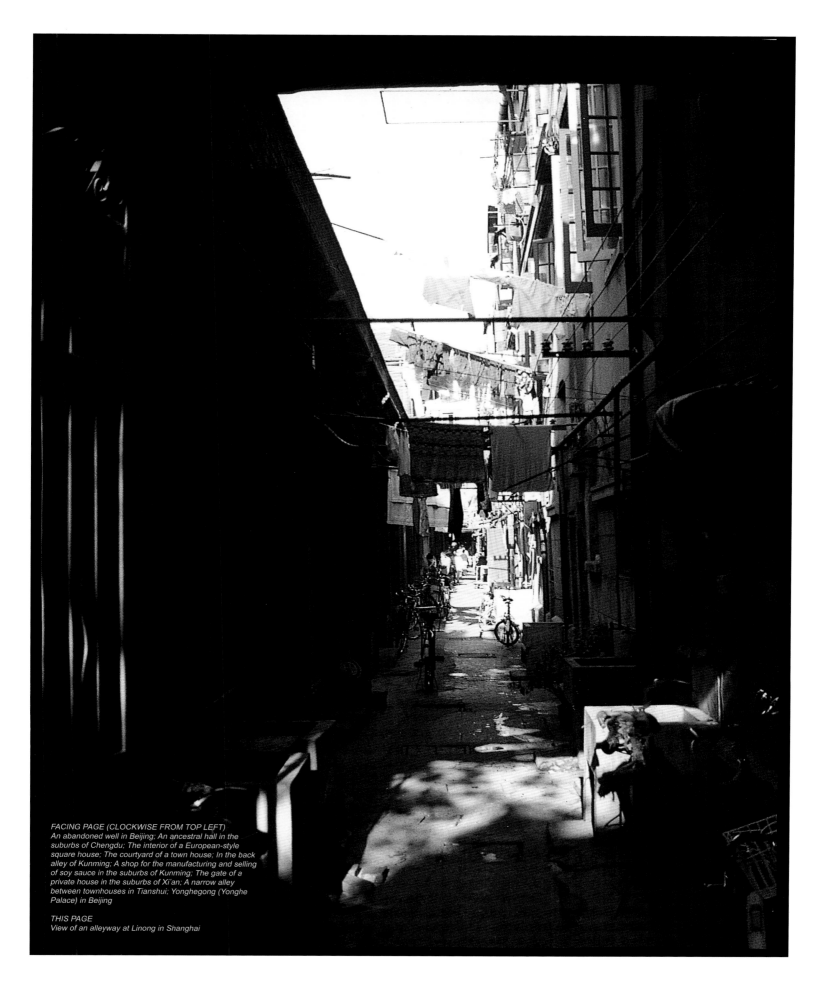

FACING PAGE (CLOCKWISE FROM TOP LEFT)
An abandoned well in Beijing; An ancestral hall in the
suburbs of Chengdu; The interior of a European-style
square house; The courtyard of a town house; In the back
alley of Kunming; A shop for the manufacturing and selling
of soy sauce in the suburbs of Kunming; The gate of a
private house in the suburbs of Xi'an; A narrow alley
between townhouses in Tianshui; Yonghegong (Yonghe
Palace) in Beijing

THIS PAGE
View of an alleyway at Linong in Shanghai

TITLE Bedroom

TITLE Bedroom

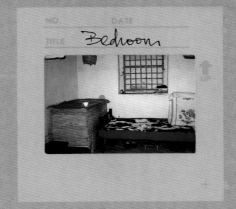

TITLE Living Room

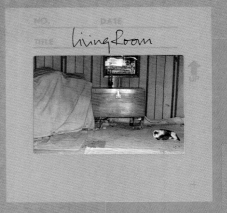

TV & Closet

Yard

TITLE Bedroom

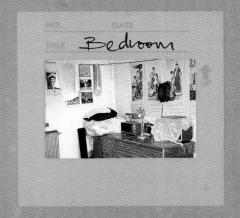

Bedroom

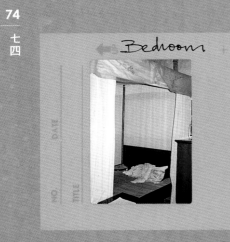

Cabinet

TITLE Bedroom

Stove

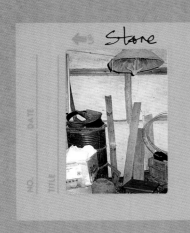

Stove

DATE TITLE

Stove

DATE TITLE

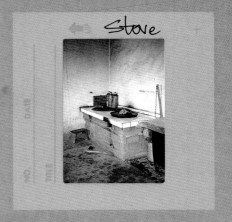

THIS SPREAD
Views of daily living spaces

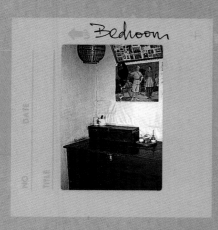
Bedroom

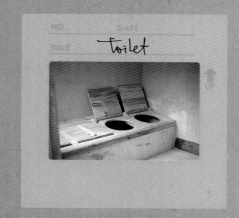
Toilet

Water Trough

Kitchen

Kitchen

Water Trough

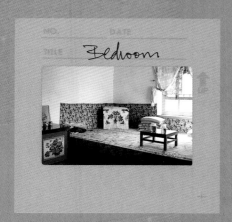
Bedroom

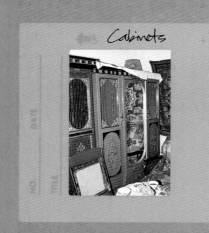
Cabinets

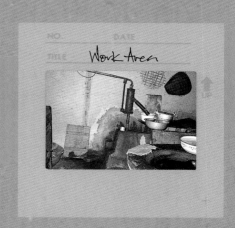
Work Area

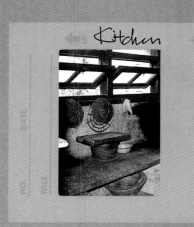
Kitchen

Family Room

Living Room

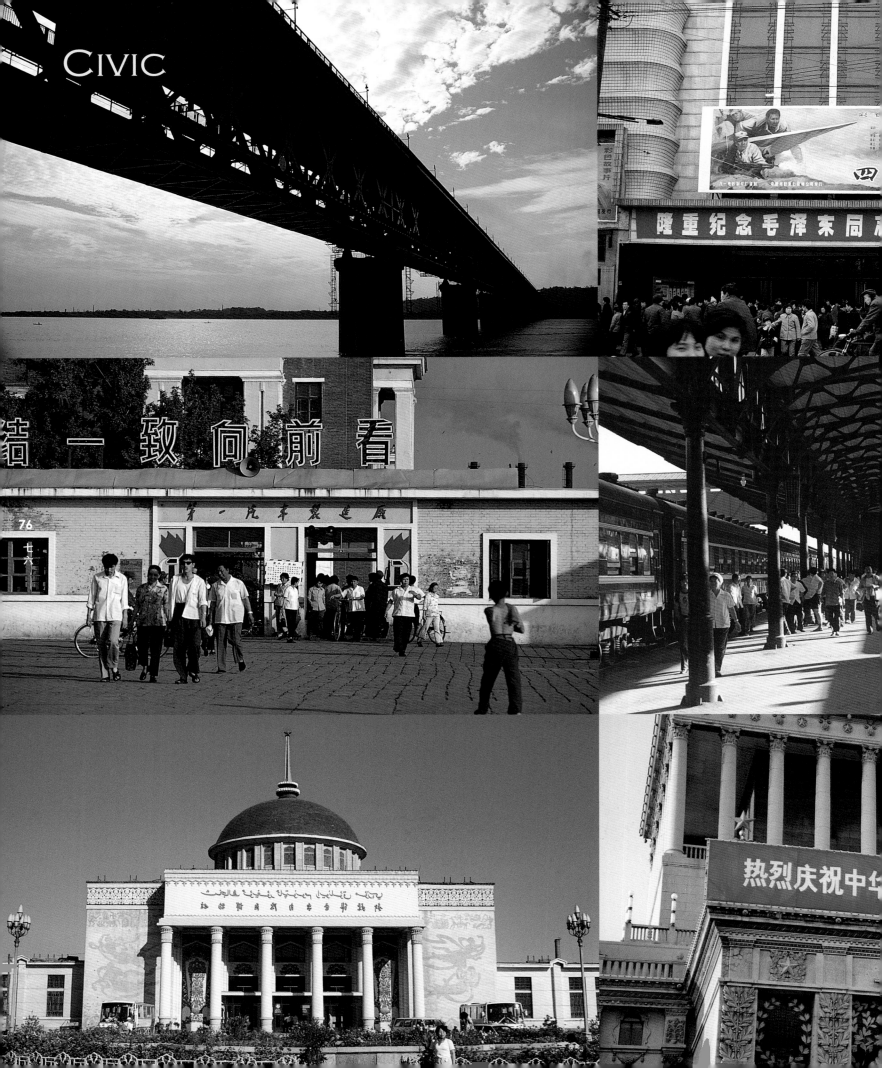

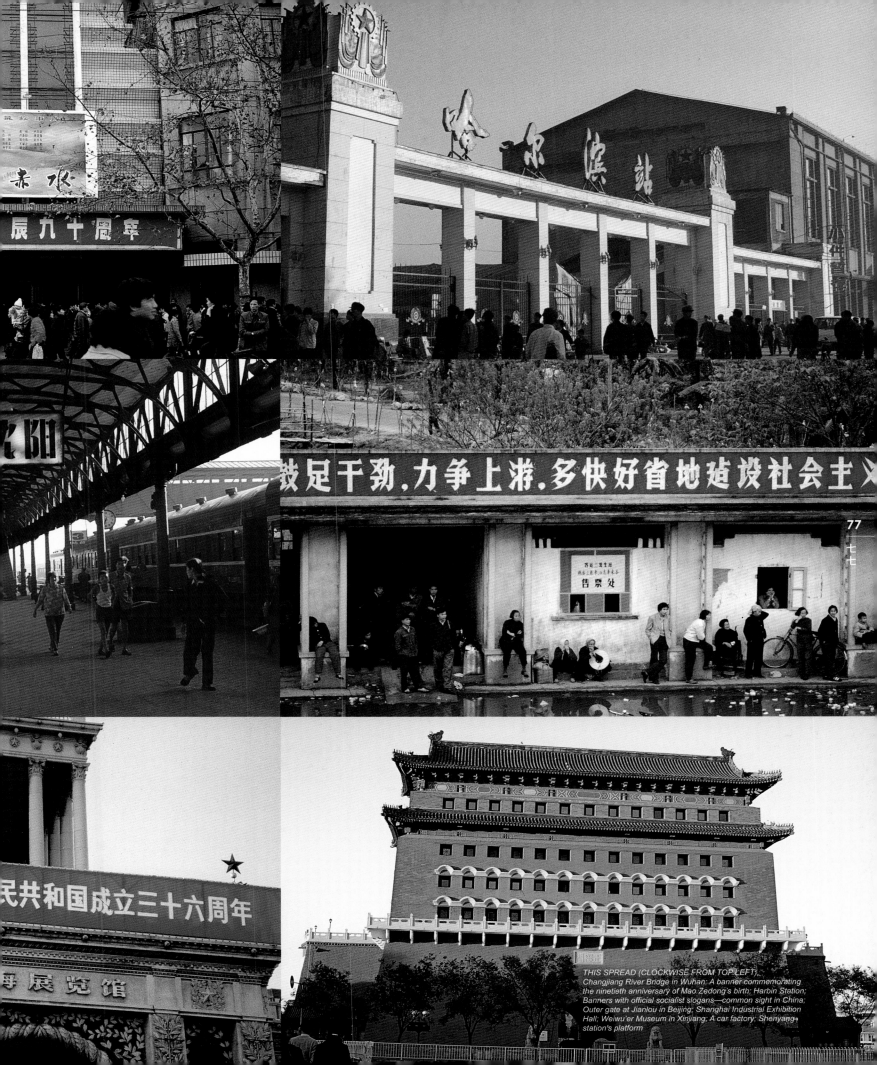

THIS SPREAD (CLOCKWISE FROM TOP LEFT):
Changjiang River Bridge in Wuhan; A banner commemorating
the ninetieth anniversary of Mao Zedong's birth; Harbin Station;
Banners with official socialist slogans—common sight in China;
Outer gate at Jianlou in Beijing; Shanghai Industrial Exhibition
Hall; Weiwu'er Museum in Xinjiang; A car factory; Shenyang
station's platform

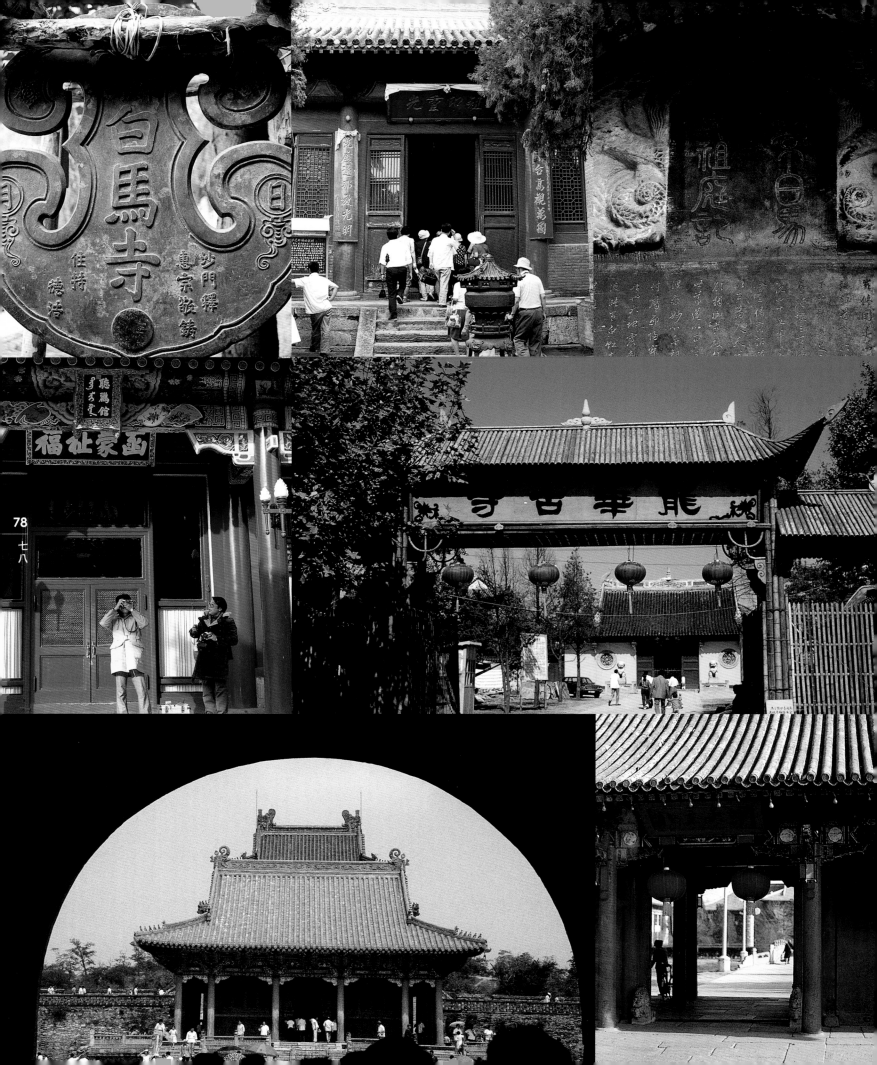

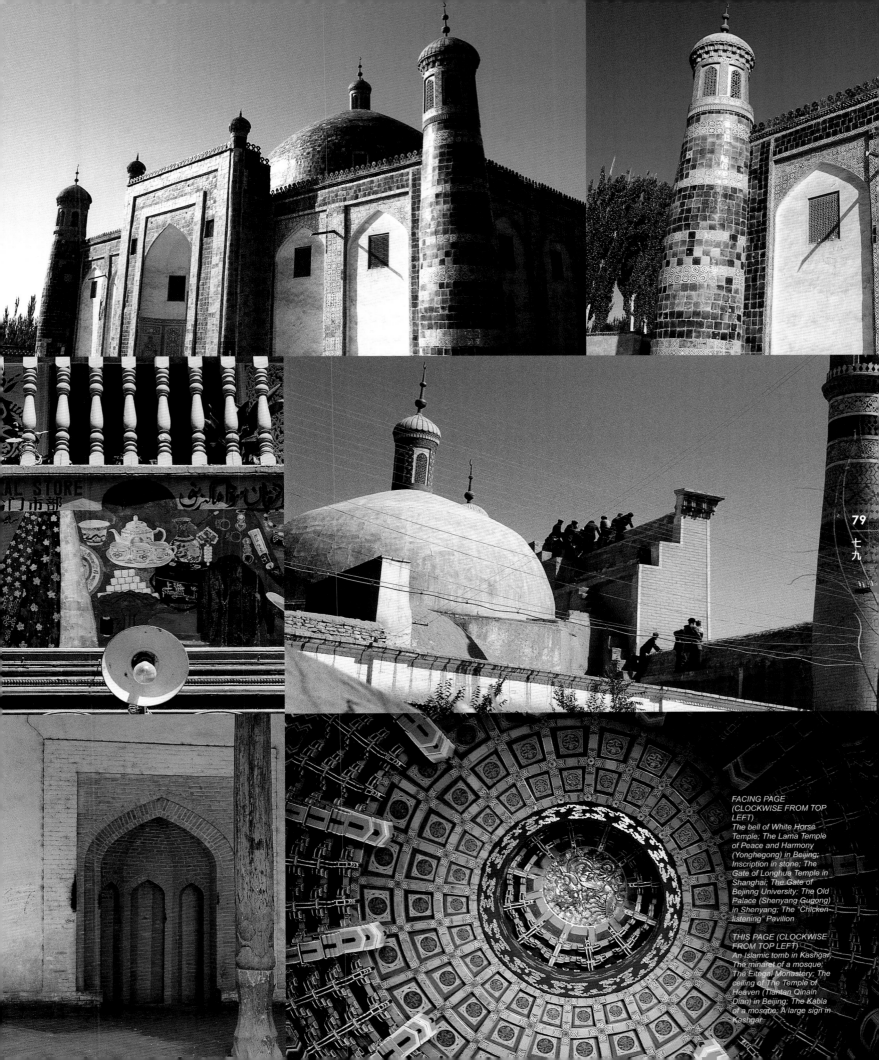

FACING PAGE (CLOCKWISE FROM TOP LEFT)
The bell of White Horse Temple; The Lama Temple of Peace and Harmony (Yonghegong) in Beijing; Inscription in stone; The Gate of Longhua Temple in Shanghai; The Gate of Beijing University; The Old Palace (Shenyang Gugong) in Shenyang; The "Chicken-listening" Pavilion

THIS PAGE (CLOCKWISE FROM TOP LEFT)
An Islamic tomb in Kashgar; The minaret of a mosque; The Eitegal Monastery; The ceiling of The Temple of Heaven (Tiantan Qinain Dian) in Beijing; The Kabla of a mosque; A large sign in Kashgar

chapter three
CULTURE

After a person's death, the body is moved to a temporary bed, where the body is cleansed and changed into a fresh set of clothing. The eldest son or grandson will then hold the head, while the other children and grandchildren will hold the arms and legs, and quietly lift the dead into the coffin. Thereafter, they will seal the coffin and nail it. After the third day, the deceased will be buried. The burial date must be chosen on an odd day of the calendar.

FACING PAGE
A scene from a performance by the
Zhejiang Song and Dance Troupe, Dailan

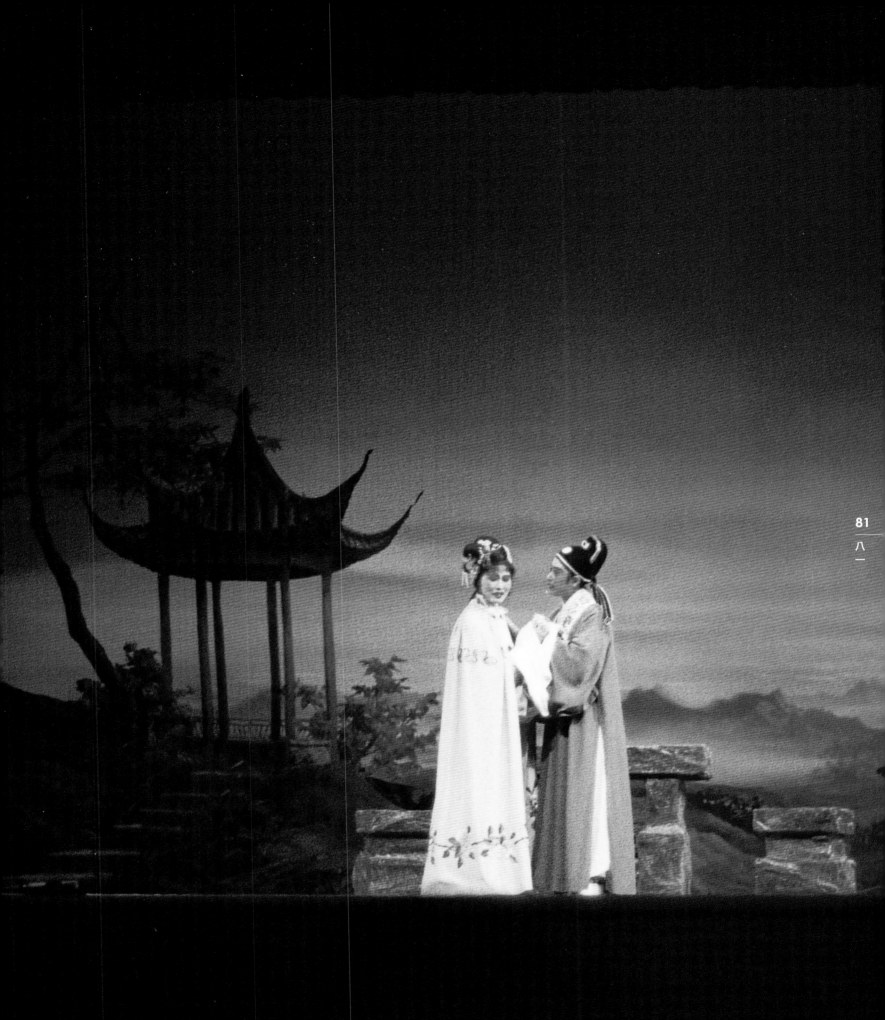

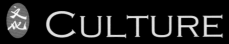

CULTURE

food . customs . arts & crafts

As with most nations that have long and rich histories, cultures and traditions form the basis of most national celebrations in China. There are many interesting Chinese traditions that are still being practiced and celebrated today, not just in China, but also everywhere in the world where the Chinese populate. Most of these traditions are celebrated to commemorate significant persons or events, and quite often, there are special dishes significant of events prepared and eaten on particular days. Apart from traditional holidays, national public holidays established after the founding of new China also find the Chinese in a celebratory mode throughout the nation. Being in one of these celebrations often brings back many childhood memories for me, where people filled the streets during festive occasions.

The national public holidays celebrated in China are: New Year's Day on January 1st, Women's Day on March 8th, Labor Day on May 1st, Youth Day on May 8th, Children's Day on June 1st, China People Liberation Army's Day on August 1st, and China's National Day on October 1st—the most widely celebrated across China. National Day was inaugurated on the 1st of October 1949, when an assembly of 300,000 people gathered at the Tiananmen Square in Beijing to witness Mao Zedong's declaration of the founding of the People's Republic of China.

The public holidays in China are far fewer than the traditional holidays. The traditional holidays follow the Chinese Lunar calendar, which is based on exact astronomical observations of the longitude of the sun and the phases of the moon. The Lunar Calendar has a sixty-year cycle, in which there are five basic elements—Metal, Water, Wood, Fire and Earth. These are combined with the 12 animal signs, which are the Rat, Ox, Tiger, Rabbit, Dragon, Snake, Horse, Lamb, Monkey, Rooster, Dog, and the Pig.

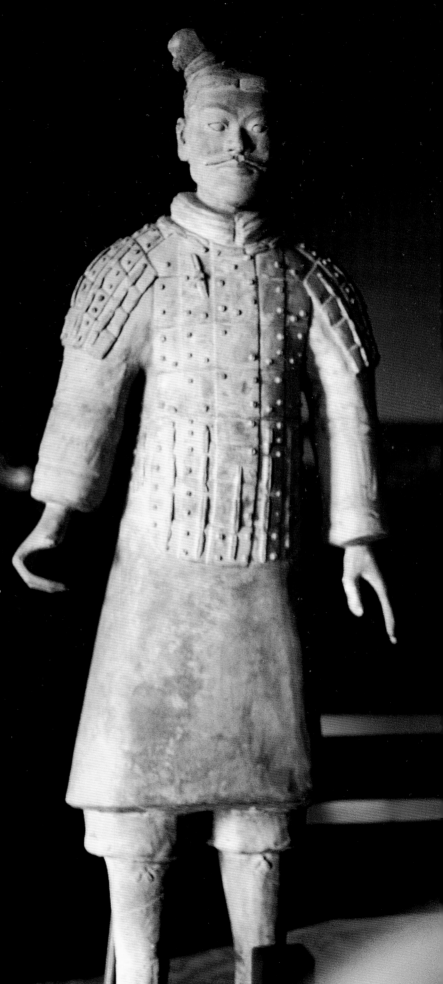

THIS PAGE
The famous terracotta warriors at The Forbidden City in Beijing

FACING PAGE
Reliefs of Buddha carved in stone

FESTIVALS

The Lunar New Year is the most significant holiday of the year for the Chinese. It is the Eastern equivalent of Christmas, whereby family members come together for a sumptuous meal known as the "reunion dinner." In the past, preparations for the New Year start from the 8th day of the 12th month (Labajie). Many customary rituals were conducted until the 15th day of the Lunar New Year. However, many of these rituals have been simplified today. Before the Lunar New Year, people will spring clean the house and buy festive goods to usher in the New Year. For the reunion dinner, northerners will prepare dishes of *jiaozi* (dumplings with meat or vegetable fillings), while southerners will have *tangyuan* (glutinous rice balls).

Yuanxiaojie (Lantern Festival) This is the 15th and final day of the Lunar New Year celebrations. Lanterns are displayed and *tangyuan* is eaten.

Qingmingjie (Qing Ming Festival) The Qing Ming Festival is one of the few traditional Chinese holidays that follows the solar calendar—typically falling on April 4, 5, or 6, or 12th day of the third Lunar month. Its name *qingming* literally means "clear brightness," which indicates the arrival of Spring, or the rebirth of nature, while marking the beginning of the planting season and other outdoor activities. People will visit their ancestors' graves and hold services for the deceased. They clean the surroundings of the grave, remove weeds, and make offerings of food, incense and paper money.

Duanwujie (Dragon Boat Festival) Falling on the 5th day of the 5th Lunar month, this is similar to the Boy's Festival in Japan. People celebrate by eating *zongzi* (rice dumplings wrapped in bamboo leaves). They also participate in dragon boat races.

Zhongyuanjie (Hungry Ghosts Festival) This falls on the 15th day of the 7th Lunar month and is also known as the Yulanpen Festival, similar to the Japanese O-Bon Festival. People visit the graves of their ancestors and hold services for them.

Zongqiujie (Mid-Autumn Festival) Falling on the 15th day of the 8th Lunar month, this is the day when all family members will gather to enjoy the view of the full moon and eat mooncakes, a sweet pastry filled with lotus seed paste.

Chongyangjie (Double-Ninth Festival) This is the 9th day of the 9th Lunar month, and is a holiday in celebration of longevity. It has become a custom for people to climb mountains to view chrysanthemums and drink wine made from these flowers.

Labajie (La Ba Festival) This is the 8th day of the 12th Lunar month. A porridge made from eight types of grains, fruits and nuts, called the *labazhou* (Eight Treasures Porridge), is prepared and eaten on this day.

Apart from these main festivals, cuisines, costumes and the different ways traditions are carried out are significant in the Chinese culture. Some of these are illustrated in the following pages:

THIS SPREAD
A sculptured relief on the wall of the Summer Palace in Beijing

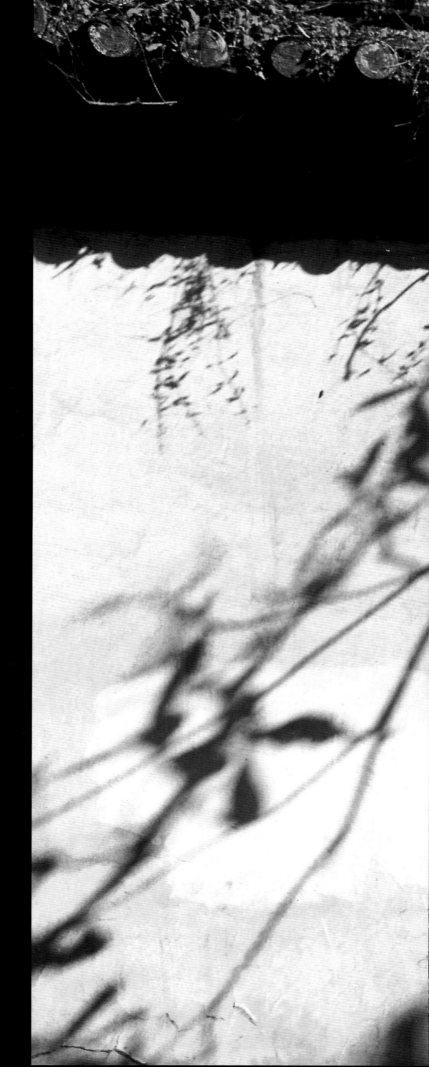

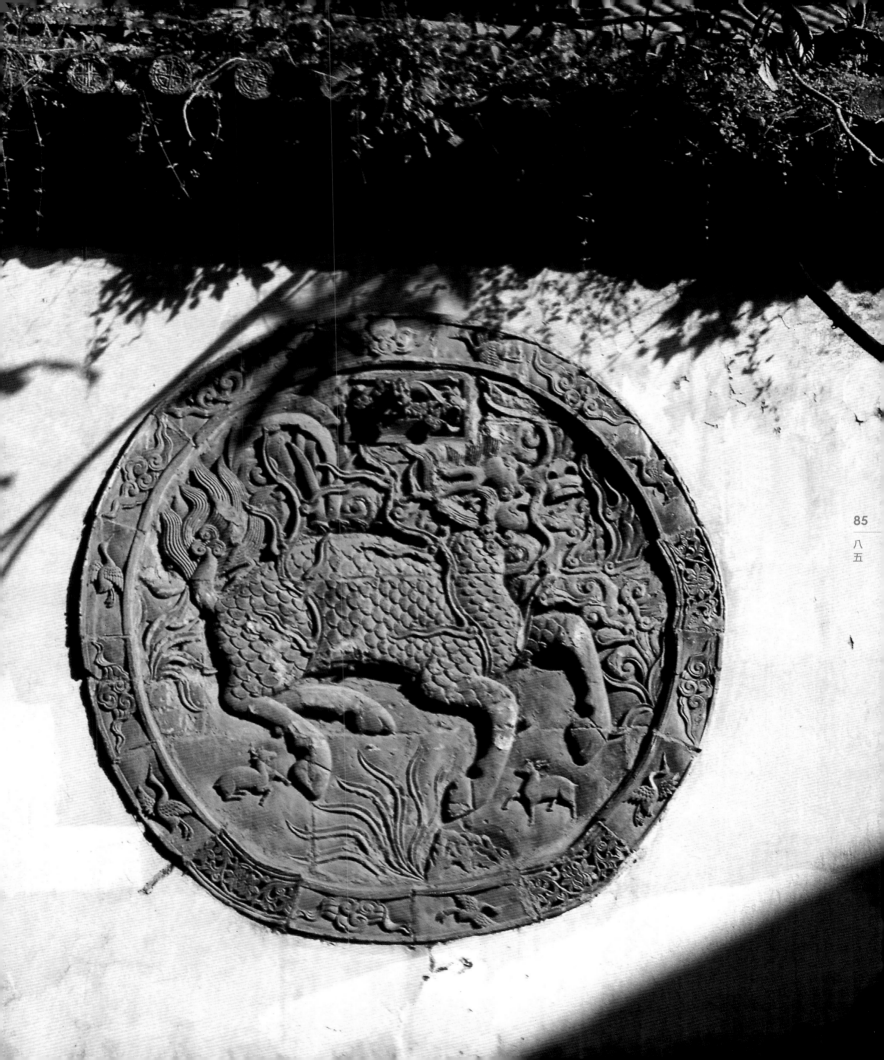

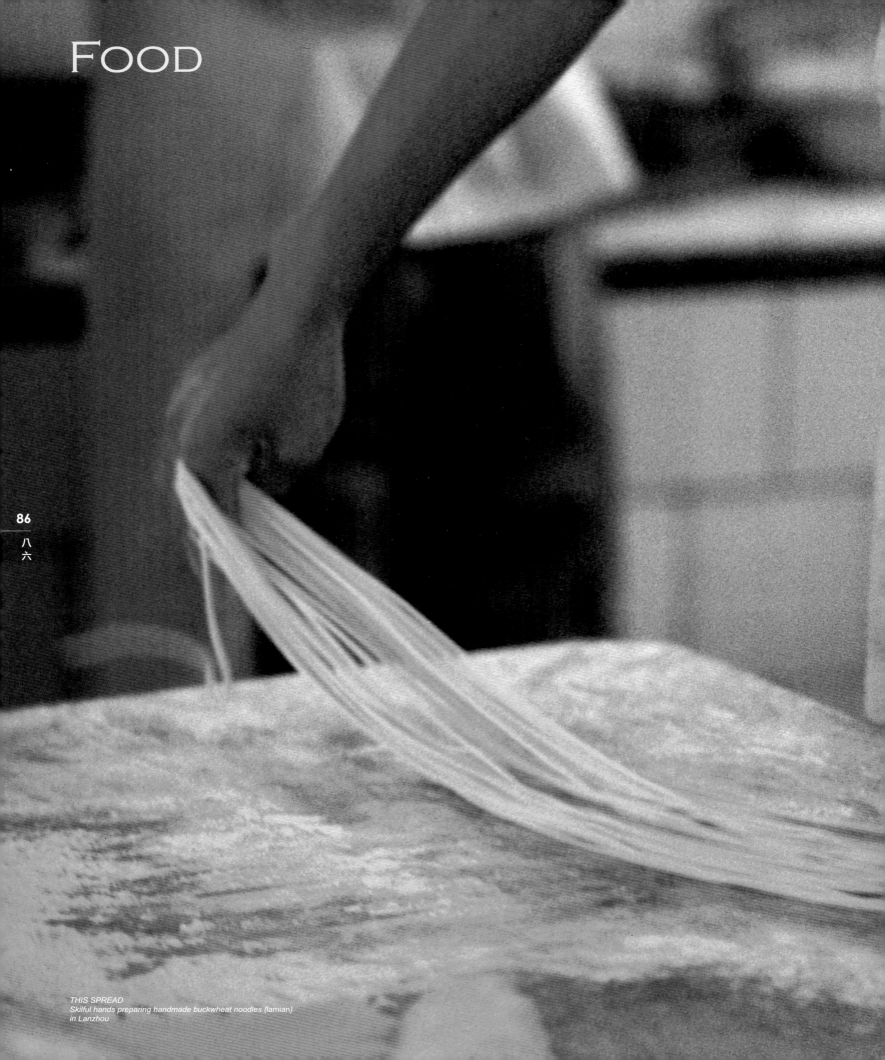

THIS SPREAD
Skilful hands preparing handmade buckwheat noodles (lamian)
in Lanzhou

Cuisines

There are many cooking methods employed in Chinese cuisine, with over 66 different styles in the basic cooking techniques. There are over 20 variations just in the frying method alone. At the same time, there are 6 styles of deep-frying and 10 basic styles of stewing.

Since ancient times, there has been a saying that goes "South is mild; North is salty; East is sour; and West is spicy" (*nandan beixian dongsuan xila*). This reflects the characteristics of the four major styles of Chinese cuisine. The food in the southern region is light and refreshing. The food of the cold north is salty. Western Sichuan cuisine is spicy, while in the lower Changjiang river region, sourness helps to bring out the taste of the ingredients. As we can see, taste is closely related to the respective regions' climates.

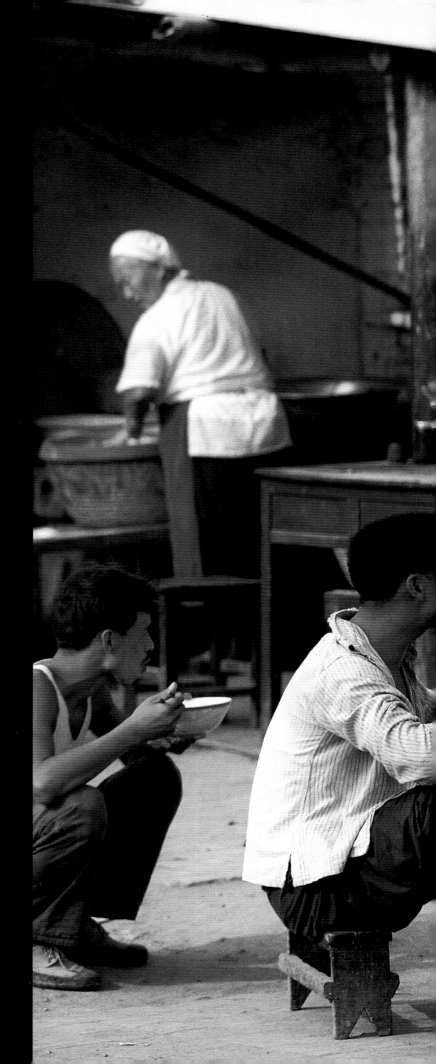

The are eight major types of cuisine representing China:

Shandong Cuisine Shandong cuisine was created during the Yuan Dynasty. It gradually spread to north China, Beijing, Tianjin, northeast China, and the palace where it influenced Imperial food. Because Shandong bordered the sea, and had mountains and fertile plains, the region had abundant aquatic products and grains as well as sea salt. The people of the area have stressed seasonings and flavorings since ancient times. Soup bases are used to bring out the freshness and taste of foods. The seasoning is also relatively salty, as sea salt is abundant in that region.

Sichuan Cuisine The origins of Sichuan Cuisine can be traced back to the Qin and Han Dynasty, although its recognition as a distinct regional system took place only in the Song Dynasty. Very spicy condiments, such as prickly ash and red pepper, are used in Sichuan cuisine. The ingredients are delicacies from land and river, edible wild herbs, and the meat of domestic animals and birds. Spicy food is eaten to help relieve the heat in Sichuan's humid summer seasons.

Jiangsu Cuisine Originating from Hangzhou, Yangzhou and Suzhou, which used to be prosperous provinces, the dishes are colorful and attractively presented. There is a heavy use of oil and sugar to create the strong tastes. Jiangsu Cuisine, also called Huaiyang Cuisine, is popular in the lower reaches of the Yangtze River. As aquatic animals are often used as main ingredients, the cuisine stresses the freshness of materials. Main cooking techniques consist of stewing, braising, roasting and simmering

Guangdong Cuisine Guangdong cuisine is well-known for its use of a wide variety of animal and exotic creatures as ingredients. Reputedly, as many as 5,000 species of animals are used, including dogs, cats, snakes, salamanders, rasses, wild cats, turtles, seals, etc. Animal bones are also used for stocks and soups. The taste is light, crisp and fresh. The chief cooking techniques employed are any one of the three methods of *jian* (pan-fry), *chao* (sauté) or *liu* (steam).

Anhui Cuisine This is known to be simple and substantial in the use of ingredients. Anhui cuisine chefs focus much more attention on the temperature when cooking and are good at braising and stewing. Often hams will be added to improve taste and sugar candy is added to gain freshness.

Hunan Cuisine Hunan cuisine consists of the local cuisines of Xiangjiang Region, Dongting Lake and the Xiangxi valley. Various ingredients are used in a great variety of cooking methods. It characterizes itself by thick and pungent flavor in which chile, pepper and shallots are usually used.

Zhejiang Cuisine Based on the cooking styles of Hangzhou, Ningbo and Shaoxing, Zhejiang cuisine is refreshing, and great care is taken to preserve the original flavors of the ingredients. It has its reputation for the freshness, tenderness, softness and smoothness of its dishes with mellow fragrances.

Fujian Cuisine Fujian is blessed with a great supply of sea produce, and hence the main feature in the cuisine is seafood. Colorful and splendid in presentation, Fujian cuisine emphasises a sour and light flavor. The most distinct feature is a "pickled taste."

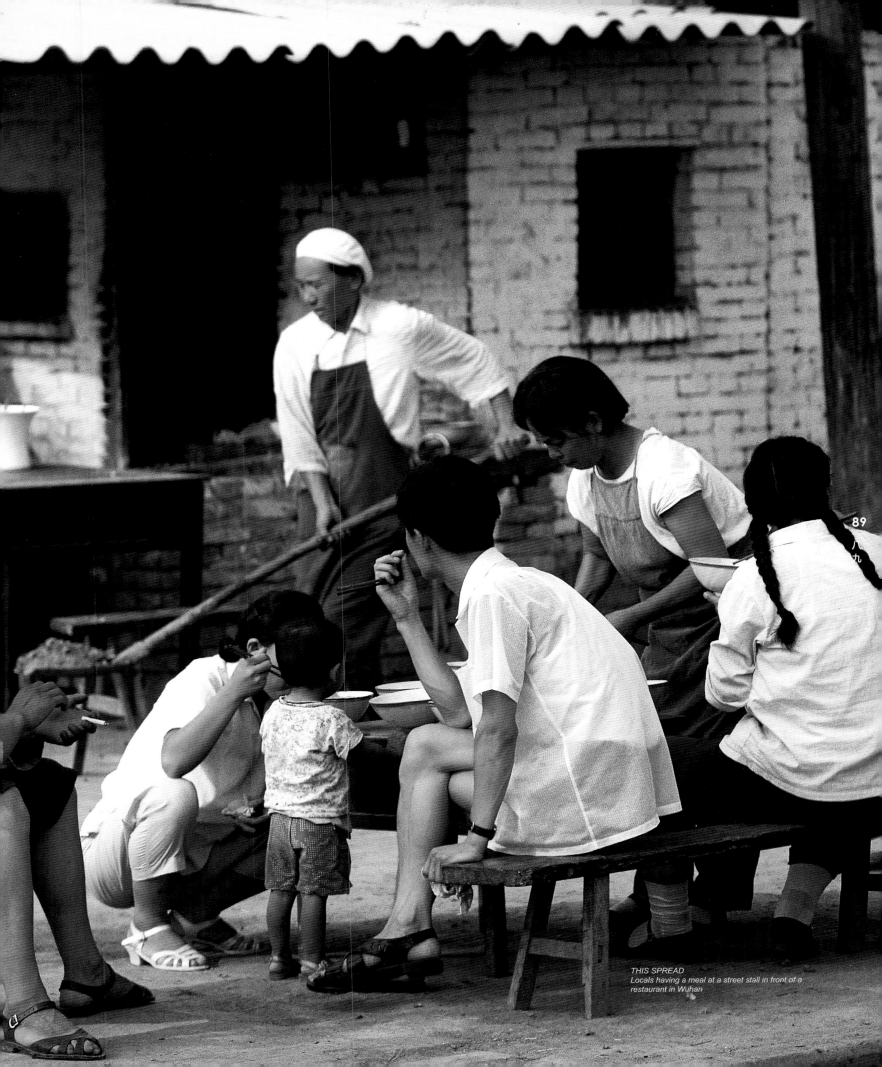

八
九

THIS SPREAD
*Locals having a meal at a street stall in front of a
restaurant in Wuhan*

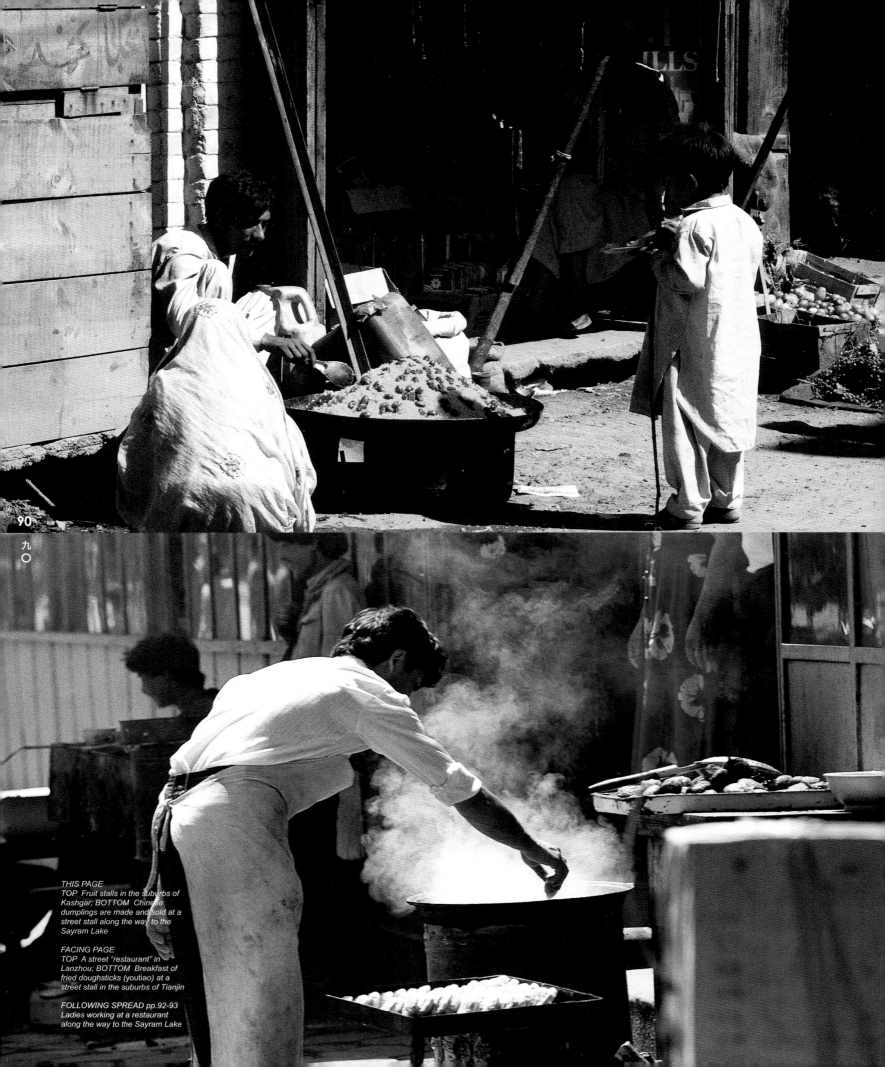

THIS PAGE
TOP Fruit stalls in the suburbs of Kashgar; BOTTOM Chinese dumplings are made and sold at a street stall along the way to the Sayram Lake

FACING PAGE
TOP A street "restaurant" in Lanzhou; BOTTOM Breakfast of fried doughsticks (youtiao) at a street stall in the suburbs of Tianjin

FOLLOWING SPREAD pp.92-93
Ladies working at a restaurant along the way to the Sayram Lake

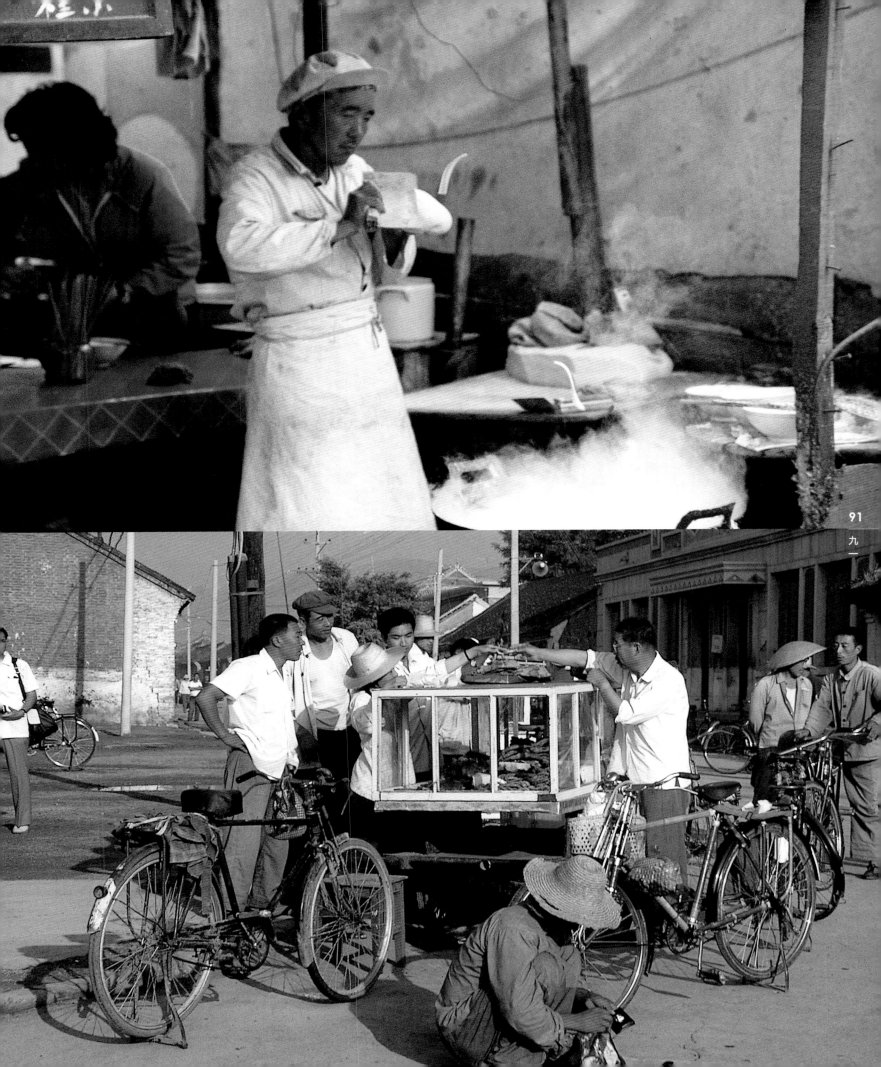

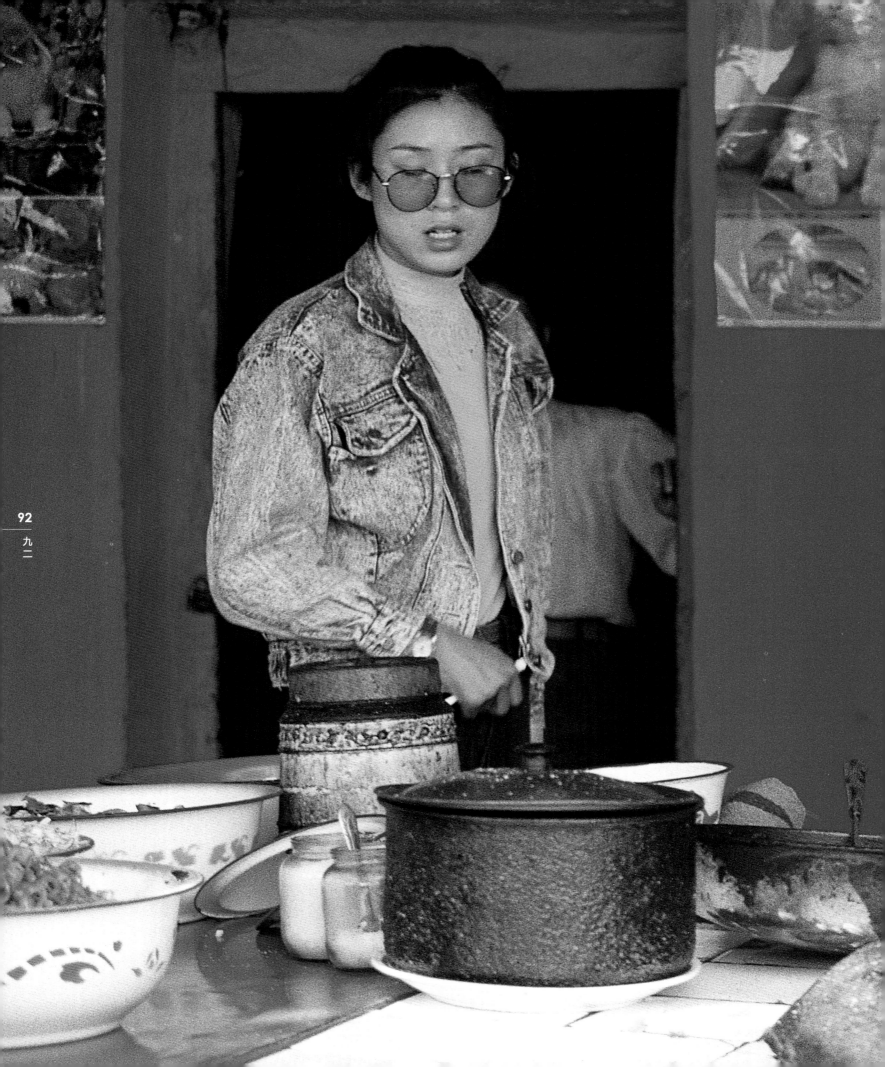

Other representative types of Chinese cuisine:

Beijing Cuisine Adopted from different regions across China, the Beijing style gathers the strengths of the cooking style of each district. The signature dishes include Peking Duck, *shuanyangrou* (Poached Mutton), *jiaozi* (Dumplings of meat and/or vegetable fillings) and Manhan Quanxi—the Qing-Han Imperial Feast which comprises 196 main courses and 124 desserts.

Shanghai Cuisine Shanghai, the major seaport in the estuary of the Yangtze River, does not really have a cuisine of its own, but successfully combines all the work of the surrounding provinces. The flavors are generally richer, heavier, sweeter and oilier than those of Cantonese cuisine. Shanghai cuisine emphasizes the freshness of the ingredients used. Spice, oil, sugar and soy sauce are liberally used to create strong and rather rich tastes.

Hakka Cuisine The hallmark of Hakka cuisine is its simplicity without compromising on taste. Bean curd is often used instead of meat for cooking. Dried and pickled foods are prominently featured in this cuisine.

TEA

The first production of tea leaves in the world was in China. Tea is nearly 5,000 years old and was discovered, as legend has it, in 2737 BC by a Chinese emperor when some tea leaves were accidentally blown into a pot of boiling water.

Green Tea Green tea has the most variety amongst all, and is primarily drunk in the south. China is famous for its high-quality *longjingcha*.

Red Tea Drunk without adding sugar or milk, red tea has been produced in China since the middle of the 17th century. The *Qimen hongcha* from Anhui province is very popular.

Oolong Tea Only the outer part of the leaf is used in the fermentation process for the unique production method for Oolong tea. Fujian, Guangdong, and Taiwan are the main production areas.

Flower Tea Flowers are infused into tea leaves, creating a special aroma. Of the Chinese flower teas, jasmine tea is among the most popular.

Pu'er Tea Pu'er teas are dark or deep brown in color. Yunnan Province is famous for this tea known as *pucha*.

ALCOHOLIC DRINKS

White wine The main ingredient is *gaoliang* (sorghum). It is colorless and often distilled to above 50% in alcohol content. Chinese white wines include *maotaijiu* from Guizhou and *fenjiu* from Shanxi.

Yellow wine Also known as *laojiu*, this wine is brewed using glutinous rice and millet. Brown in color, the wine has an alcohol content of 14-17%. Examples include Zhejiang's *shaoxingjiu*.

Grape Wine Production began in Shandong at the end of 19th century. Huabei and Tongbei are the main production centers.

Beer A German beer factory was established in Qingdao, Shandong Province and started production at the start of the 20th Century. The beer that it produces, Tsingtao Beer, is widely known.

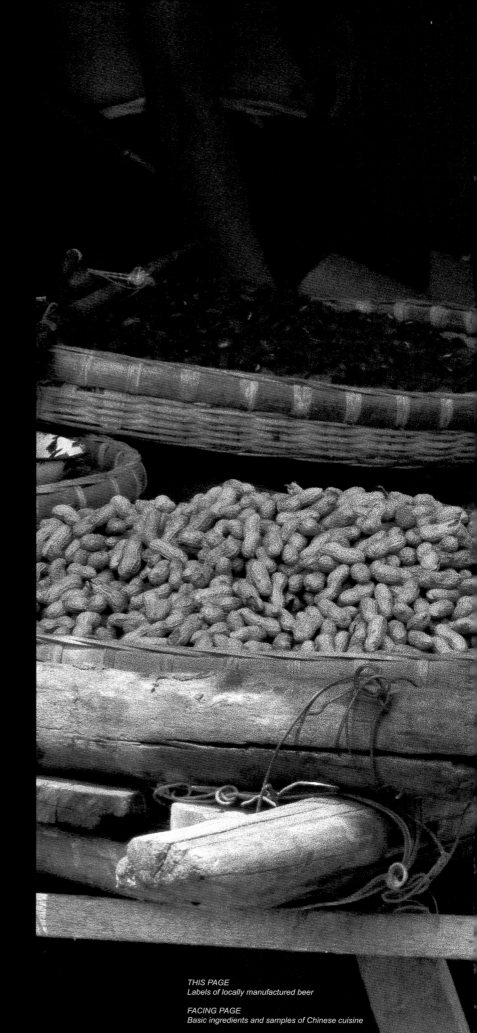

THIS PAGE
Labels of locally manufactured beer

FACING PAGE
Basic ingredients and samples of Chinese cuisine

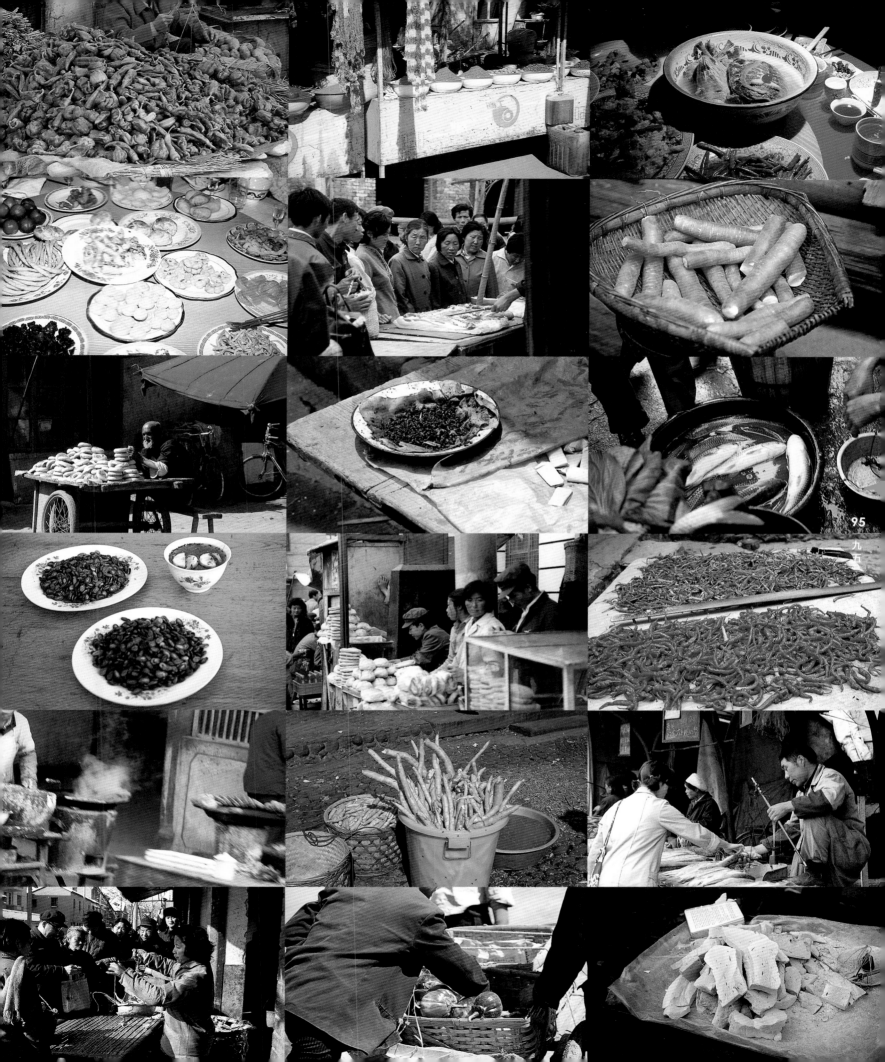

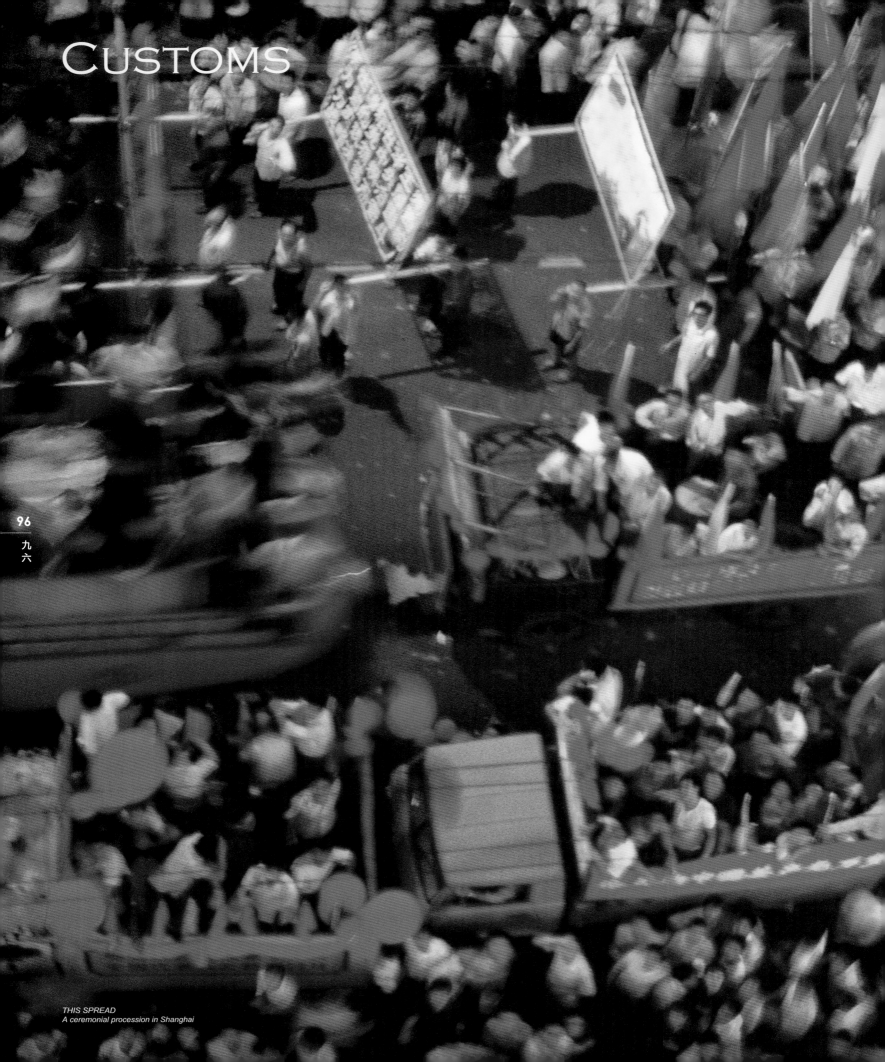

96

九
六

THIS SPREAD
A ceremonial procession in Shanghai

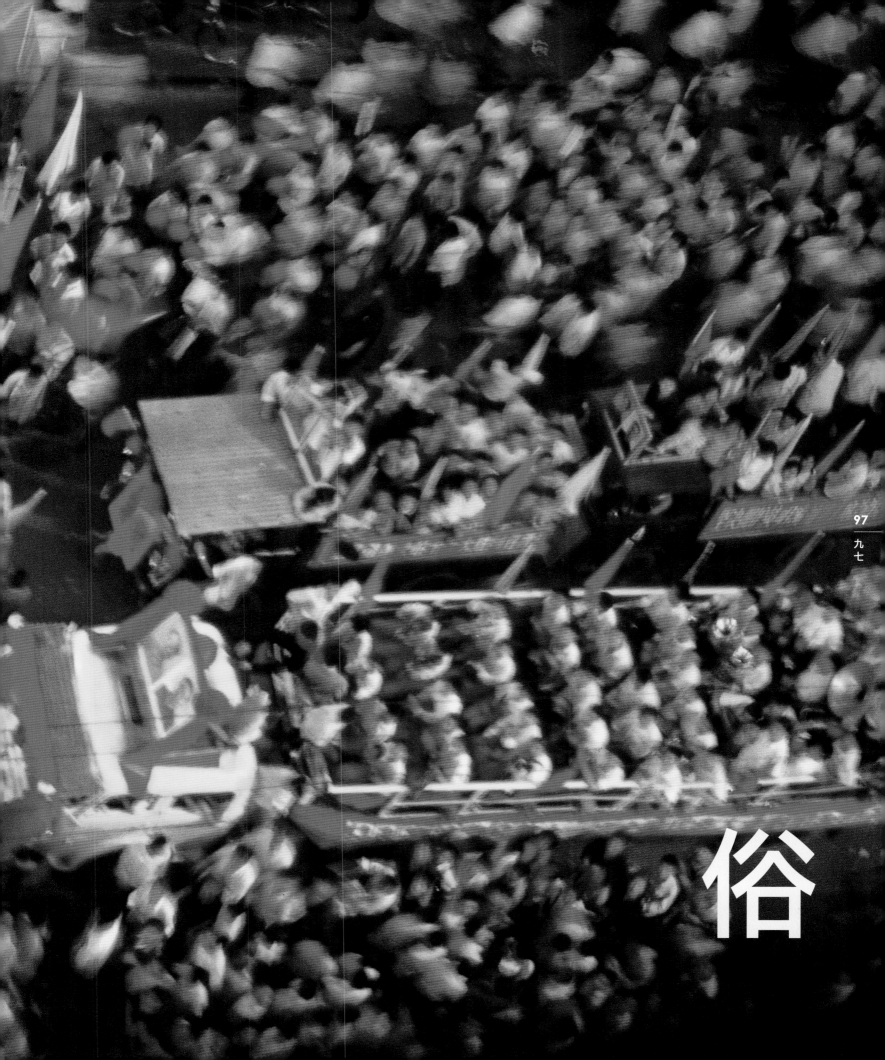

俗

WEDDINGS

I met many young villagers carrying a bride's trousseau to the groom's house on my way to the Guoqing Temple of Mount Tiantai. The bride packed her clothing into two bundles and made her way to the groom's house under the watchful eyes of guests who were joining in the celebration. Incidentally, that particular scene reminded me of the day of my own wedding.

A typical marriage ceremony in a Chinese farming village starts from the time the bridegroom leaves to pick up his bride from her home. Wedding presents brought to the bride's home are carried on a longbow by the groom's entourage of young men. Carried in rows, the presents are shown off to the villagers on the way to the bride's home. Upon reaching the bride's home, the presents and laid and displayed in a room for the guests to view.

In the past, instead of cars, carriages were used. With variations across different regions, the *shangjiao* (carriage) was embellished with splendid designs. It had a red damask curtain embroidered with a golden dragon, and four yellow tassels hanging from the four corners of the carriage's roof. Before the bride entered the carriage, she would sit on a chair, holding artificial flowers in her hand, while her brothers or male relatives carried her around.

Once the bride arrived at the bridegroom's home, she would be carried out from the car by the groom's entourage, who would pass her over a fire to ward off evil spirits before she entered the house.

The typical wedding ceremony is conducted in the central courtyard of the bridegroom's house. A piece of red paper written with both the bridegroom's and bride's names will be hung on the courtyard wall facing the south. The bridegroom and the bride will sit before of the courtyard wall. During the ceremony, they will follow the order of the master of the ceremony, who declares, "First, bow to Heaven and Earth. Second, bow to your parents. Third, bow to each other."

A wedding banquet follows the ceremony. A section of the garden will be used as a temporary kitchen. All the preparations for the banquet, including cooking, carrying and the washing of plates, are assisted by the men from the village.

In my hometown in Japan, the bride will scoop rice for each guest during the wedding dinner. This symbolizes the taking over of domestic duties from her mother-in-law. The wedding dinner not only celebrates the new couple's happiness, but also expresses hope for the next generation.

98
九
八

THIS SPREAD
BACKGROUND A typical wedding invitation card;
RIGHT The Kong family wedding banquet in Qufu

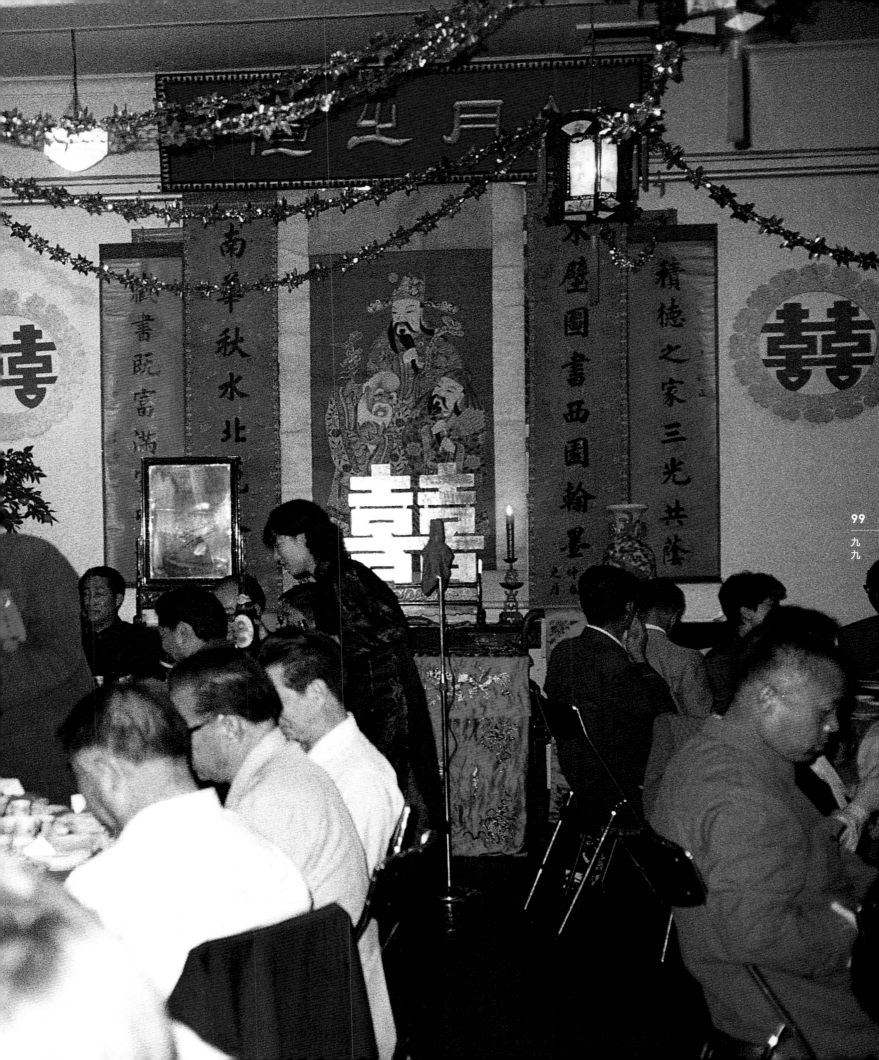

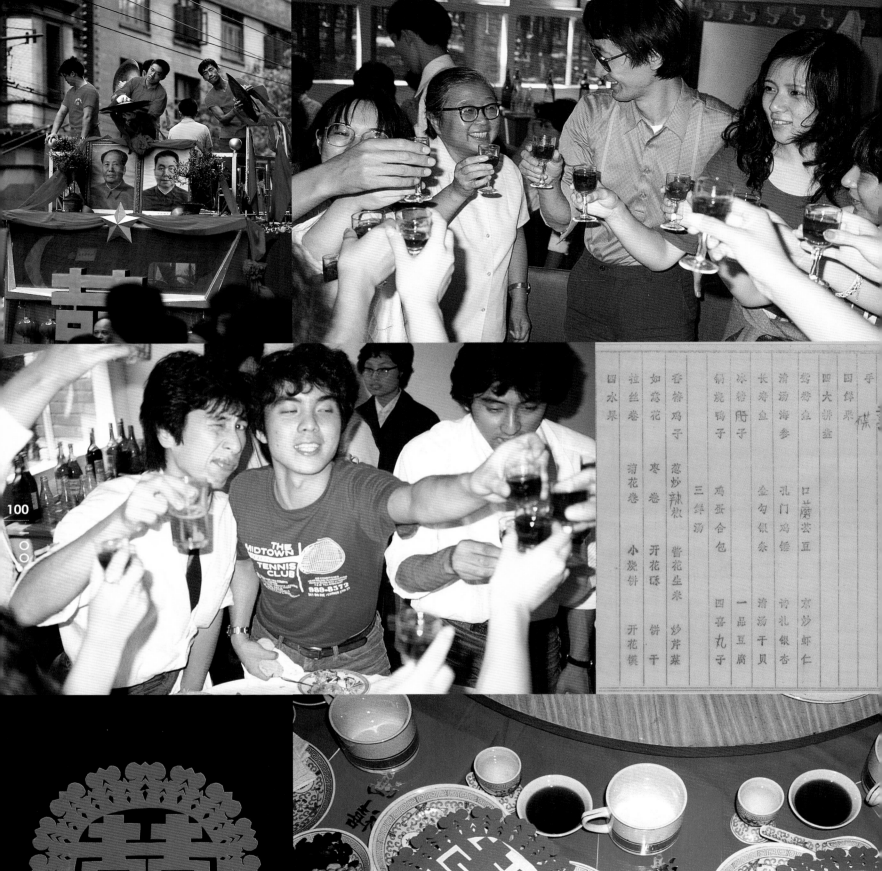

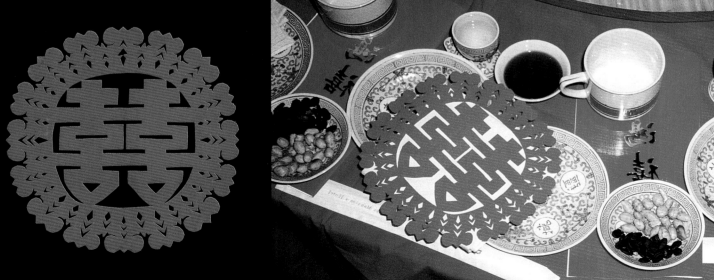

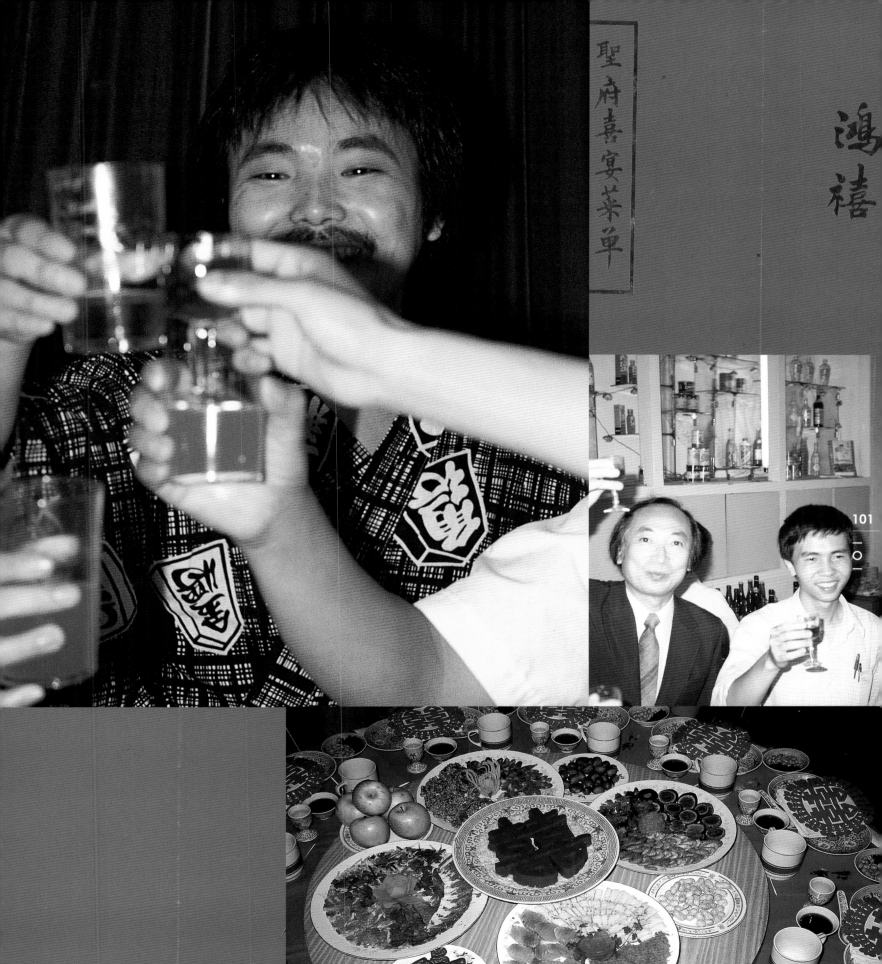

聖府嘉宴菜單

鴻
禧

THIS SPREAD
Scenes from a typical Chinese wedding

FOLLOWING PAGES pp.102-103
Scenes from ceremonial processions in Shanghai
(p.102 TOP and BOTTOM; p.103 BOTTOM) and
Wuhan (p.103 TOP)

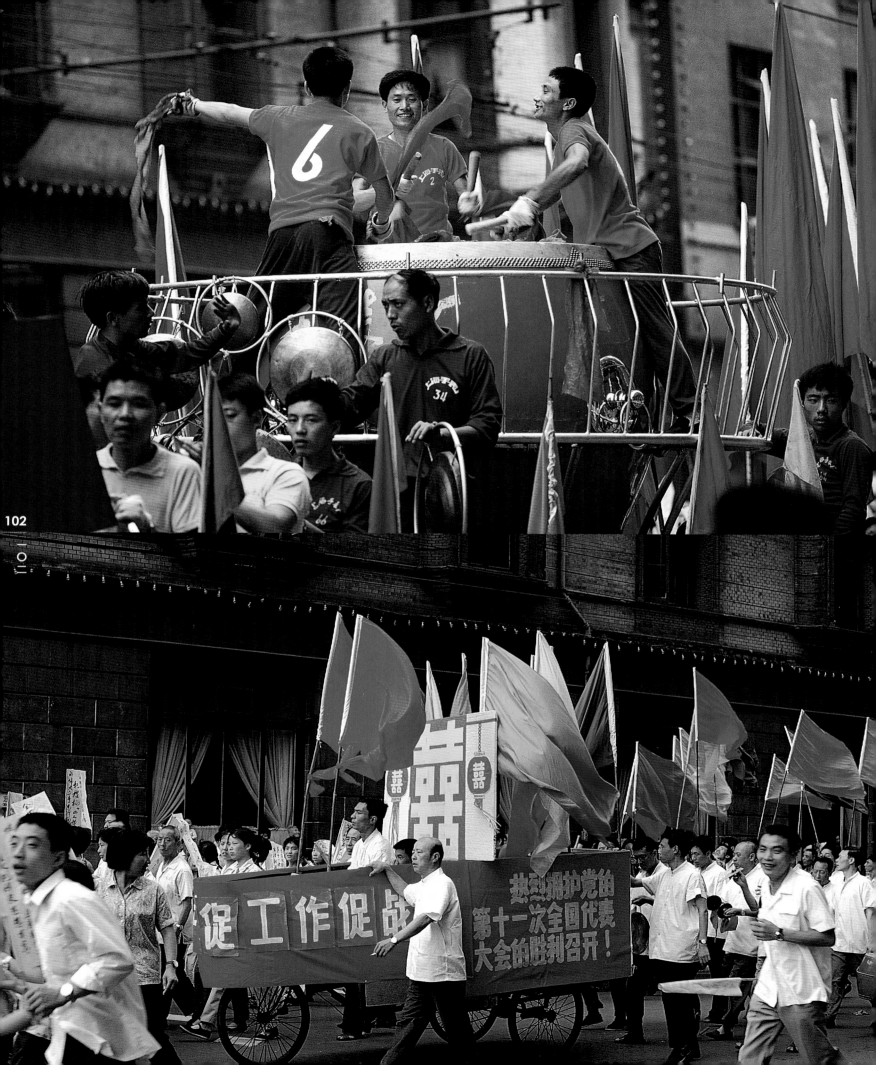

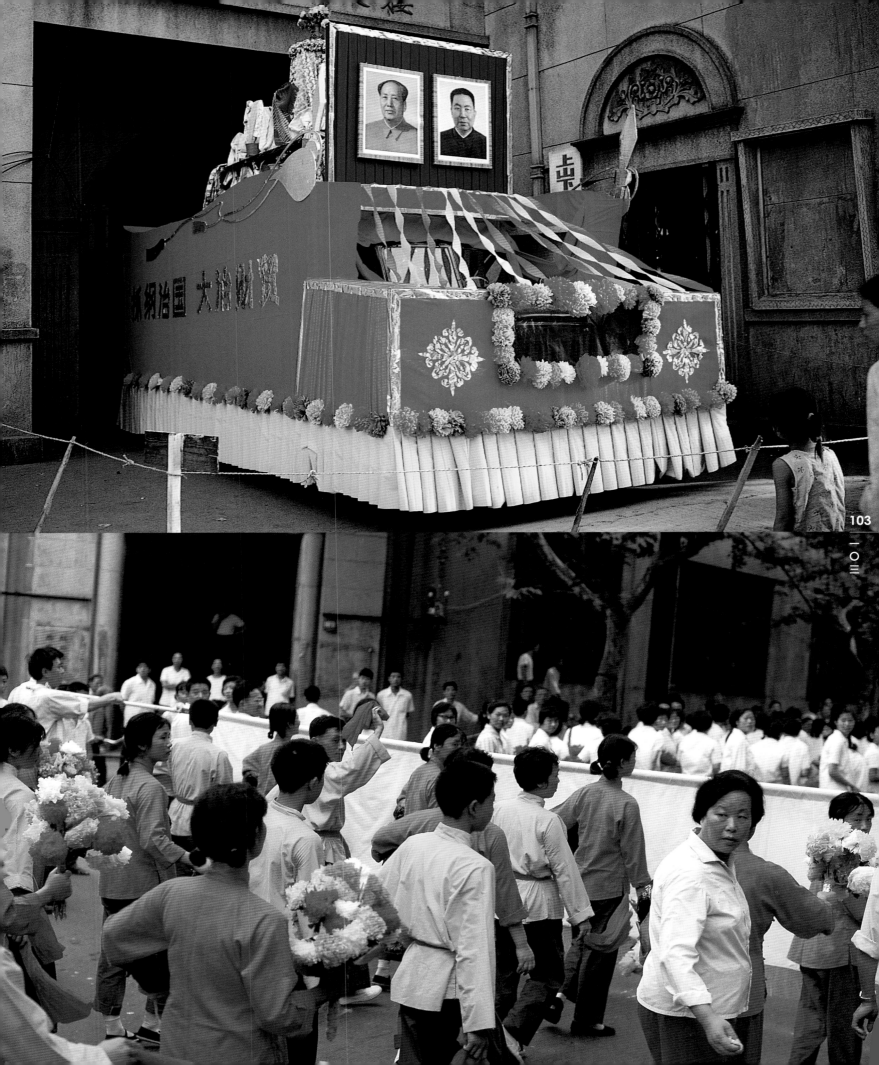

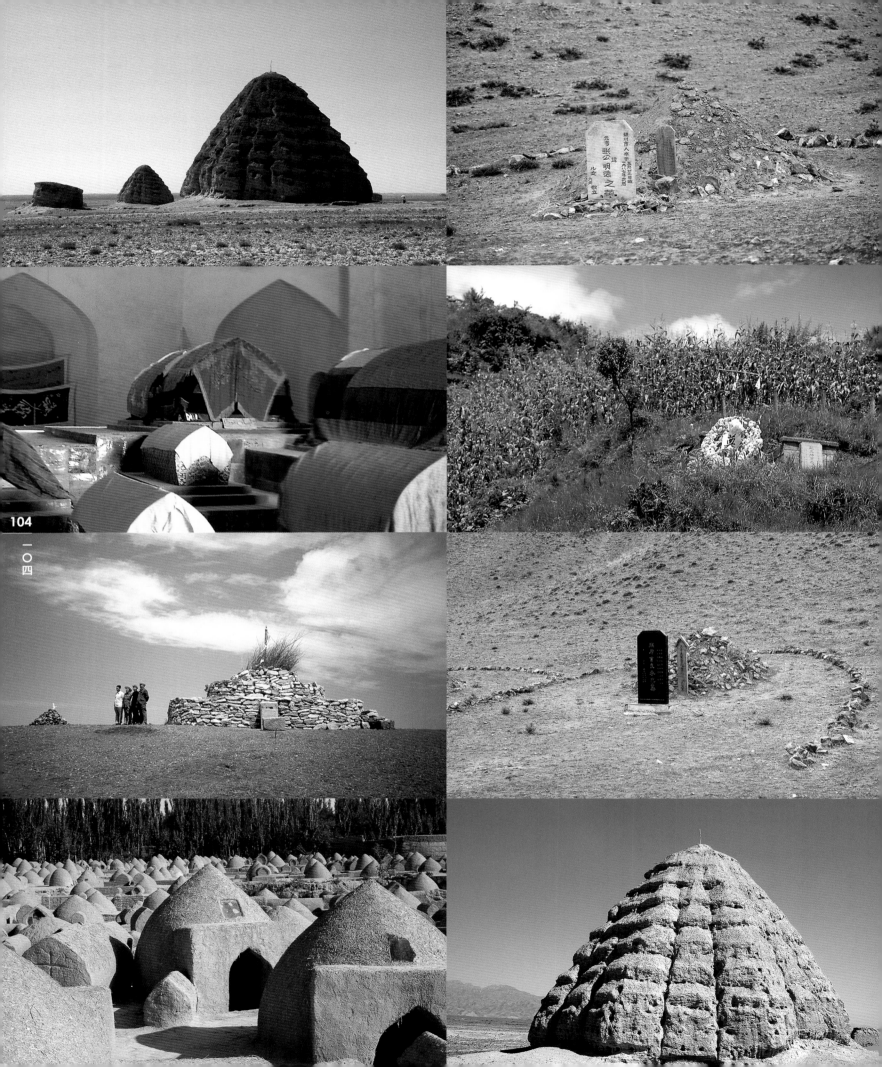

FUNERALS

While cremation is widely practiced in urban districts today, burial is still widely conducted in the rural areas.

After a person's death, the body is moved to a temporary bed, where the body is cleansed and changed into a fresh set of clothing. The eldest son or grandson will then hold the head, while the other children and grandchildren will hold the arms and legs, and quietly lift the dead into the coffin. Thereafter, they will seal the coffin and nail it. After the third day, the deceased will be buried. The burial date must be chosen on an odd day of the calendar. During the final funeral procession, the coffin will be borne by the children and grandchildren. Other mourners will follow behind in the procession. Once they reach the graveyard, the coffin is placed onto the burial site with care. The eldest son will start by throwing some soil onto the grave, and other relatives and friends will follow. The proper burial is done by a mortician, who will build a 10 to 15 inch high mound on the grave. Then, a white flag is placed on top of the grave. After the burial, the soil of the grave will be levelled and a gravestone will be set up. Thereafter, rituals are conducted every 7 days for the duration of 7 weeks.

THIS PAGE
Reliefs on the facade of a shrine

FACING PAGE
Tombstones and burial grounds of both
the Islamic and Chinese cultures

ARTS AND CRAFTS

THE 4 TREASURES OF STUDY

These refer to the brush, ink, paper and ink stone. The *hubi, huimo, xuanzhi* and *duanyan,* respectively, have a long tradition and are rare articles amongst the treasures, well-known even in foreign countries.

Hubi (Brush) Particularly famous is the *hubi* made in Shanlian Town, Huzhou City of Zhejiang Province.

Huimo (Chinese Ink) The *huimo* made in She County of Anhui Province is particularly famous.

Xuanzhi (Paper) Jin County of Anhui Province is most famous for its paper. The bark of the *qingtan* (sandalwood tree) that grows in the mountains of Jin County provides the chief raw material.

Duanyan (Ink Stone) The *duanqing* rock, from which the famous ink stone is made, is found in the outskirts of Zhaoqing City in Guangdong Province. *Duanqing* rock is green in color, with a glossy sheen, and is formed from coagulated lava.

CHINESE PAINTING

Chinese paintings include *guohua* (traditional Chinese painting), *youhua* (oil painting), *banhua* (print), *shuicaihua* (water color painting), *bihua* (wall painting), *nianhua* (New Year paintings) and *lianhuantu* (comics). Chinese painting began after the great inventor Cai Lun formulated the technology for manufacturing paper at the end of the Han Dynasty. The paintings are drawn using paper, brush, ink and a water-soluble pigment. Themes include people, landscapes, flowers and birds. These are still popular themes today.

A type of painting that is considered to be distinctively Chinese is the *nianhua*. The *nianhua* is a print poster placed on the wall or the door during Lunar New Year. With strong black outlines and the brightly pigmented red and green inks, these paintings are particularly eye-catching. They are displayed for good fortune and prosperity and are the symbols of the New Year, especially in the rural areas, where people believe that these will drive away evil spirits and bring in good luck.

The most famous of the *nianhua* are the *taohua wunianhua* produced in Taohuawu of Suzhou City, the *yangliu qinnianhua* by Yang Liuqing of Tianjin, the *weifang nianhua* of Wei Fang City in the Shandong Province, the *mianzhu nianhua* of the Mian Zhu district in the Sichuan Province, the *zhuxian nianhua* of Zhu Xian Town in Kai Feng City in the Henan Province and *xianshan nianhua* of Xian Shan City in the Guangdong Province.

THIS PAGE
A wall painting in the suburbs of Xi'an

FACING PAGE
A standing Buddhist sculpture in the Lower Huayan Temple in Datong

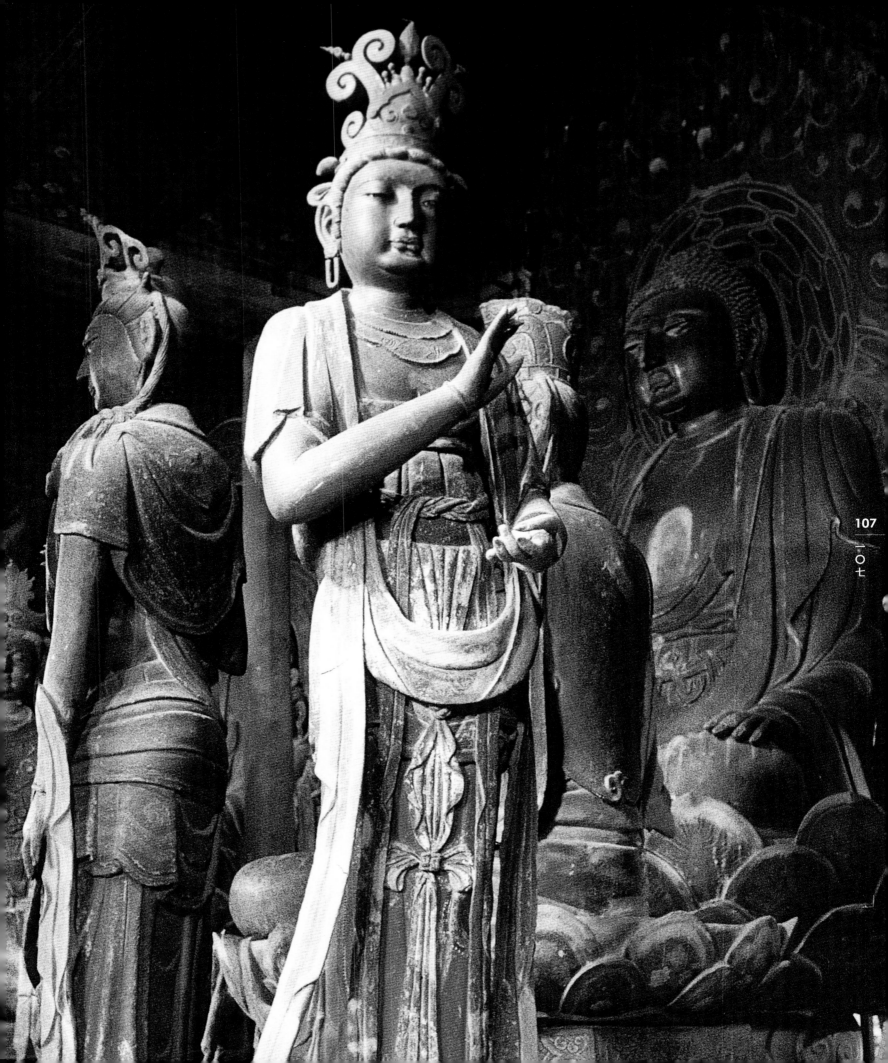

Calligraphy

It is said that calligraphy started when inscriptions were made on bones and tortoise carapaces. Subsequently, Chinese calligraphy spread to Korea, Japan and Southeast Asia. There are 5 typestyles in Chinese calligraphy, namely the *caoshu* (cursive style), *kaishu* (square style), *xingshu* (semi-cursive style), *zhuanshu* (seal style) and *lishu* (official style).

***Caoshu* (Cursive Style)** It was adapted from the lishu into a "running" or "swift" style. The strokes are connected and the characters are written contiguously.

***Kaishu* (Square Style)** This typestyle was developed during the Suitang era. The strokes reflect strict rules. The character shape is systematic and square.

***Xingshu* (Semi-cursive Style)** The typestyle is a cross between the *kaishu* and *caoshu*. It is a more humanist typestyle as there are less stroke omissions as compared to *caoshu*, and thus, it is easier to understand.

***Zhuanshu* (Seal Style)** This is the pictorial form of a character based on hieroglyphics.

***Lishu* (Official Style)** Improved from the *zhuanshu*, the characters are adapted from a rounded style to squarish forms.

Excellent calligraphy can be viewed in many places, including the National Palace Museum, the China History Museum in Beijing, the Shanghai Museum, the Nanjing Museum, Dai Temple in Taishan, Xileng Shrine in Hangzhou, Lanting (Orchid Pavilion) in Shaoxing, the Long Men Grottoes of Luoyang, Moya in Shandong, the Stone Door in Han Zhong and the Three Great Stone Statues of Xi'an, Qufu and Zhaoling.

Duilian (Double Banner)

During the Lunar New Year, the owner of the house will write his wishes and hopes in black ink on two slender pieces of red paper of identical sizes. The banners are pasted on both sides of the entrance to the house. These used to be known as the *taofu* (peach talisman), as people believed that peach has power to ward off the devil, and therefore hung boards made from peach wood on both sides of the gate to the house. The Emperor of the late Shu Dynasty in the 10th century started this tradition by writing phrases on peach boards, and they have since evolved gradually to the *duilian* (as known since the Ming Dynasty).

THIS SPREAD
Images showing various art, calligraphic and carving styles and practices

FOLLOWING SPREAD pp.116-117
Doorways and entrances "decorated" with calligraphic signs

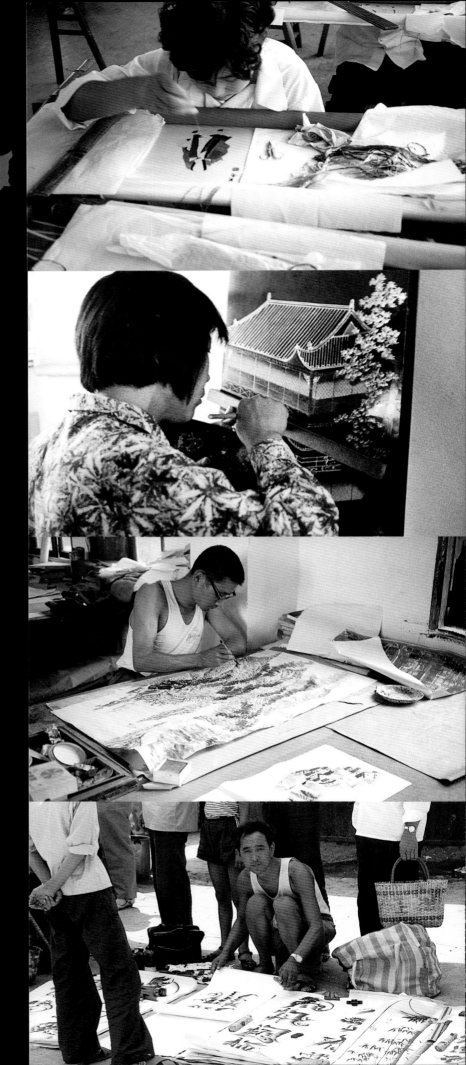

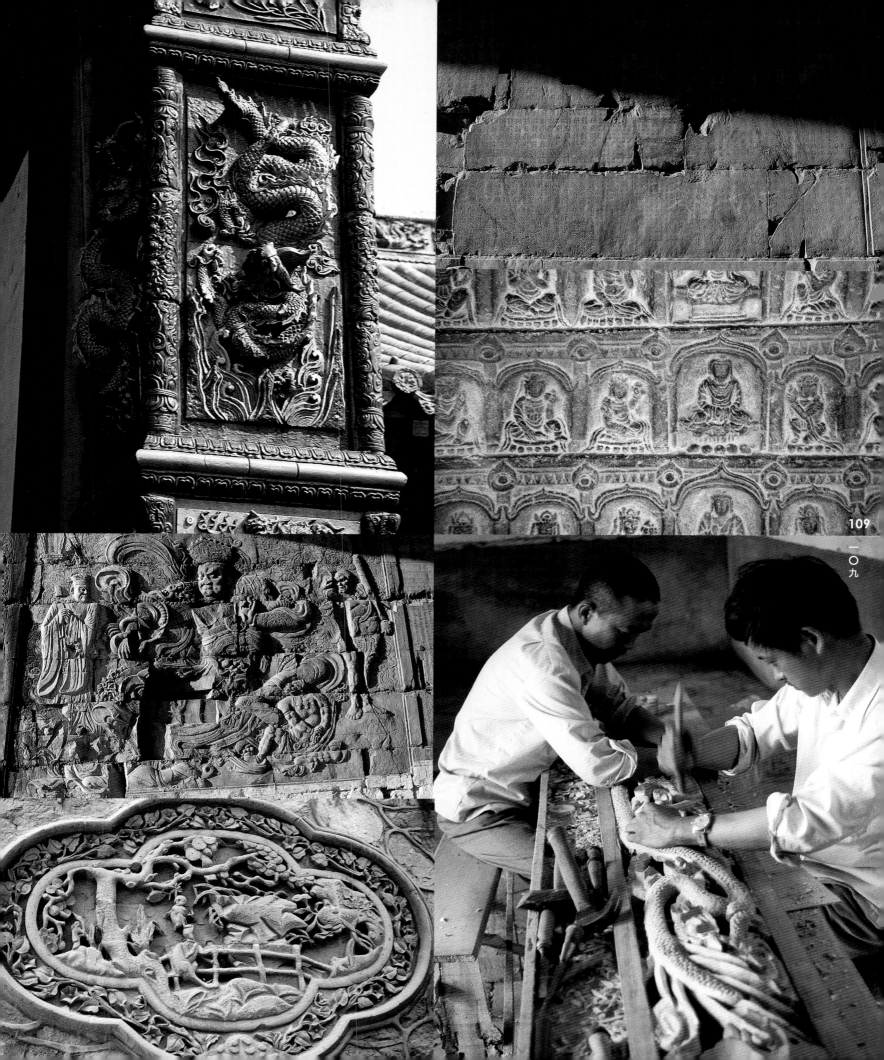

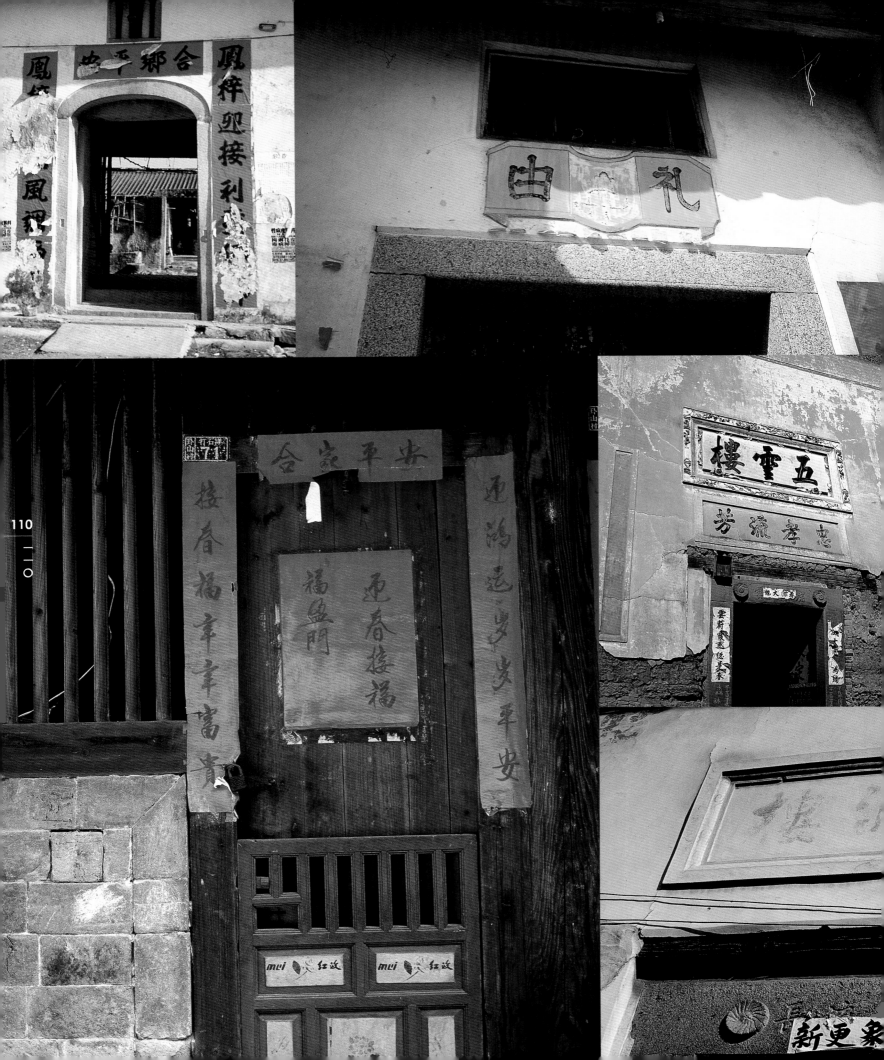

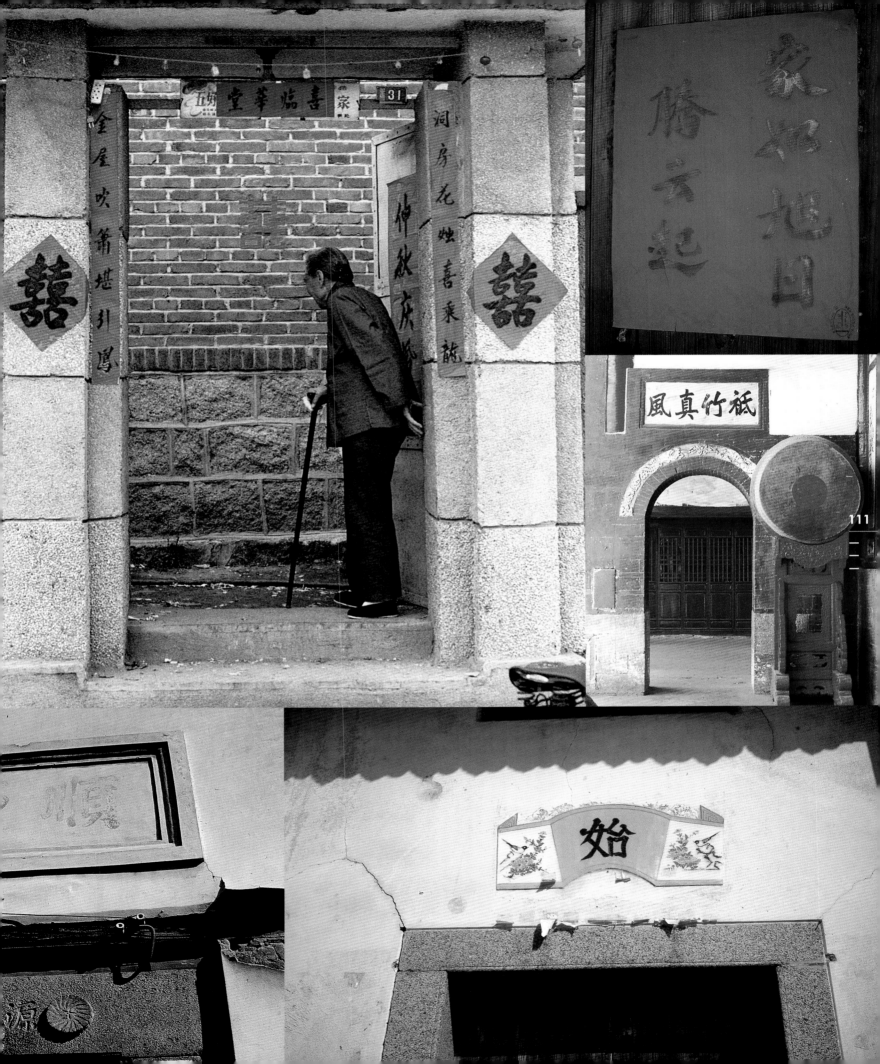

111

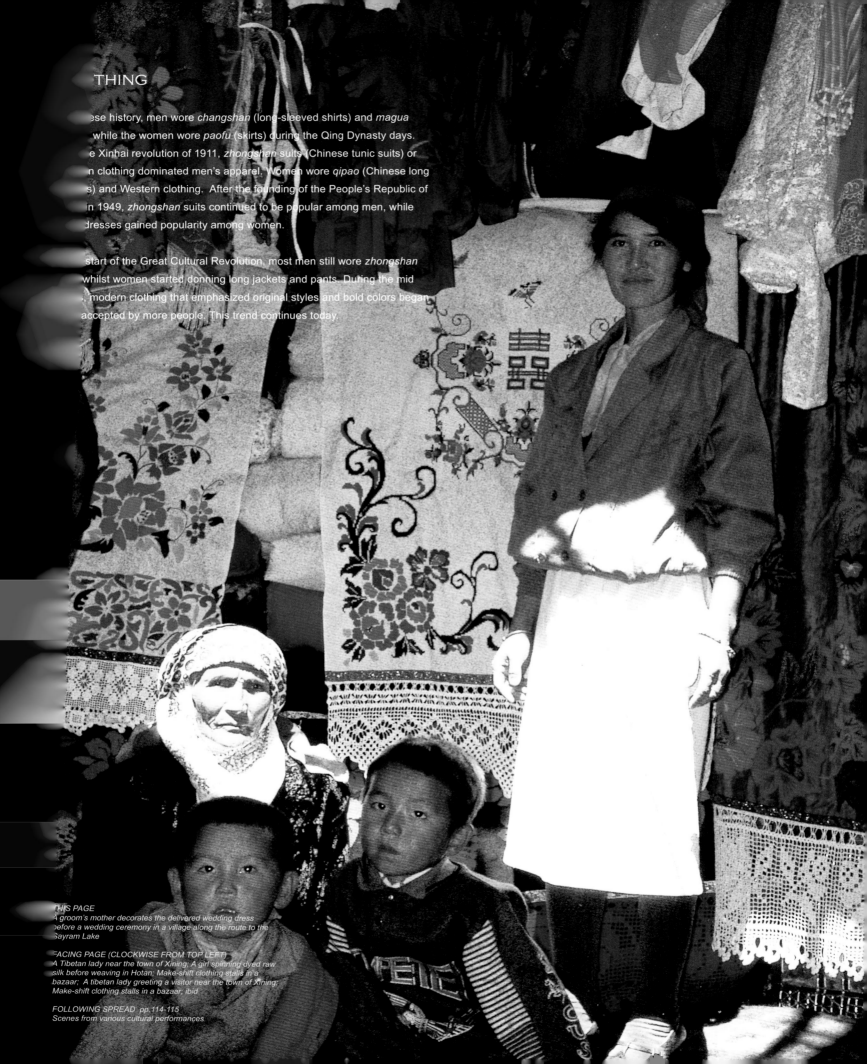

THING

ese history, men wore *changshan* (long-sleeved shirts) and *magua* while the women wore *paofu* (skirts) during the Qing Dynasty days. e Xinhai revolution of 1911, *zhongshan* suits (Chinese tunic suits) or n clothing dominated men's apparel. Women wore *qipao* (Chinese long s) and Western clothing. After the founding of the People's Republic of n 1949, *zhongshan* suits continued to be popular among men, while dresses gained popularity among women.

start of the Great Cultural Revolution, most men still wore *zhongshan* whilst women started donning long jackets and pants. During the mid , modern clothing that emphasized original styles and bold colors began accepted by more people. This trend continues today.

THIS PAGE
A groom's mother decorates the delivered wedding dress before a wedding ceremony in a village along the route to the Sayram Lake

FACING PAGE (CLOCKWISE FROM TOP LEFT)
A Tibetan lady near the town of Xining; A girl spinning dyed raw silk before weaving in Hotan; Make-shift clothing stalls in a bazaar; A tibetan lady greeting a visitor near the town of Xining; Make-shift clothing stalls in a bazaar; ibid

FOLLOWING SPREAD pp.114-115
Scenes from various cultural performances

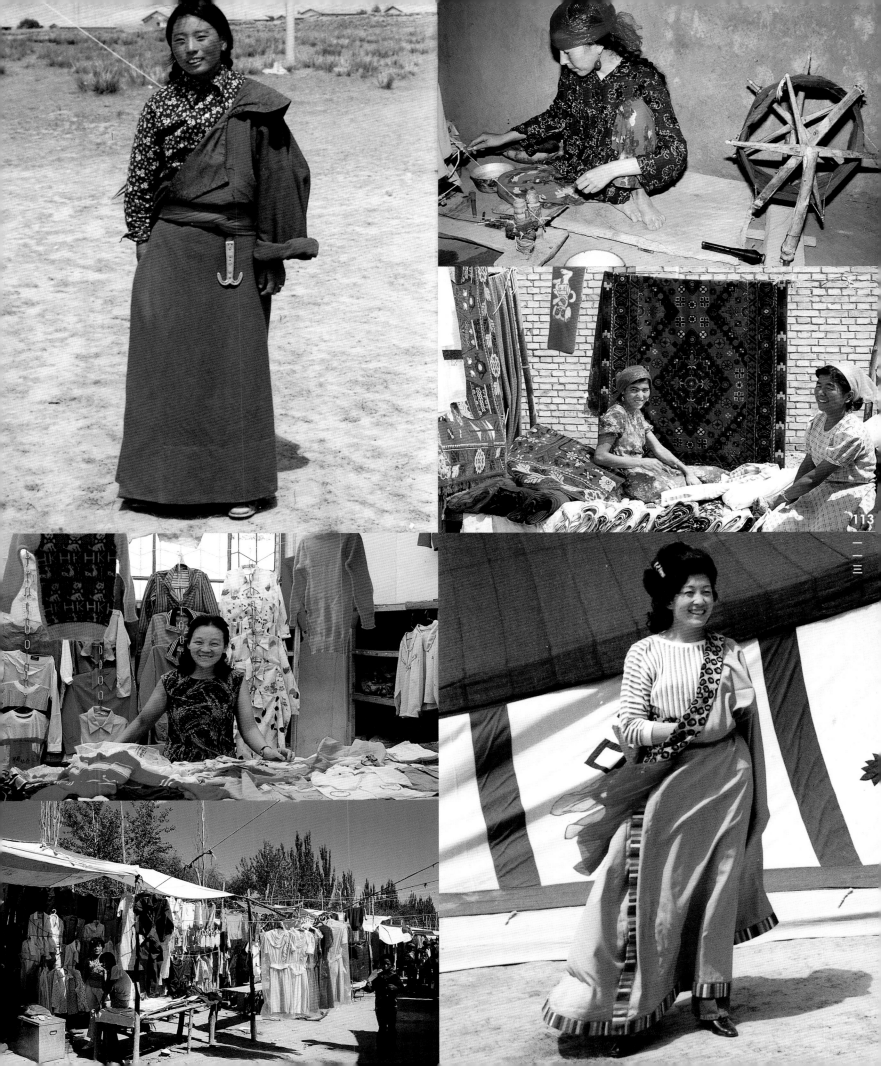

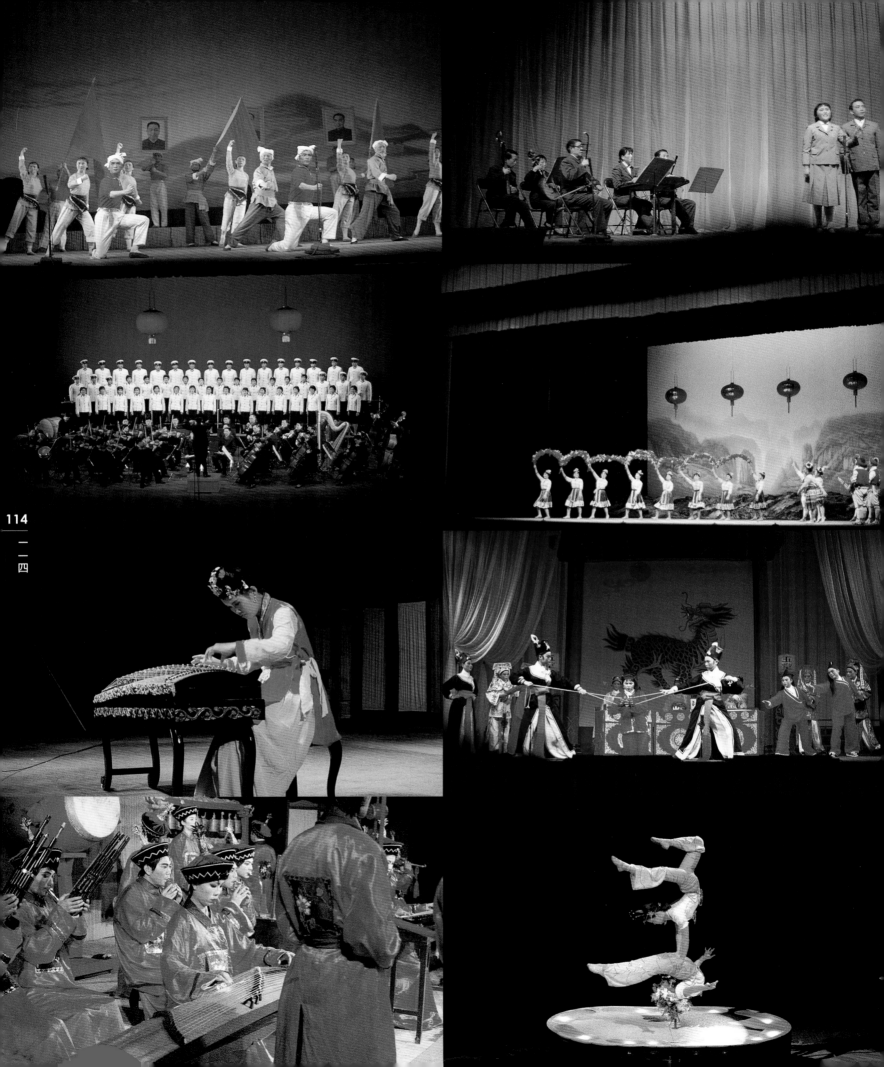

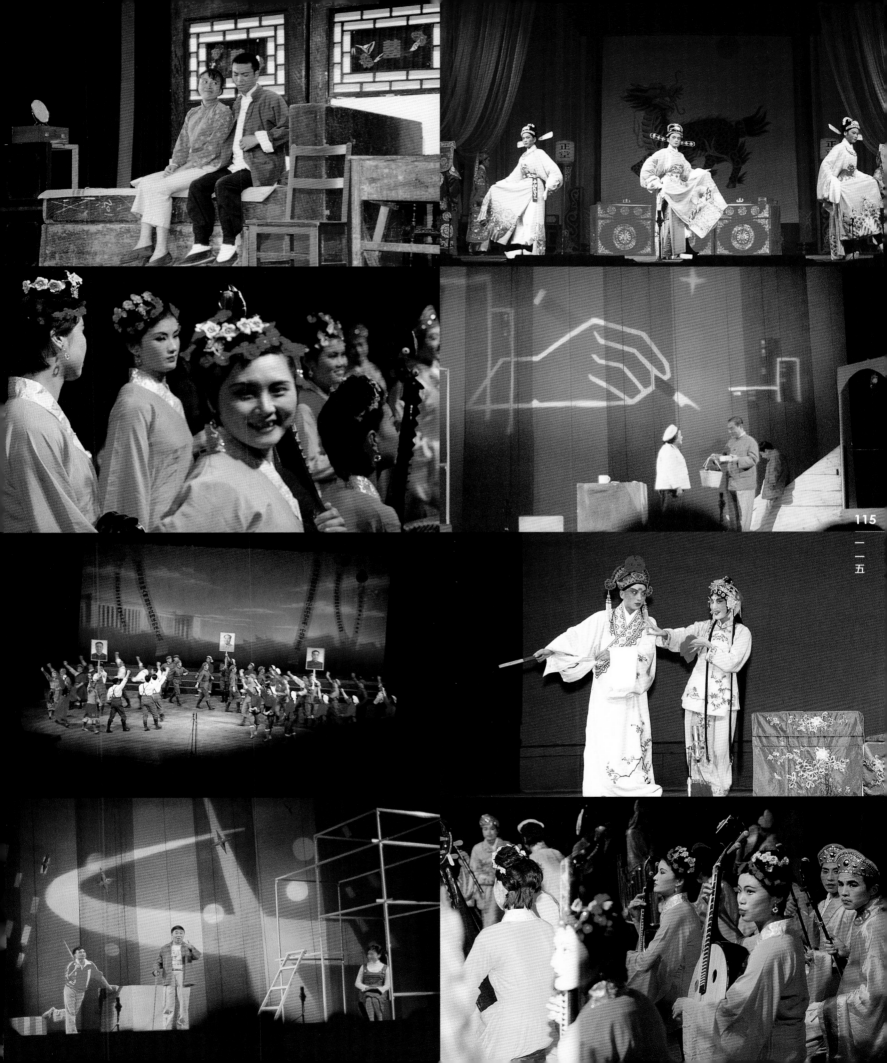

chapter four

NATURE

A symbiotic relationship exists between Man and Land—the earth upon which one sets foot is also the earth that feeds under one's faithful toiling. While China is traditionally an agricultural society, the land does not merely sustain one physically; it nurtures one spiritually and culturally as well. In a vast land like China, we find many types of landscapes existing throughout the country, each of which is unique and particular to the inhabitants of the region.

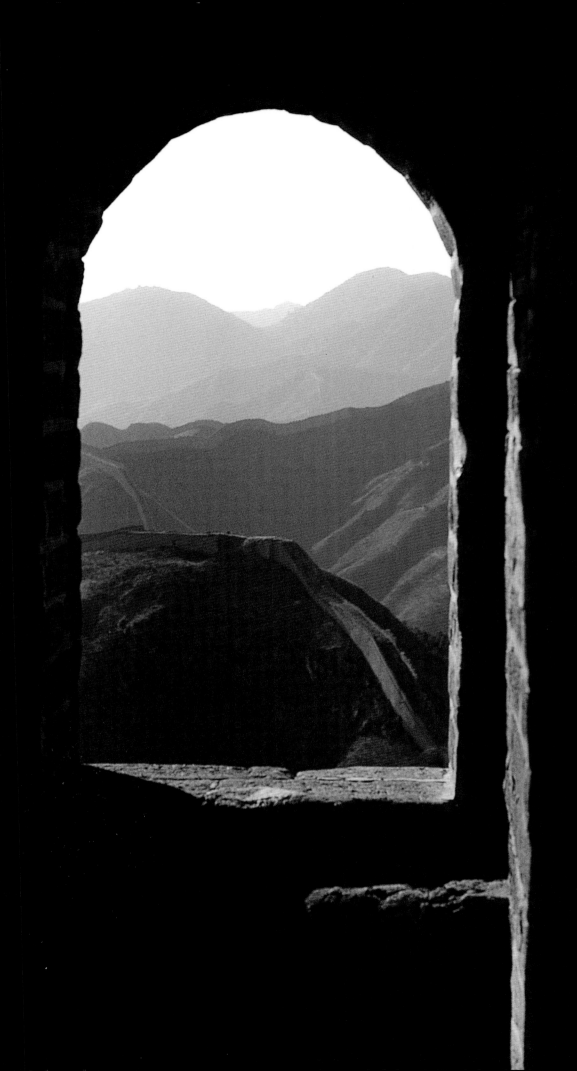

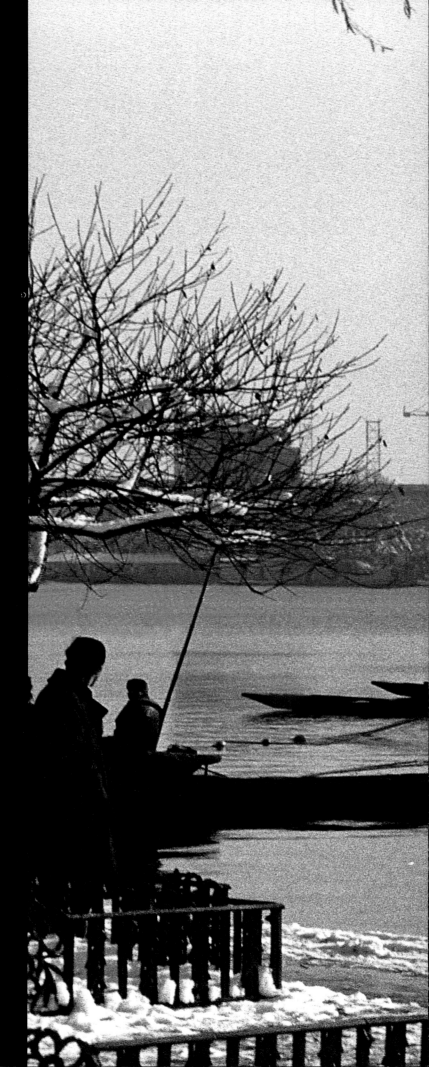

NATURE
climate . landscapes . animals

CLIMATE

In the Chinese language, the character 天 (*tien*), has multiple meanings—it can mean the sky, the day, the heavens or the natural orders of life. This single character like most other Chinese characters, has several different implications, each of which can be quite different from another. On a similar note, because of the extent of China's land area and multitude of differences in its topographical landscape, there are many climatic conditions in China alone. These climates experienced across China differ from one region to the next and they, too, can be quite diverse and extreme.

China is basically divided climatically into three main regions—the East Monsoon Zone, the Northwest Arid/Semi-Arid Zone and the Qingzang Cold Highland Zone. As a result of these varied conditions, the inhabitants of China have adapted their architecture and lifestyles to the environments of the different regions. Thus, in addition to diverse weather conditions across China, different dialect and cultural influences are also contributing factors to the kaleidoscopic set of living environments, unique to each of the different regions across China.

East Monsoon Zone The East Monsoon Zone lies to the east of the Daxing'anling Ridges and south of the Inner Mongolian Highland. It is on the eastern side of the Qingzang region, straddling between the inner highlands and the ocean. This zone encompasses the eastern regions of China and here, we can find the Huangtu Plateau, the Sichuan Basin, the Yungui Plateau and mountain ranges. It covers approximately 45% of the country's land area and is settled by 95% of the population. A large part of this region is approximately 3,250 feet above sea level while the areas further to the east comprise great fields at 1,650 feet above sea level.

During summer, the southwest monsoon brings about many notable changes in the weather, causing abundant rain and high temperatures. In winter, most parts of the region are cold and dry, influenced by the cold continental winds from the north. A large part of this region is covered in forests, and hence, the floral and faunal life is amazingly rich. At the same time, the region is abundant in natural resources as several major rivers run through here, which include the Changjiang (Long River) or Yangtze River, Huanghe (Yellow River), Zhujiang (Pearl River), Songhuajiang (Songhua River), Liaohe (Liao River), Haihe (Hai River) etc.

THIS SPREAD
Fishermen casting their nets in the morning at Xihu (West Lake)

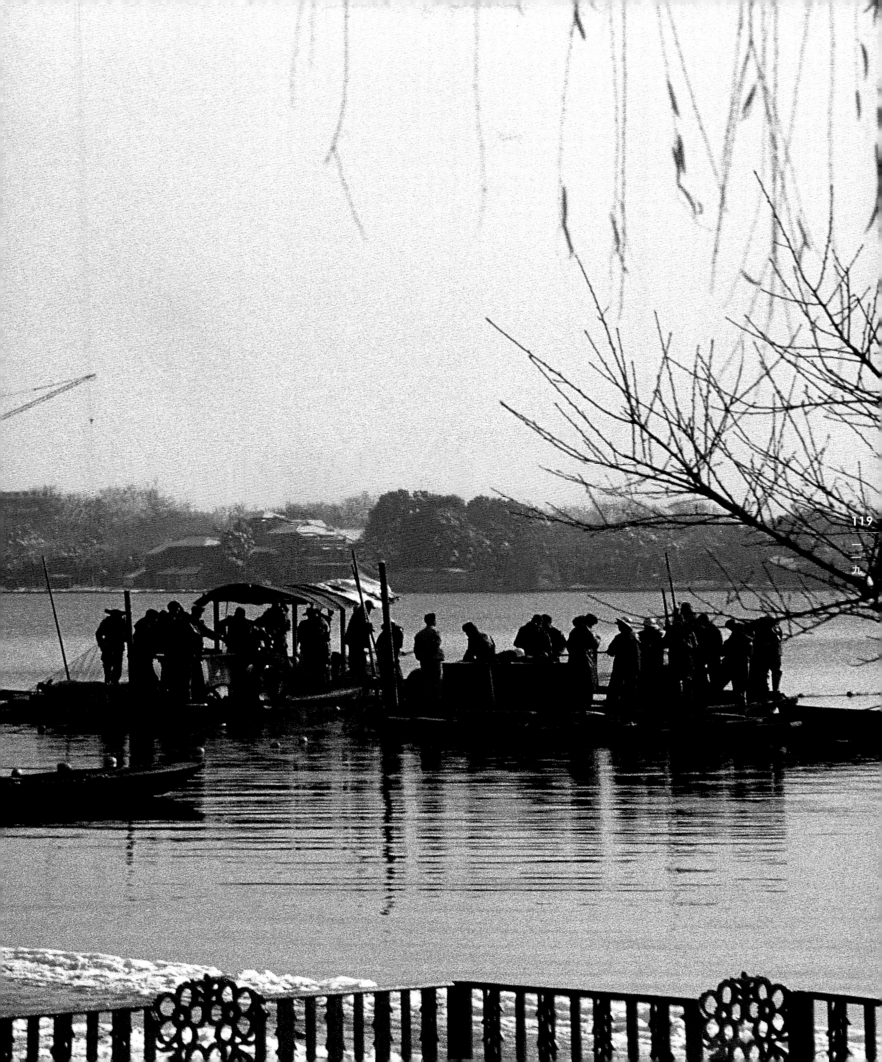

Northwest Arid/Semi-Arid Zone The Northwest Arid/Semi-Arid Zone is represented by the north-western regions of China, bound by lines formed by the Daxing'anling Ridges in the west, the Kunlun-Aherjin-Qilian mountains in the south and the Great Wall in the north. We can find mountain ranges of over 10,000 feet above sea level as well as an inland basin of 800 to 1,600 feet above sea level in this highland zone. Covering 30% of China's land area and settled by 4% of the population, it is the region where the low-lying Turpan Depession, known as the "Oasis of Fire," can be found. This is the hottest area in all of China. The lowest point of the Aydingkol Lake at the Turpan Basin—the second lowest lake in the world—is 500 feet below sea level.

As this region is situated deep within the inlands of the Eurasian continent, the effects of seasonal winds are less felt here. The climate is dry and a wide range of temperatures is registered during different parts of the day. Much of the land of this region is characterized by grassy plains, interspersed with deserts and extensive barren areas. While there are many inland rivers and short streams, there is also a high proportion of swamps and a number of large lakes, most of which are saline. As fresh water is essential to the cultivation of plants and crops, coupled with the fact that a large part of this region is non-cultivatable grass plains or wastelands, agricultural development has remained nearly non-existent.

Qingzang Cold Highland Zone This refers to the remote south-western extremity of China bounded by the Kunlun-Aherjin-Qilian Mountains in the north, the Himalayan Mountains in the south, the cross-mountain ranges in the east, and the country border in the west. The landform is mainly mountainous ranges with towering peaks. It covers 25% of China's land area and contains 1% of its total population.

On the average, the Qingzang Cold Highland Zone is about 13,000 feet above sea level. There are some peaks that are more than 23,000 to 26,000 feet above sea level. As a result, the air here is thin and temperatures are typically low. Permafrost occurs in the soil in a large part of this region. Due to the harsh climate, the population here is also very low. Where populated, the people generally engage in stock farming, with only a small proportion involved in forestry and food cultivation.

FACING PAGE (CLOCKWISE FROM TOP LEFT)
Bao of the Kirghiz ethnic minority group at Dalong Lake; A farming village in Yinchuan Lanzhou; Barren land in the arid mountains of Urumuqi Turpan; Ruins at the foot of a mountain near Dalong Lake; The Lan Pavilion at Shaoxing; Rivers—the cradle of life; A farming village in Taoshan; The snow-capped mountains of Tianshan

FOLLOWING SPREAD pp.122-123
The Ulungar Lake, surrounded by white sands, in the mountainous Pamir Range

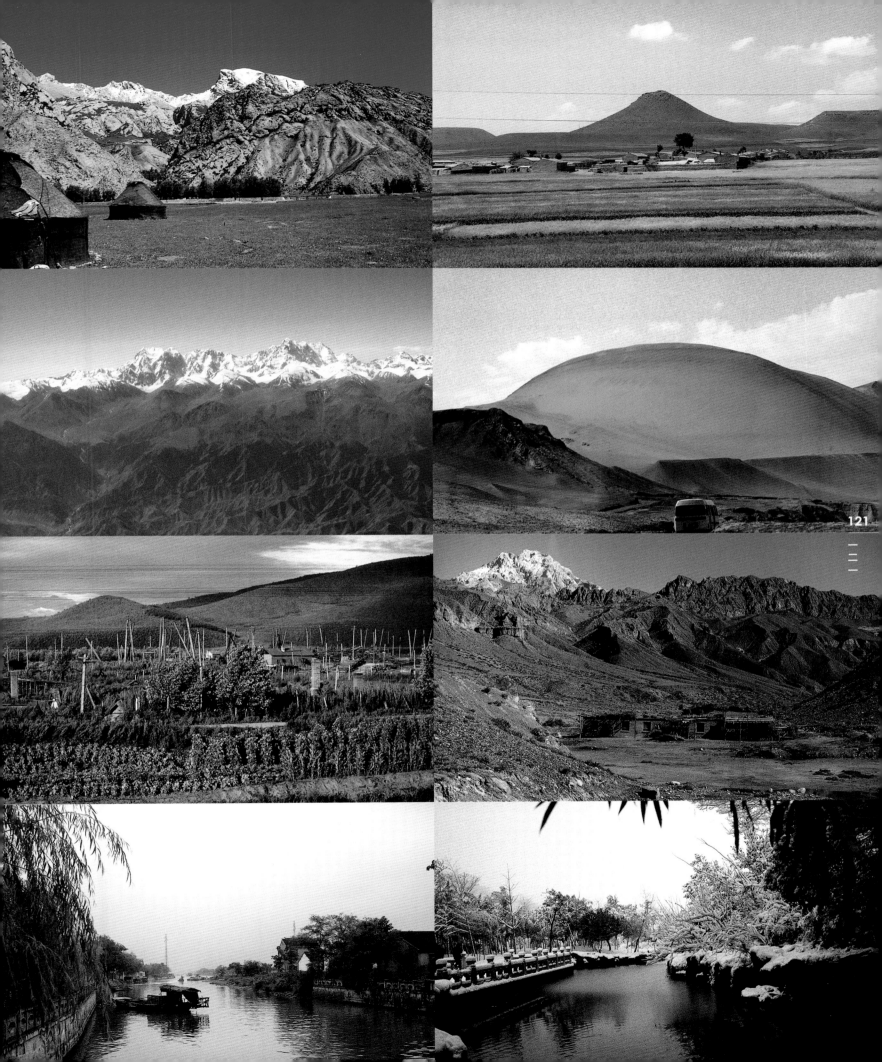

121

LANDSCAPES

MOUNTAINS

With more than two-thirds of its total land area covered by mountains, plateaus and hills, and with the remaining areas divided into basins and plains, China's landform ranges widely and dramatically. As such, the beauty of China's landscapes—with their towering ridges and deep basins—has inspired great Chinese art and poetry since ancient times.

China's topography consists mainly of highlands—a third of China's total land area is made up of mountains alone. According to ancient beliefs, mountains, especially the tallest ones, were pillars separating heaven from earth. Also regarded as connectors between heaven and earth, mountains are commonly associated with religious beliefs and are the sites of many temples and pilgrimages. With 7 of the 8 highest peaks of the world located in China, man appears diminutive in the midst of their greatness. The mountain systems in China run mainly northeast-southwest or east-west, and because of this topographic feature, many rivers and streams run in an east-west direction, with the majority heading eastwards.

Wuyue (Five Great Mountains) Since the beginning of the Yellow River civilization in the Han era, the Central Plains have remained the cradle of development of the Chinese culture. The Chinese people have revered the Wuyue (Five Great Mountains) of the Central Plains as sacred mountains since long ago. The five great mountains are differentiated by their relative positions—Dongyue Taishan in the east, Xiyue Huashan in the west, Nanyue Hengshan in the south, Beiyue Hengshan in the north and Zhongyue Songshan in the center—and all together they are said to resemble a flower blossom.

Dongyue Taishan Composed primarily of gneiss—banded metamorphic rock composites—Taishan sits within a fault-block mountain district located in the Shandong Province. Standing at 5,070 feet, the scenery from the ridges is breathtaking. Successive emperors in the history of China had performed royal crowning or burial services at this sacred place. Dongyue Taishan—the most famous among the Wuyue Mountains—has many ancient sites with numerous stone monuments. The many temples there have also become increasingly popular with tourists and visitors.

Xiyue Huashan Xiyue Huashan is situated in the east of the Shanxi Province. Part of the Tailingshan Mountain range, it is a fault mountain district formed by granite rock. At 6,550 feet above sea level, the multiple granite rock peaks are indeed a spectacular sight to behold.

Nanyue Hengshan Nanyue Hengshan in the Hunan province is, like Huashan, also a fault-block mountain composed of granite rock. With as many as 72 peaks, the most famous of them are Zhurong Main Peak, which rises 4,232 feet in height, as well as Tianzhu, Yurong, Jigai and Shilin.

Beiyue Hengshan Beiyue Hengshan is sited in the northeastern part of Shanxi Province, like Huashan. The main peak is Xuanwufeng, which is 6,617 feet above sea level. Historically, it has also served as a defense fortress against northern invaders.

Zhongyue Songshan Zhongyue Songshan is in Henan Province. As it is situated in the center of the Central Plains, it is called the Zhongyue (Mountain of the Center). The three high peaks are the Taishishan in the east, Junjishan in the center and Shaoshishan in the south. Shaolin Temple, the birthplace of the Shaolin style of martial art, is located at the northern foot of Shaoshishan.

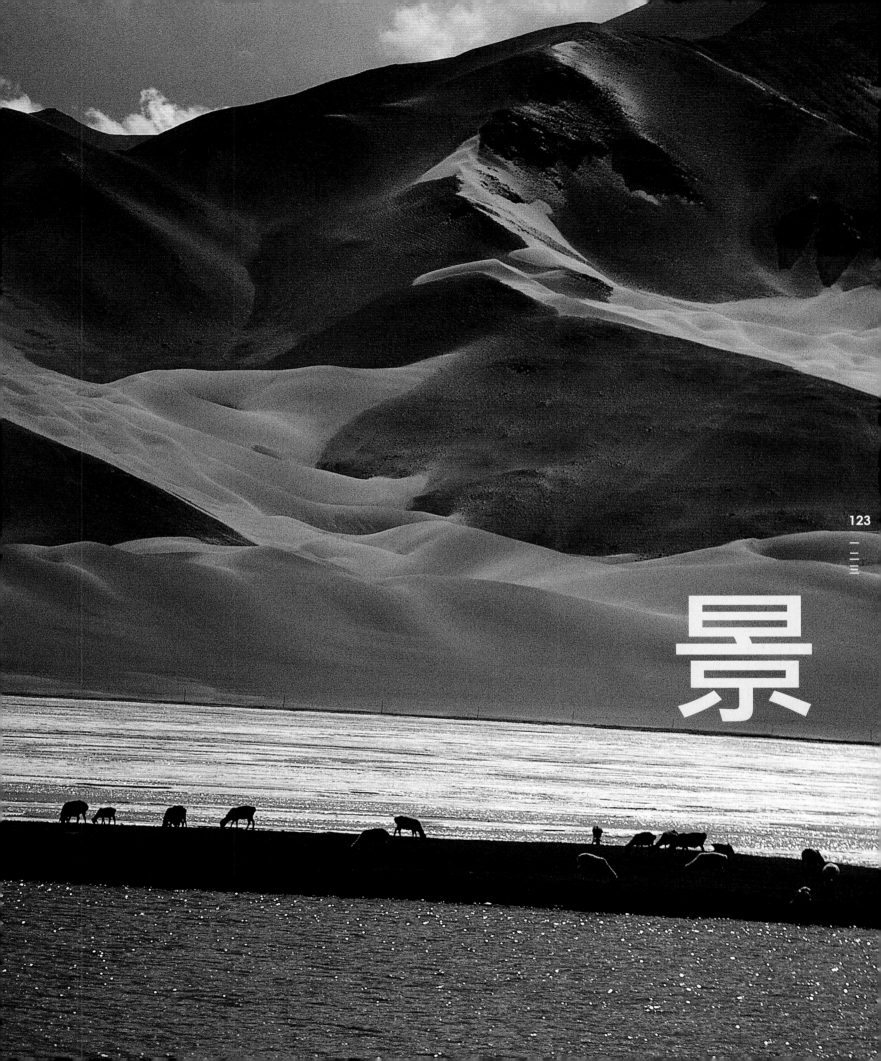

景

Four Major Sacred Mountains of Buddhism

China, where Buddhism is widely practiced, holds many sacred grounds. Among these sacred places of Chinese Buddhism are four major ones, known collectively as the *sidalingchang*, or the four sacred mountains of Buddhism. The *sidalingchang* consists of Wutaishan, Putuoshan, Jiuhuashan and E'meishan.

Situated in the Shanxi Province, Wutaishan (Mt. Wutai) is also known as Qingliangshan (Refreshing Mountain) as it is also popular as a summer resort. The highest peak is Yedoufeng, which is 10,030 feet above sea level and consists of five connected smaller peaks. Since the Han era, Wutaishan has acted as a religious center for Chinese Buddhism. Forty-seven temples are located there. Among them, the more famous include the Xiantong Temple, Tayuan Temple, Pusa Temple, Shuxiang Temple and Luohou Temple, which are also known as the Wutaichansi (Wutai Holy Temples) of Wutaishan. Wutaishan is the sacred place to Wenzhu Bodhisattva.

Putuoshan (Mt. Putuo) is an island among the Zhoushan group of islands in Zhejiang Province. The highest peak is Fodingshan, which stands at 956 feet above sea level. Legend has it that In AD 916, a Japanese monk, Hui'e, made a pilgrimage to Wutaishan. On his return, Hui'e took with him a Guan Yin statue. However, on the journey, the monk was caught in a typhoon. Fortunately, he survived this and drifted ashore to Putuoshan.

In gratitude, the monk paid homage to Guan Yin on this island. Subsequently, this legend was popularized and the island became known to all as the holy grounds of Guan Yin Bodhisattva. The three most important temples on Putuoshan are Puji, Fayu and Huiji. Each building is an impressive structure of intricate detailing and construction.

Jiuhuashan (Mt. Jiuhua) is located in the Qingyang District of the Anhui Province. The mountain has 99 peaks. The main peak, Shiwangshan, is 4,403 feet above sea level. There are many mountain streams, rocks, waterfalls, caves, pines, and bamboo. The 78 temples house 1,500 Buddhist statues. The Huachengshi of Jiuhuashan has been a famous old temple since the mountain was opened up. It is known as the sacred ground of Dizang Bodhisattva.

Located in E'mei District of the Sichuan Province, E'meishan (Mt. E'mei) is known as the sacred ground of the Puxian Bodhisattva. The main peak, Wanfoding, is 10,167 feet above sea level. At the foot of the mountain is Baoguo Temple and Fuhu Temple. Halfway up the mountain one can find Wannian Temple, Hongchunping, Fofeng Temple and Zhongfeng Temple, which add much color to the scenery formed by the various peaks and valleys. At the top of the mountain, there are many temples, including the Woyun Temple—an especially well-known site for spectacular views.

THIS SPREAD
(LEFT and RIGHT images) Picturesque landscape of China

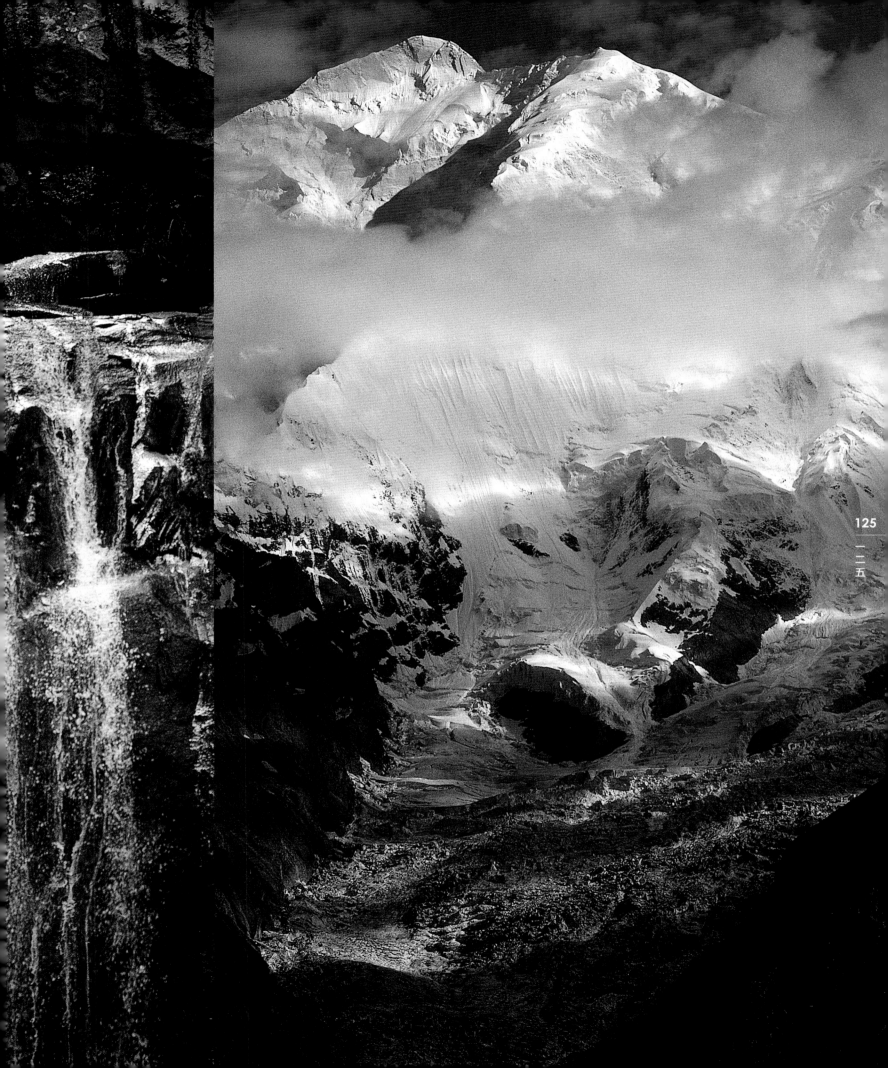

LAND

A symbiotic relationship exists between man and land; the earth upon which one sets foot is also the earth that feeds under one's faithful toiling. While China is traditionally an agricultural society, the land does not merely sustain one physically; it nurtures spiritually and culturally as well. In a vast land like China, many types of landscapes exist throughout the country, each of which is unique and particular to the inhabitants of the region.

Stone Forests One of the interesting features of China's landscape is the *shilin* or "stone forest," and at Kunming in central Yunnan, north of the Dianchi Basin, you will find the famed *shilin*—a vast collection of limestone pillars that reveal many stories with their elaborate forms. Believed to be a seabed 270 million years ago, judging from the marine fossils found here, this region has subsequently risen to the surface. In these stone forests, you will find graceful columns of limestone that have weathered through the centuries under the forces of wind and rain, carving them into the various poetic forms that we see today. At 65 to 100 feet high, each pillar exhibits a different sense of exquisiteness and beauty.

Limestone Caves Under changing temperatures and pressures and the erosive actions of underground rivers and lakes, seams of coal measures and limestone have, under the hands of nature, cut a beautiful karstic landscape in Guilin of the Guangxi Basin. There is the saying that goes "*Guilin shanshui tianxia diyi*"—Guilin scenery is the best in the world. In Guilin, one can see hills of coal measures standing close together. Often, along the riverbank, one will catch sight of the many pine trees perched precariously off steep cliffs, like a Chinese landscape painting come to life. In Guilin, the abundant underground water has sculpted numerous caves of stalagmites and stalactites in the region, the magnificent sights truly demonstrating the powerful artistry of nature. Limestone caves occur as a result of water containing dissolved carbon dioxide that gradually seeps into crevices found along coal measures and erodes them. When in Guilin, a visit to the famous limestone caves Qixingyan (Qixing Cave) and Ludiyan (Ludi Cave) is a must.

Deserts Much of the northwestern part of China is covered by deserts, such as the Taklimakan, Gurbantunggut, Mu'us Deserts etc. At an area of 130,500 square miles, Taklimakan Desert is the largest desert in China, accounting for 47% of China's total desert landmass. Floating sand dunes, some as high as 1,000 feet, account for 85% of the desert area. The southeast and northwest winds have shaped sand dunes in various fashions and sizes, including crescent, pyramid, lattice-shaped or a combination of the various shapes.

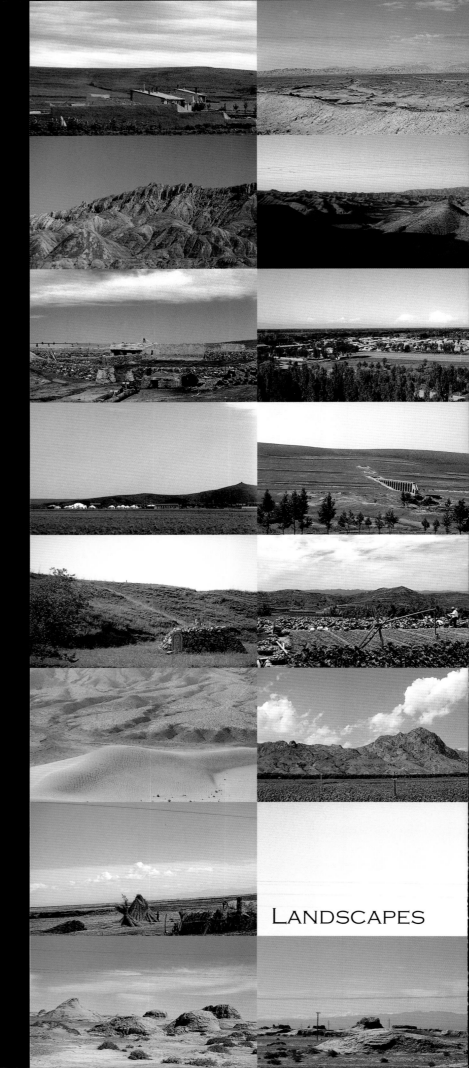

THIS SPREAD
Images of landforms and terrains across China

LANDSCAPES

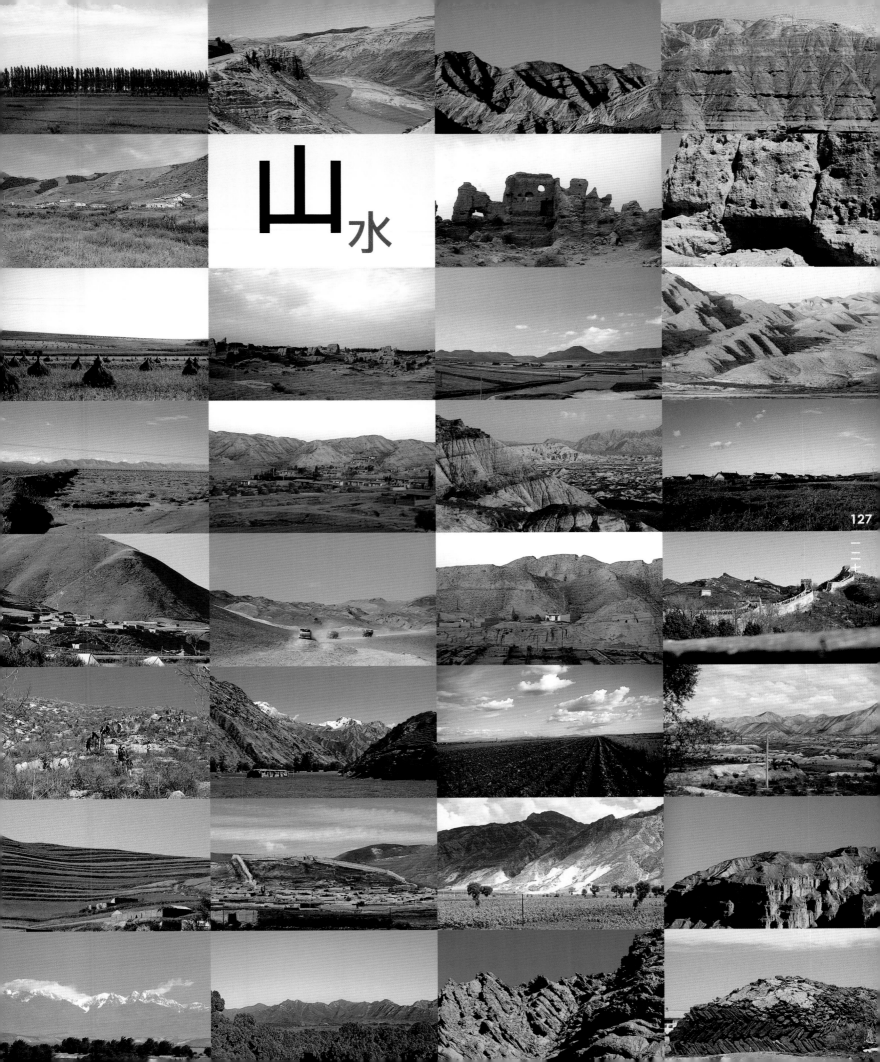

山水

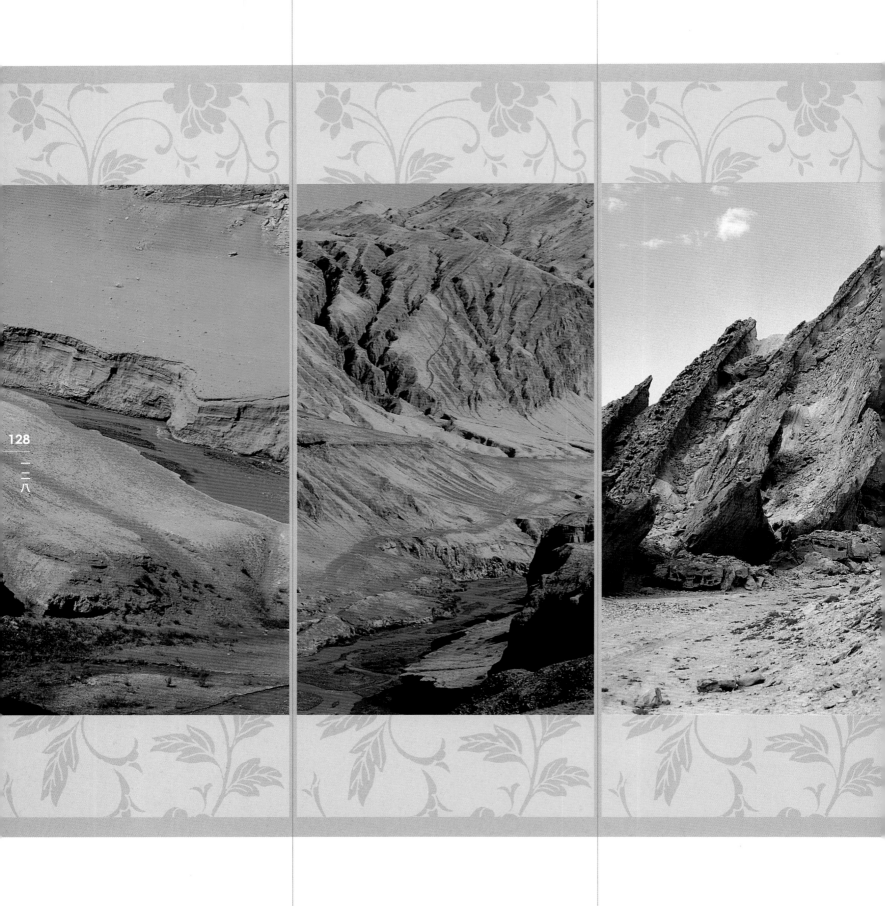

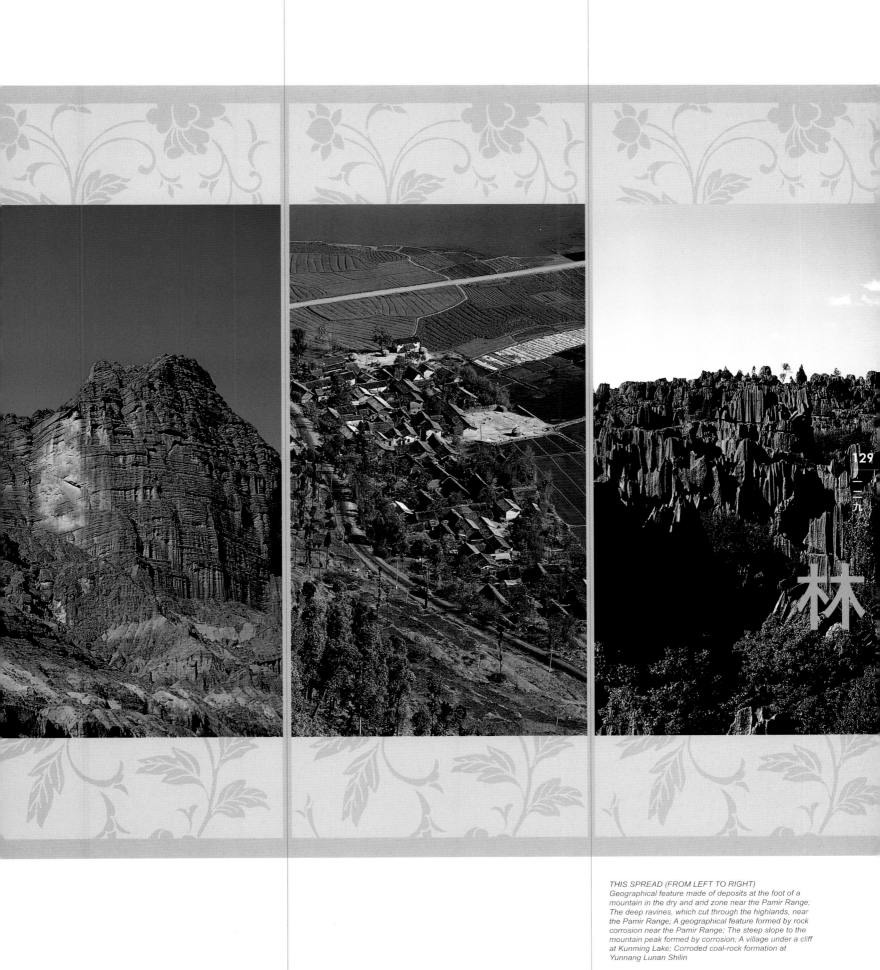

129
一二九

林

THIS SPREAD (FROM LEFT TO RIGHT)
Geographical feature made of deposits at the foot of a
mountain in the dry and arid zone near the Pamir Range;
The deep ravines, which cut through the highlands, near
the Pamir Range; A geographical feature formed by rock
corrosion near the Pamir Range; The steep slope to the
mountain peak formed by corrosion; A village under a cliff
at Kunming Lake; Corroded coal-rock formation at
Yunnang Lunan Shilin

RIVERS

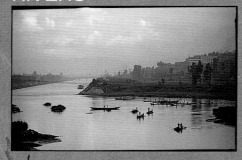

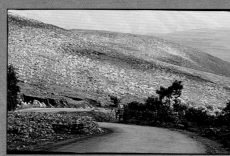

THIS PAGE (CLOCKWISE FROM TOP LEFT)
A creek; A branch of the Yellow River (Huanghe);
Wujiang River in Minjiang; The Yellow River (Huanghe);
A branch of Jinshajiang; A branch of the Yellow River
(Huanghe)

FACING PAGE (CLOCKWISE FROM TOP LEFT)
Qinghai Lake; Xiangjiang; Dalong Lake; A river bank;
The Three Gorges; Lijiang

Water is not only a fundamental element in the Chinese landscape, it also encapsulates the way of life of the Chinese. Rivers have, throughout history, provided a source of livelihood for the people. Many of them have formed the greatest of waterways, and have brought civilization and cultural development to the lands through which they run. The number of rivers that run throughout China is great. More than 1,500 rivers in China have a basin area of over 350 square miles. Most flow towards the east, along the undulating landform across China into the Pacific Ocean. The main rivers of China are: Changjiang (Long River) or Yangtze River, Huanghe (Yellow River), Heilongjiang (Black Dragon River), Zhujiang (Pearl River), Liaohe (Liao River), Huaihe (Huai River) and Qiantangjiang (Qiantang River).

Changjiang (Long River) or Yangtze River The longest river in China, Changjiang or Yangtze River, rises from the south-western parts of the Qinghai Province and flows into the East Ocean at Shanghai. In its course, it passes through Tibet, Yunnan, Sichuan, Hubei, Hunan, Jiangxi and Anhui. The full length of the river is 3,915 miles. The basin has an astonishing area of 695,000 square miles. The river is naturally advantageous to sailing and navigation. Not surprisingly, it has been the main artery for water transportation since ancient times.

Huanghe (Yellow River) Huanghe is the second longest river in China. The river finds its source at the snowbound highlands of Qinghai (Qing Sea), and flows into Bohai (Bo Sea). At a length of 3,395 miles, an incredible amount of silt and sand pours into the Huanghe through its entire course. Flowing from the mountains into the Huabei Pingyuan (North China Plain), the speed of flow of the river is decreased drastically as it enters the Huabei Pingyuan, allowing silt and sand to deposit on the riverbed. This has resulted in the progressive increase in the height of the riverbed. At this time, it has become higher in sea level in comparison with the surrounding plains. Many towns and cities have developed along the middle to lower reaches of the Huanghe, giving rise to a center of development for Chinese culture. Known as the birthplace of the ancient Han civilization, the Huanghe can thus be said to be a "river of life" for the Han people.

Zhujiang (Pearl River) Estimated to be 1,323 miles long, Zhujiang is the longest river in southern China. It combines the three rivers of Xijiang (West River), Beijiang (North River) and Dongjiang (East River) and flows into Nanhai (South Sea). With the large river volume, Zhujiang has all the natural geographical conditions to develop a comprehensive river network, bringing great progress to the development of river transportation here.

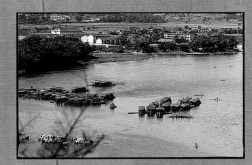
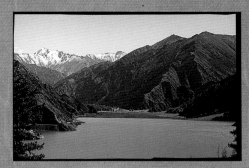

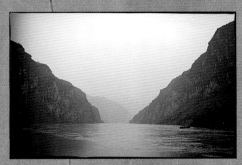

Dayunhe (Grand Canal) The Dayunhe (Grand Canal) has been the main source of transportation for servicing China's economic centers in the south and the administrative and military centers in the north since ancient times. Forming an important link between the Huanghe and Changjiang, it was opened for transportation by the Emperors Wendi and Yangdi in the Sui Dynasty (AD581-617). The construction of this canal, made possible only through the conscription of manual labor, was painfully long and grueling, which eventually led to the fall of Yangdi. Measuring 1,119 miles in total length, this is also believed to be the longest man-made canal in the world.

Sanxia (Three Gorges) When the Changjiang or Yangtze River flows from Sichuan basin into the eastern plain, it cuts squarely across the Wushan Mountain Ridge, which runs from the north to the south. The long and constant erosion by the Yangtze River has scored deep valleys in the land. The three valleys of Qutangxia (Qutang Gorge), Wuxia (Witch's Gorge) and Xilingxia (Xiling Gorge) extend from the upper reaches, and are collectively called Sanxia (Three Gorges). The famous Baidicheng (White Emperor Castle), located at the entrance to Qutangxia, was where Liu Bei (Xuan De)—the hero who founded the country of Shu during the War of the Three Kingdoms—spent the last days of his life.

There are many steep cliffs rising sharply from the banks of Qutangxia, which create a visually arresting and impressive sight. At the center of Sanxia, a Wuxia tributary cuts up Wushan mountain, creating three small ravines—Longmenxia (Dragon's Gate Gorge), Bawuxia (Misty Gorge) and Dicuixia (Emerald Gorge)—which have come to be known as Xiaosanxia (Three Lesser Gorges). The view here is somewhat different from along the main stream. The scenery appears quite different in different light and weather conditions. Along Wuxia, many strange crags stand upon both sides of the banks, creating a surreal and mysterious atmosphere. Xilingxia, which passes through the most complex landform, has the strongest water current.

Raising much controversy in recent years is the Three Gorges Dam project, which commenced work in 1994 and is expected to be completed by 2009. The total investment is estimated to be 150 billion yuan and it will involve the relocation of 1.13 million inhabitants. Known as the world's largest construction project, the 575-foot-high dam will create a great lake that extends 375 miles upstream, foreseen to yield enormous benefits in electricity generation, flood control and water transportation.

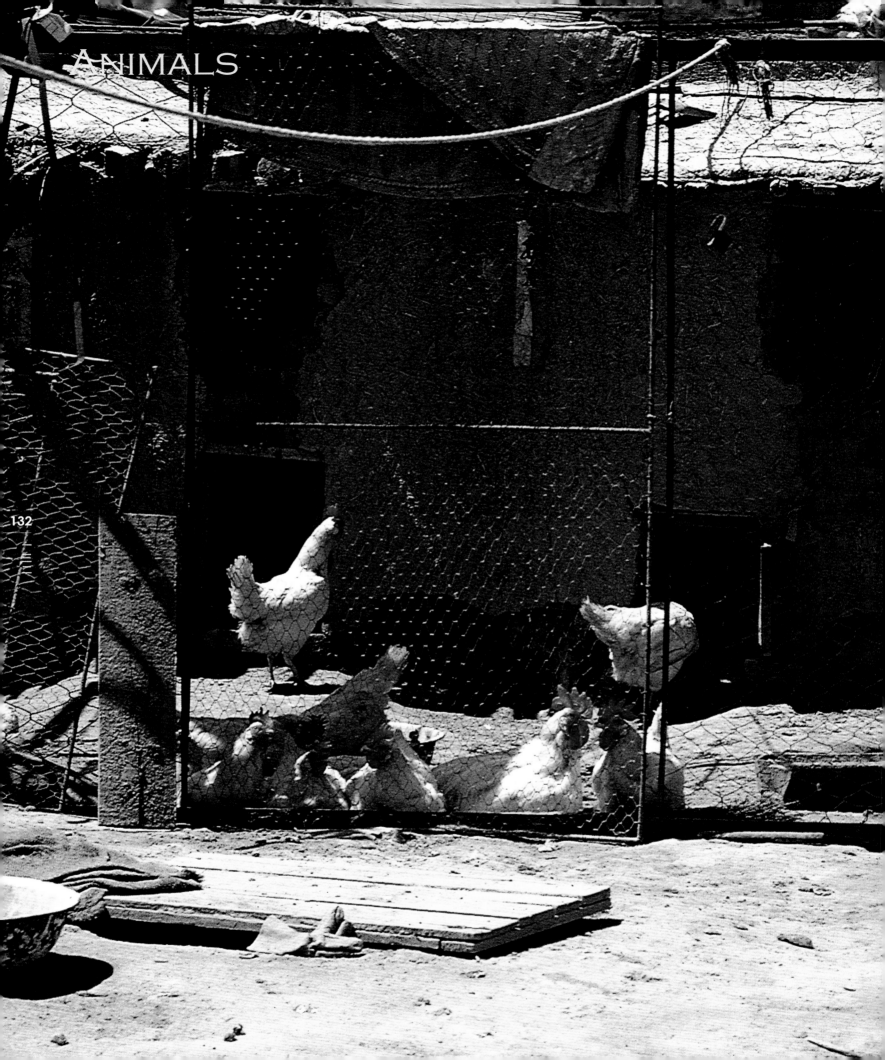

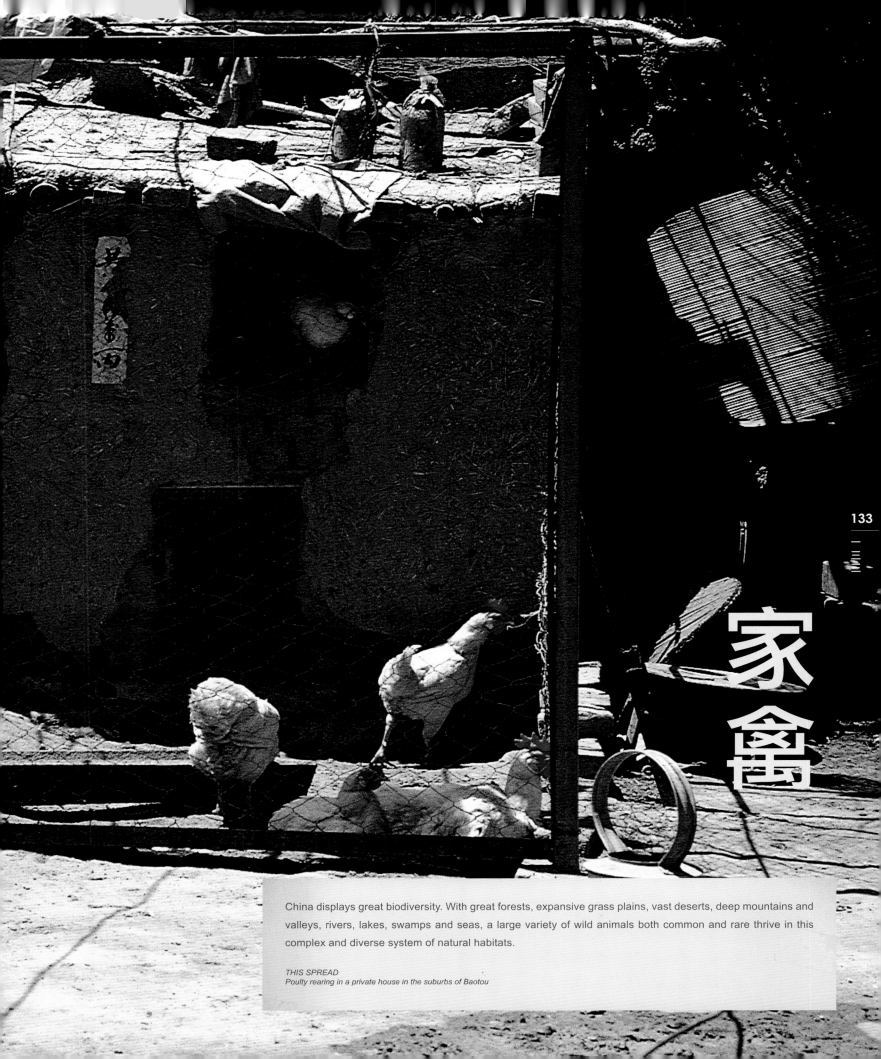

家禽

China displays great biodiversity. With great forests, expansive grass plains, vast deserts, deep mountains and valleys, rivers, lakes, swamps and seas, a large variety of wild animals both common and rare thrive in this complex and diverse system of natural habitats.

THIS SPREAD
Poulty rearing in a private house in the suburbs of Baotou

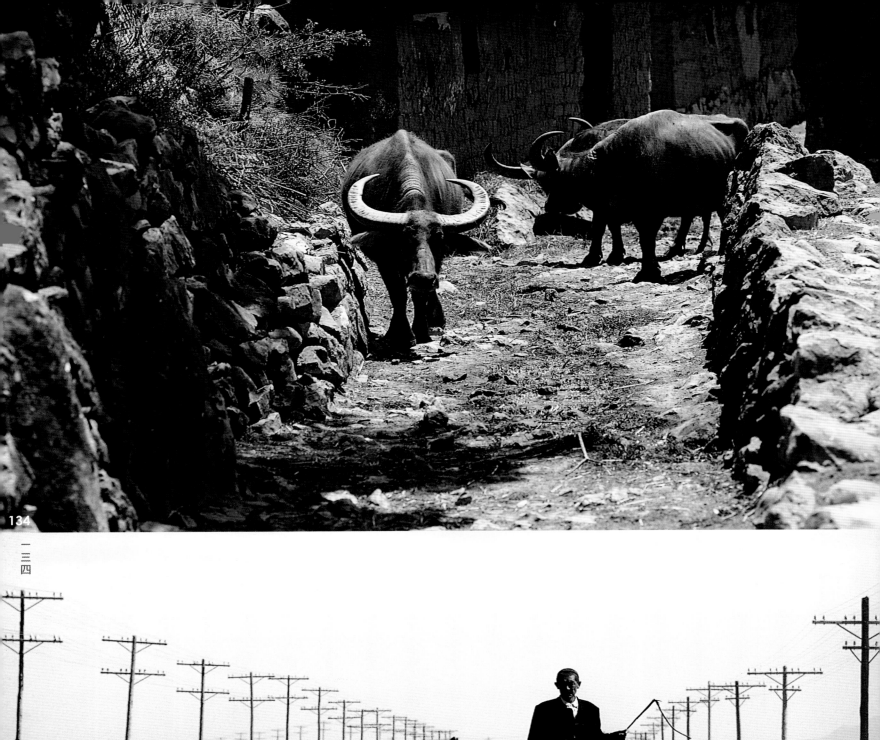

一
三
四

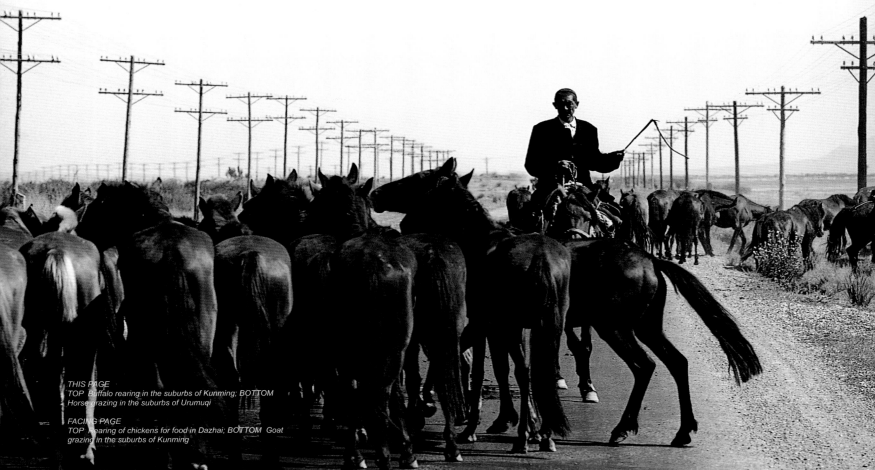

THIS PAGE
TOP Buffalo rearing in the suburbs of Kunming; BOTTOM
Horse grazing in the suburbs of Urumuqi

FACING PAGE
TOP Rearing of chickens for food in Dazhai; BOTTOM Goat
grazing in the suburbs of Kunming

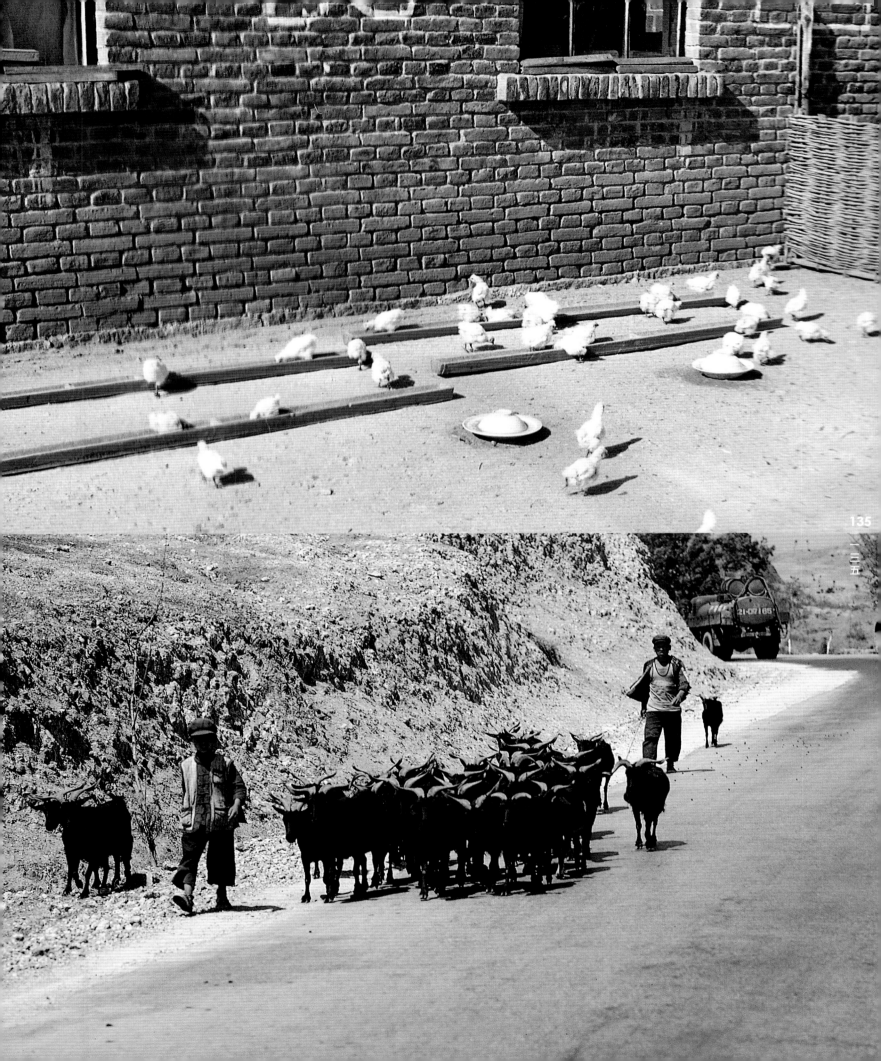

The following are some of the animals that are typically found in China:

Xiongmao **(Giant Panda)** Known as *xiongmao* in Mandarin, which literally translates as "bear cat," this animal bears a curious resemblance to both bears and cats. In reality, however, it behaves like neither. Like a stuffed animal, it is covered in fine black and white fur. Found only in China, the panda is considered a national treasure of the country. It resides in deep mountain parts near the border of the Sichuan Province, south of the Gansu Province and the eastern part of Tibet. Although carnivorous by nature, breeders have transformed the panda's diet into a plant-based one. Young bamboo is among the panda's favorite type of food. Currently, it is estimated that there are just over 1,000 live pandas in China. As such, ten protective districts have been set up throughout the country to protect and breed this endangered species. Almost every zoo in the major cities of China now breeds the panda in captivity.

Baiji **(Yangtze River Dolphin)** The *baiji* is 8 feet in length, and sports a grey or light blue back and white abdomen. There are 130 teeth in its long beak. Breeding in the Dongting Lake and the middle and downstream reaches of the Yangtze River, it feeds on fish in the river. A highly endangered species, its numbers are estimated to be about 100 today.

Jinsihou **(Golden Monkey)** The matured *jinsihou* is about 20 to 30 inches in height and 45 to 65 pounds in weight. It has an upturned nose and sky-blue face, with white patches around the eyes. Deriving its name from the golden, soft hair covering its limbs, shoulders and back, the *jinsihou* is found mainly in the forests at the 10,000-foot highland area of the Xiaxi Province in Tailing. It resides in trees and survives on a herbivorous diet of fruit, leaves and buds. Being community animals, the *jinsihou* appoint amongst them a monkey chief. As they are agile and difficult to be spotted or captured alive, *jinsihou* are a "must-see" in zoos.

Dongbeihu **(Siberia Tiger)** Measuring more than 10 feet in length and weighing over 650 pounds, the Northeast Tiger is also given the title "The King of Beasts," as a pattern on its forehead resembles the character 王 *(wang), or* "king." It resides in the primeval forests in the north-eastern part of Xiaoxing'anling and also the Changbai Mountains. There are no more than 150 tigers alive today.

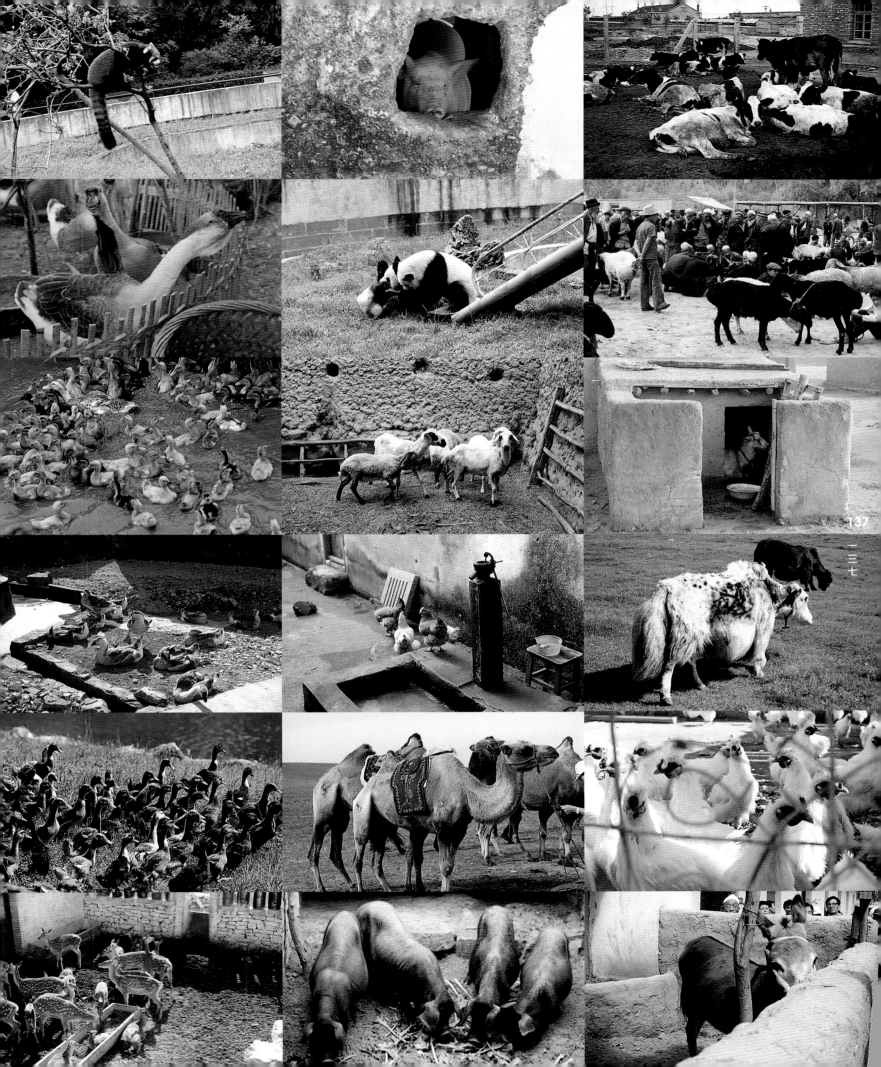

chapter five
SOCIETY

Within a short span of 20 years, China went into a flux greater than it has ever experienced in its 3000-year-old civilization. Now, over 36% of the population resides in the urban areas. Rapid modernization and industrialization has seen the skylines of Chinese cities change dramatically. High-rise blocks and skyscrapers in concrete, glass and steel now dominate over yesteryear's buildings of vernacular fashion.

FACING PAGE
Pictures of hairstlyes at a salon in Harbin

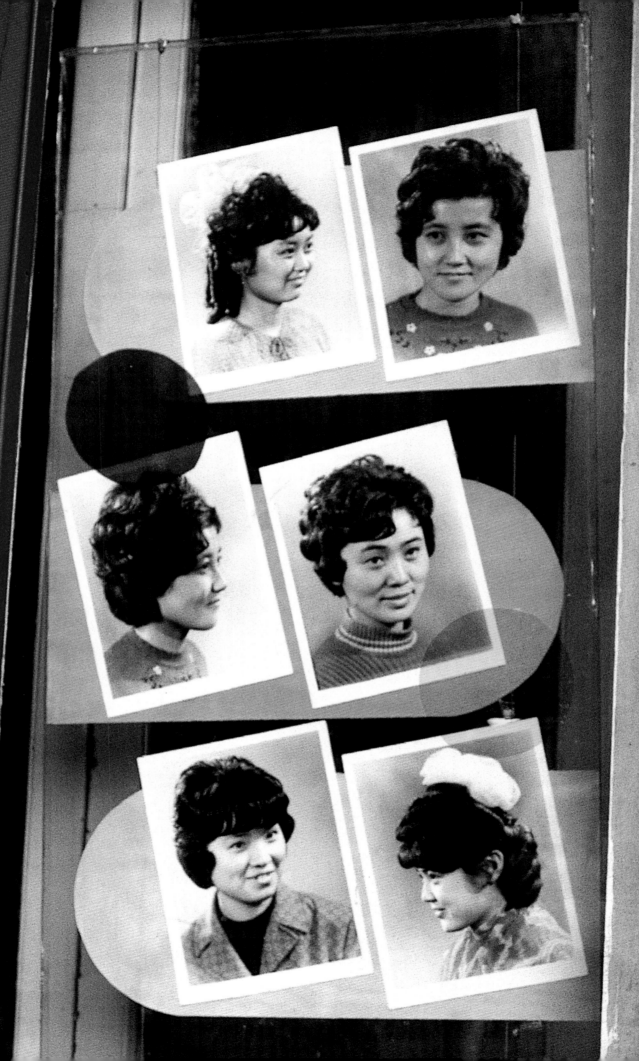

SOCIETY

city . religion . education

I have been visiting China since 1976. I started on my long quest from the northern regions, as I first wanted to see China from its political center— Beijing and its surroundings—and thereafter, slowly extended my sights southwards.

Chinese cities have transformed drastically after years of economic reform. Today, high-rise residential buildings are commonplace and remnants of history seem to be completely wiped out in these cities. However, while cities are flourishing, the development of rural China lags behind. As I look back now and draw a comparison between China and Japan, I would say that the rate of change in China is much more rapid than in Japan. I cannot help but notice tremendous change happening at alarming rates in the cities each time I visit China.

When China opened its doors in the eighties, little did anyone imagine the phenomenal growth that Chinese cities would experience. From 193 cities in 1979, the number of cities grew more than threefold to 668 in 1999. Within a short span of 20 years, China underwent a flux greater than it has ever experienced in its 3,000-year history. Now, over 36% of the population resides in the urban areas. Rapid modernization and industrialization have attributed to the dramatic change in its skylines. High-rise blocks and skyscrapers in concrete, glass and steel now dominate yesteryear's vernacular buildings. The political and cultural scars that marked the urbanscape have accumulated over the centuries. While being masked over, they still remain noticeable in a number of urban pockets—for now—before modernization and commercialization completely erase their physical trails.

Harbin, Heilongjiang Province In the Manchurian language, "Harbin" translates loosely into "the place for drying fishing nets." Russia's cultural influence on Harbin intensified after the Russian government seized power and extended the Siberian railway into northeastern China in 1896. They chose Harbin to manage the new section of the railway. By 1903, when the railway was completed, Harbin's population expanded quickly. A modern city was starting to take shape. However, Russia's influence declined following the Russian defeat in the Russian-Japanese War (1904-5), and nationals from sixteen countries settled in Harbin and set up several thousand industrial, commercial and banking companies. The Chinese also established their own businesses in brewing, foodstuffs and the textile industries.

Because of this cultural synthesis, we find European streetscapes painted unreservedly across this Chinese city. In fact, it has even been named the "Little Paris of the East." Flanking the tree-lined streets are many Russian-styled buildings. As many Russians dwelled by the sandbars of Songhuajiang (Songhua River), we can catch sight of the unique Russian streetscape in this area as well. The climate in Harbin is harsh and cold, and especially bitter in winter. The annual Ice Lantern Festival is a major event that should not be missed when in Harbin.

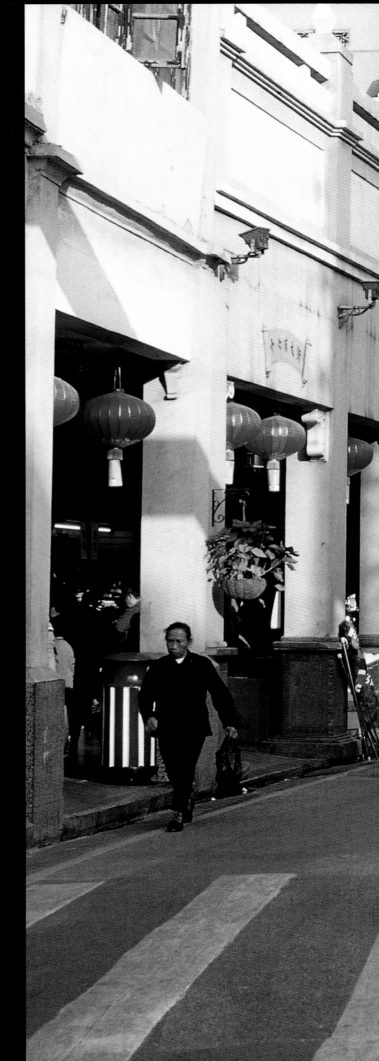

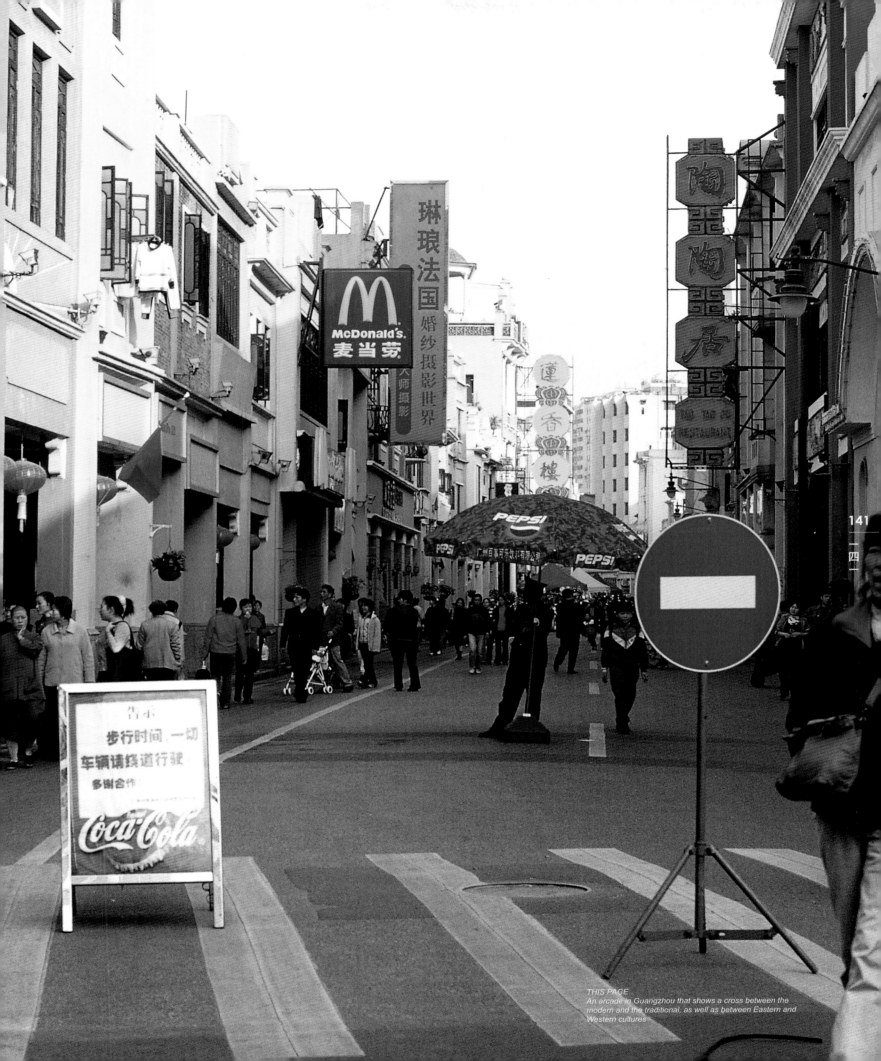

THIS PAGE
An arcade in Guangzhou that shows a cross between the modern and the traditional, as well as between Eastern and Western cultures

Changchun, Jilin Province Changchun, located northeast of Beijing, is the capital of the Jilin province. Located in the middle of the northeast plain, Changchun, or "Eternal Spring," was first settled more than 1,000 years ago. But it did not develop much until the turn of the 20th century. Changchun was the capital city of the "puppet" Manchurian administration in the years of Japanese occupation of the northeastern territories (1931-1945). Originally known as Xinjing (New Capital), it was renamed Changchun in October 1948. Many of the main buildings that remain in the city are remnants of the Manchurian era. The palace of the last emperor of the Qing Dynasty (1644-1911) Aixinjueluo Puyi, named deprecatingly "The Puppet Emperor's Palace," is now a museum for objects of the Japanese Occupation. Also in Changchun is a huge meteorite, thought to be the world's largest, that fell onto Jilin in 1976. The city is also known for its car manufacturing industry—the hugely popular "Red Flag" car is manufactured here.

Shenyang, Liaoning Province Shenyang is situated along the northern shore of the Shenshui tributary of Liaohe (Liao River). During the years between 1625 and 1643, it was called Shengjing (The Prosperous Capital). Subsequently, it was renamed Fengtianfu and eventually, Shenyang. The chief attractions of Shenyang include the Shenyang Imperial Museum, where there are many historical relics retrieved from the Beiling (North Mausoleum) and Dongling (East Mausoleum) of the Qing Dynasty. Up till this day, it is still possible to catch glimpses of the ancient city canal system from the former Manchukuo. The Liaoning Guesthouse and Shenyang Station are the other attractions.

Beijing The capital of the modern People's Republic of China, Beijing has held an important place in history as the center of administration since the Yuan Dynasty. The numerous palaces, gardens and temples constructed in the Yuan and Ming Dynasty have survived through the raging tides of time, with much of the interior ornamentation and furniture impeccably preserved and restored. The city is orderly planned according to a grid system, with the Forbidden City in the center. Almost like a wooded city, the many trees lining the streets and the many gardens and parks create picturesque scenes throughout the city.

Tianjin, Shanxi Province Tianjin has traditionally been one of the most important commercial centers in northeastern China, due to its favorable geographical location along the Haihe (Hai River). The city flourished from the Yongji Canal—part of the Dayunhe (The Grand Canal) system—as it provided a port of call between the north and the south. In 1860, the port was opened as a result of the accession of the Beijing Treaty. Trade concessions for nine countries were made by the end of the 19th century. The Old Cultural Town is now a prosperous town containing many rows of houses of Ming and Qing styles.

Taiyuan, Shanxi Province Meaning "The Great Plain" in Chinese, this ancient capital was established at the end of the Chunqiu (Spring Autumn) Period. Called Jinyang in the past, it was built as a defense base against the northern invaders. In its heyday, the city thrived as one of the most prosperous cities in China, but today much of its former glory is erased by heavy industrialization that has swept through the city.

Datong, Shanxi Province During the early Beiwei (Northern Wei) Period in AD 386 to 533, this was a great city known as Pingcheng (City of Peace). It prospered as a military base for the northern territories. Much of the city has changed, but there remain a few important historical sites in this dusty city that remind one of its more glorious days as an imperial city, such as the Yungang Shiku (Yungang Buddhist Caves), Upper and Lower Huayan Monasteries, Shanhua Temple and Jiulongbi (Nine Dragon Wall).

Qingdao, Shandong Province A period of colonialization by the Germans around the turn of the 20th century left a deep German imprint in Qingdao, which remains clearly visible today in the city's planning and landscape. At first sight, Qingdao is almost like any ancient town along the Rhein River, fortified to withstand the onslaught of oncoming adversaries. In Qingdao, we can find many German-inspired buildings and towns, as well as China's famed Tsingtao Brewery.

Qufu, Shandong Province This area prospered as the metropolitan city of Lu during the Chunqiu (Spring Autumn) Period. As the birthplace of Confucius, it has been revered through successive dynasties as the holy place of Confucianism, except during the Cultural Revolution when many Confucian edifices were desecrated by the Red Guards.

Zhengzhou, Henan Province The modern-day capital of the Henan Province, Zhengzhou was transformed into a city during the Yin Period around 15th century BC. Scattered archeological sites along the outskirts of the city hint at the city's long history of development. Historically, the most significant event must have been the large-scale strike of 7 February 1923, where the Beijing-Wuhan Railway laborers fought against imperialism and feudalism. Today, Zhengzhou plays an important role as the national center of wholesale grain trade and an international freight transfer hub.

Kaifeng, Henan Province Built in the country Zheng during the Chunqiu (Spring Autumn) Period, this ancient city was renamed Jing (The Capital) in AD 960. It thrived as the metropolis of the Beisong (Northern Song) Dynasty for 160 years. The Pagoda of Kaibao Temple, a 13-story octagonal iron structure, is one of the most famous buildings from the past that has survived till modern times. Kaifeng is also known as the *qichao gudu* (ancient capital of seven dynasties), boasting a proud history spanning 2,700 years.

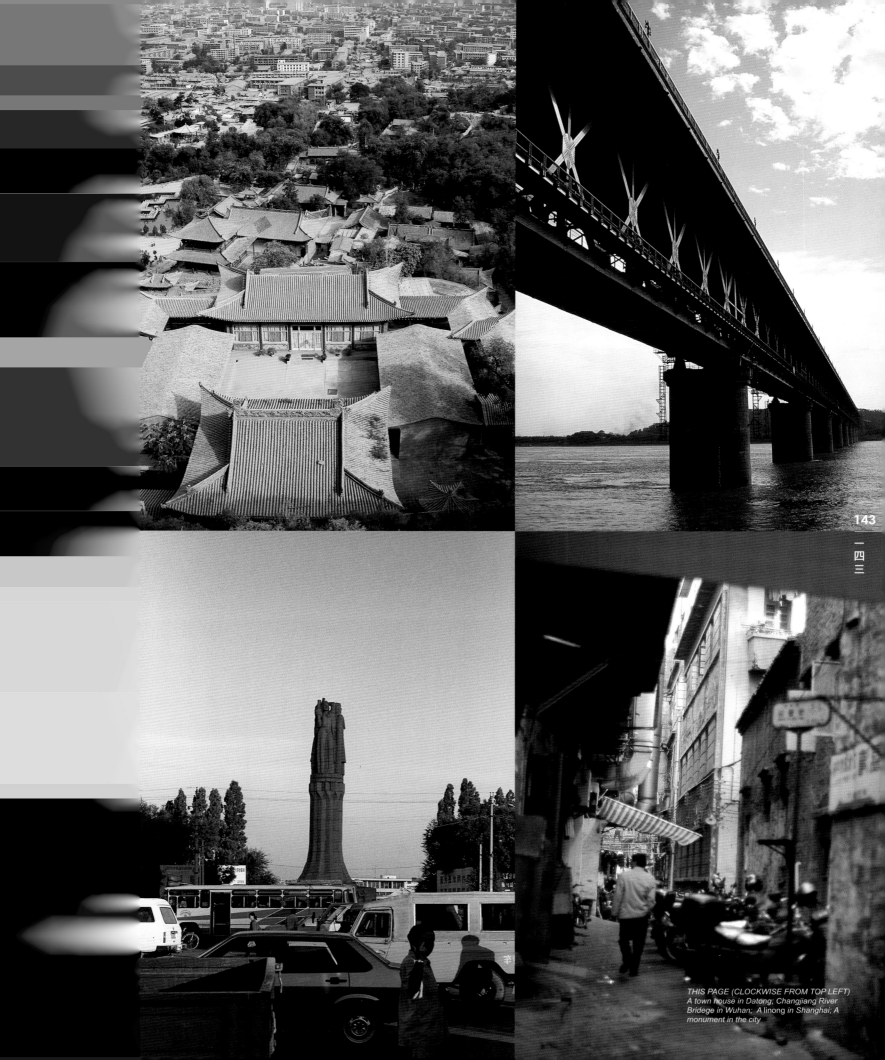

THIS PAGE (CLOCKWISE FROM TOP LEFT)
A town house in Datong; Changjiang River
Bridege in Wuhan; A linong in Shanghai; A
monument in the city

Luoyang, Henan Province Luoyang traces its beginnings back to its status as the capital of Dongzhou (Eastern Zhou) in 770 BC. Thereafter, it succeeded as the capital of nine dynasties—the Late Han, Wei, Xijin (Western Jin), Beiwei (Northern Wei) and Late Tang—earning it the majestic title of Jiuchao Gudu (Ancient Capital of the Nine Dynasties). Having lost much of its past glory and stateliness, it is now perhaps better known for its peonies nationwide. The Baimasi (White Horse Temple), the oldest Buddhist temple in China, and the Longmen Shiku (Dragon Gate Grottoes), one of the two largest stone caves in China, are both found in Luoyang.

Xi'an, Shanxi Province Thought to be established in 2205 BC, Xi'an has played capital to eleven dynasties, including Xizhou, Qin, Early Han, Sui and Tang. It was renamed Chang'an after the Han Dynasty. Xi'an is the starting point of the Silk Road. Zhang Qian and Xuan Zang brought Buddhism into China via this route. The famed Bingmayong—Army of Terracotta Warriors—is found in Xi'an, buried near to the mausoleum of Qin Shihuang, the Emperor of the Qin Dynasty who unified China in
221 BC.

Shanghai Opened to foreign trade after the Opium War of 1842, the various concessionary territories set up for countries like America, Japan, Britain and France has thrust Shanghai into unprecedented development. Known as the "Paris of the East," the path of the city's development in history has embossed in the cityscape a meld of European and Chinese influences. Among the most developed areas of the city is the Shanghai Bund, which remains a very important commercial center today. While modern development has colonized much of the city, there are still some cultural and historical attractions, including Yüfo Temple, Longhua Temple, Yüyuan (Jade Garden), Yü Garden Mall and Xinxing City.

Nanjing, Jiangsu Province An ancient city built in the Chunqiu (Spring Autumn) Period, Nanjing was the capital of Wu during the Three-Kingdom Period. Subsequently, it became the capital of Dongjin (Eastern Jin), Southern Dynasty (AD 420-588) and Nantang. Together with Beijing, Shanghai and Luoyang, it is considered one of the *sidagudu* (four great ancient cities). Today, Nanjing is a cosmopolitan city with wide tree-lined avenues and towering skyscrapers. Attractions here include the Zhongshan Cemetery, the Astronomical Observation Center at Zijin Mountain and Nanjing-Changjiang Great Bridge.

Wuhan, Hubei Province Wuhan, one of the most densely populated cities in China, is the result of the merging of three older cities in 1949: Wuchang, the political and educational center, Hankou, the business center, and Hanyang, the industrial center. As the industrial and economic powerhouse of central China, Wuhan enjoys a flourishing metallurgy and machinery industry. Attractions include the Wuhan-Changjiang Great Bridge, which stands testament to the city's economic achievements, and Guiyuan Chansi (Temple of the Return to Purity), one of the most important Buddhist temples in China.

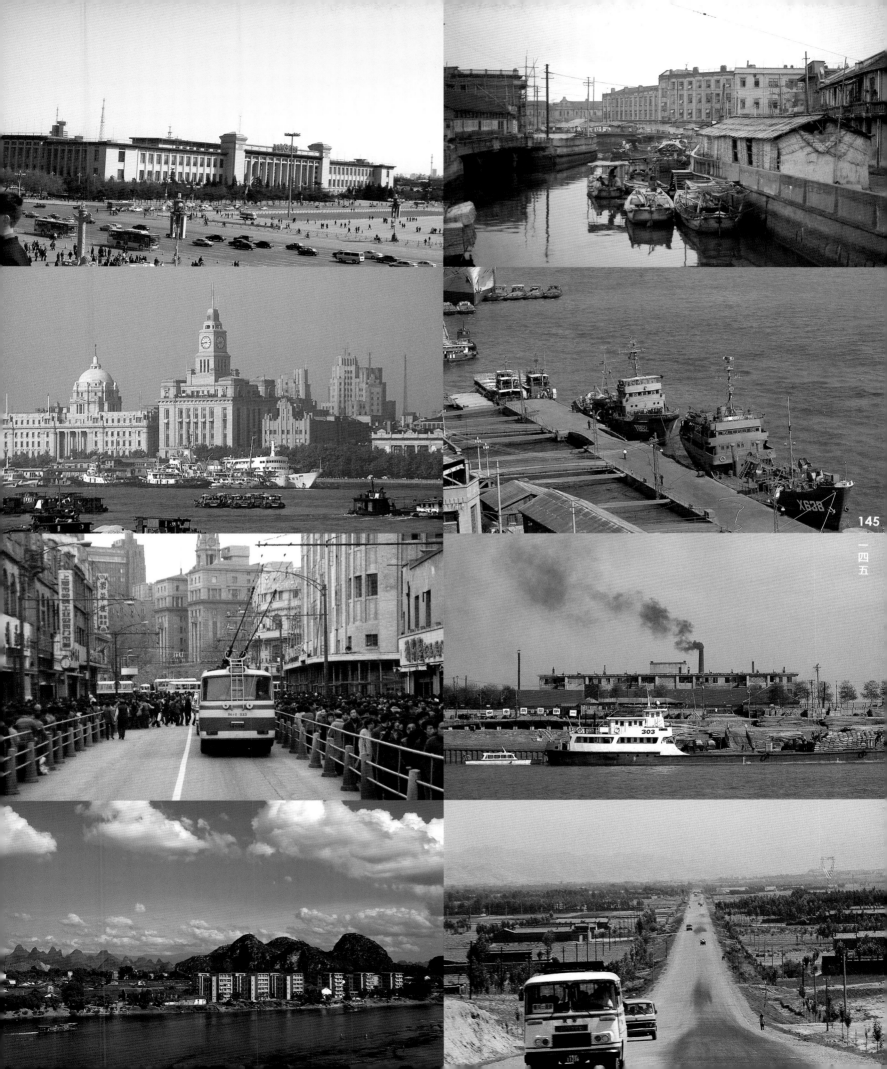

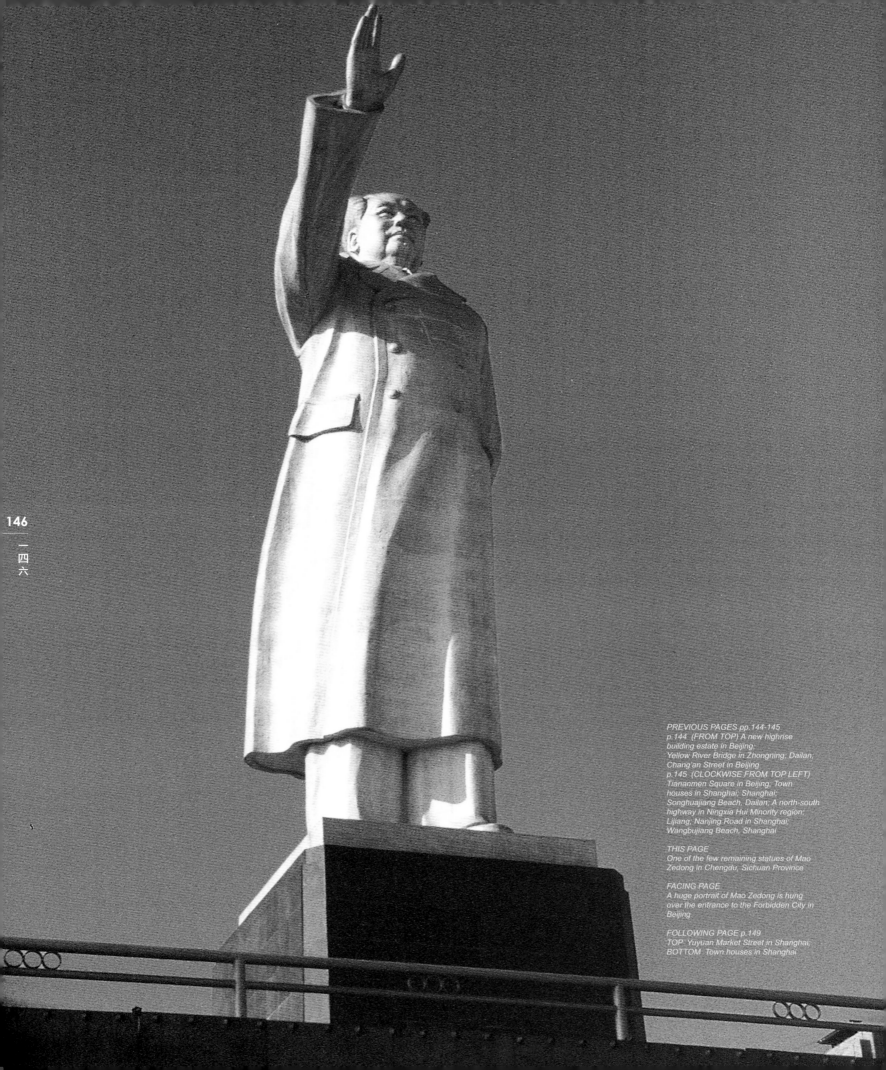

PREVIOUS PAGES pp.144-145
p.144 (FROM TOP) A new highrise building estate in Beijing; Yellow River Bridge in Zhongning; Dailan; Chang'an Street in Beijing
p.145 (CLOCKWISE FROM TOP LEFT) Tiananmen Square in Beijing; Town houses in Shanghai; Shanghai; Songhuajiang Beach, Dailan; A north-south highway in Ningxia Hui Minority region; Lijiang; Nanjing Road in Shanghai; Wangbujiang Beach, Shanghai

THIS PAGE
One of the few remaining statues of Mao Zedong in Chengdu, Sichuan Province

FACING PAGE
A huge portrait of Mao Zedong is hung over the entrance to the Forbidden City in Beijing

FOLLOWING PAGE p.149
TOP: Yuyuan Market Street in Shanghai; BOTTOM: Town houses in Shanghai

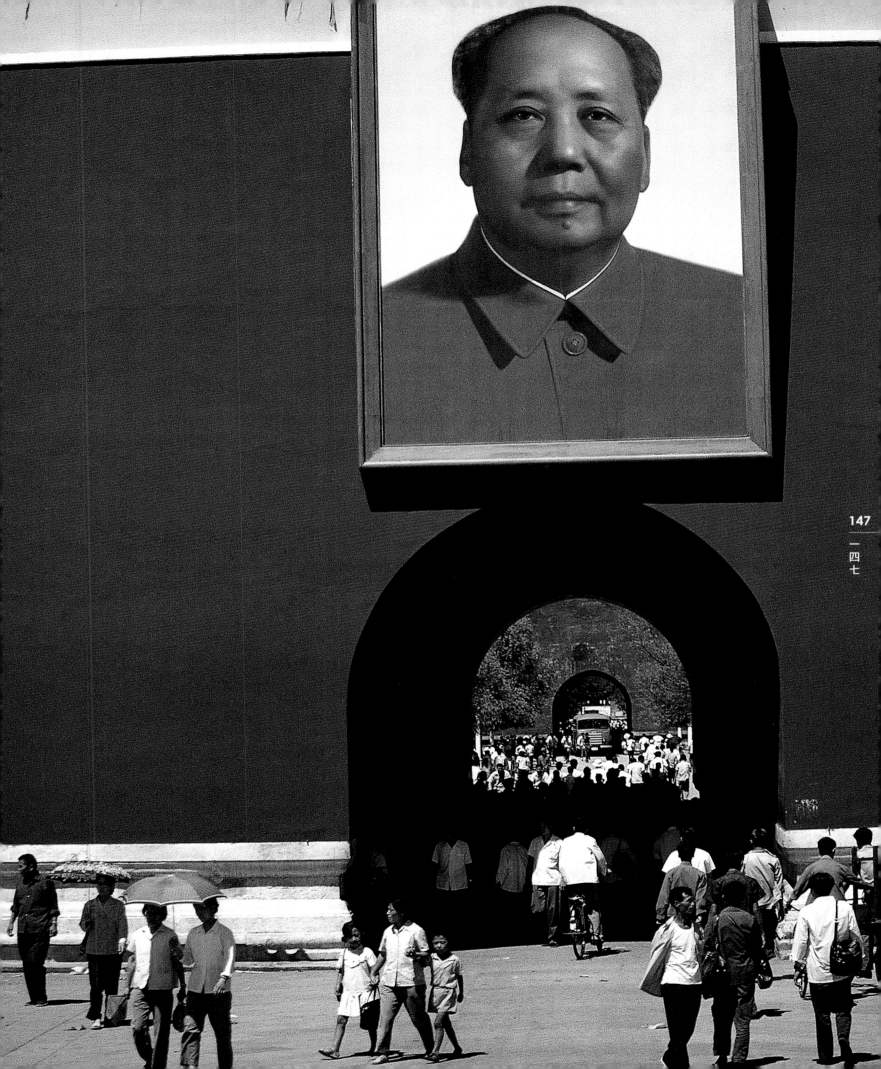

Suzhou, Jiangsu Province Suzhou was the beautiful ancient capital of Wu during the Chunqiu (Spring Autumn) Period. Also called the "Venice of the Orient," a web of creeks and boundary rivers (originating from Tai Lake in the east) seem to flow endlessly through Suzhou, painting a scenic landscape that has allegedly earned even the praise of the great explorer, Marco Polo. The gardens of Suzhou are famed and stand in a class of their own, sporting a distinctive style that sets them apart from other Chinese landscape gardens. Today, there are more than 170 gardens, including the famous Zhuozheng Yuan (Garden of the Humble Administrator), considered to be among the best here.

Kunming, Yunnan Province Enjoying a perpetually Spring-like climate throughout the year, Kunming is amongst the most pleasant of cities to visit, with temperatures hovering around 58 °F. Since ancient times, Kunming has also been known as the "Spring City." In the famous Heilongtan (Black Dragon Lake) Garden, one can find refreshing spring water that gushes out endlessly, aged plum trees from the Tang Dynasty, and oak and tea plants from the Song Dynasty.

Xiamen, Fujian Province Built in the Ming Dynasty as a defense against coastal pirates, Xiamen also flourished as a commercial center and trading port due to the presence of a deep natural harbor and its favorable geographical position. The Nanjing Treaty of 1842 has opened Xiamen to liberal foreign influences. This is evident from the many European inspired buildings, which have survived until today. A large number of Chinese emigrants trace their ancestry to this region as well, which in a way has contributed to the economic prosperity of Xiamen.

Guangzhou, Guangdong Province Guangzhou has a history of development in its early days as a trading base in the south. It formed the embarkation point on the Silk Road from the sea. Like many cities of China that were forcibly opened as a result of the Opium War, European influences are evident in the architecture here. It is also the hometown of many Cantonese Chinese. Today, Guangzhou is a bustling city negotiating the extremes of rich and poor, seeming to have forgotten its dramatic history of revolt and mayhem.

Chongqing, Sichuan Province Opened in the 19th century as an inland port and trading center, Chongqing was for a period of time, from 1937 to 1946, the capital of Chiang Kai-Shek's Kuomintang government. Hongyan Cun (Red Crag Village), where Kuomintang leaders Zhou Enlai and colleagues based their office and living premises during World War II and the early part of the Liberation War, is in Chongqing. It is also called the "Mountain City" because it is nestled amidst mountains. With its hot and humid climate, it is one of the "Three Great Furnaces" of China. Being a highly industrialized city surrounded by mountains, Chongqing suffers from a serious pollution problem, earning it an unenviable name—"The City of Fog."

Changsha, Hunan Province Changsha is an ancient city built in the Qin Dynasty during the 3rd century BC. The fertile plains around Xiangjiang (Xiang River), which runs through Hunan, has allowed Changsha to prosper into a center of trade for agricultural produce. It is at the same time known for being the center of the revolutionary work of Mao Zedong in his youth. Among Changsha's exports, its textile products are most famed. Known as *xiangxiu*, they are considered to be among the best embroidery products in China.

Nanning, Guangxi Zhuang Autonomous Region This city is poetically set amidst a vast bamboo forest. A large part of the local population is made up of the minority Zhuang Tribe and therefore Nanning is also known as "The Town of the Zhuang Tribe." Sharing borders with Vietnam, there is a railroad that runs from Nanning into Vietnam. As a result, a lively trade has taken form here.

Lanzhou, Gansu Province Lanzhou is situated at the eastern edge of the Hexi Corridor. Since ancient times, it has been developed as a transition zone connecting the Central Plains to its western neighboring areas, remaining important throughout history as one of the key gateways to China along the Silk Road. The first woolen textile factory in China was established here in 1876, where the industry has prospered since.

Xining, Qinghai Province First established in the Han Dynasty during the reign of Emperor Wu, Xining is an amalgam of Tibetan, Muslim, Mongolian and Chinese cultures. Sharing the border with Tibet, this city has operated as a military garrison and secondarily as a trading center, due to its ideal position as an interchange of routes between China and Central Asia. The modern-day Xining is heavily industrialized, which has caused the city to be shrouded in a perpetual fog.

Baotou, Inner Mongolia Autonomous Region In Mongolian, the name of the city literally means "the place where deers with peculiar patterns dwell." Baotou is where a number of railroads in China terminate. Bearing rich coal and iron deposits and heavily industrialized like many other northwestern cities, it is one of the most important iron and steel production centers of China. The famous Wudang Zhao (Wudang Monastery) is located here.

Hangzhou, Zhejiang Province This city truly developed only after the opening of the Great Canal in AD 610. It formed the terminal point of The Silk Road, and was an important commercial center for the trading of precious goods. As the capital of the Nansong (Southern Song) Dynasty, it nurtured the flourishing of culture in the fields of opera, art, literature, landscape gardening and architecture for several centuries. Now, Hangzhou is one of the most famous tourist spots in China, where tourists flock to visit the famed West Lake every year. And as Marco Polo commented, "This city is the most beautiful and magnificent heavenly city in the world."

城 市

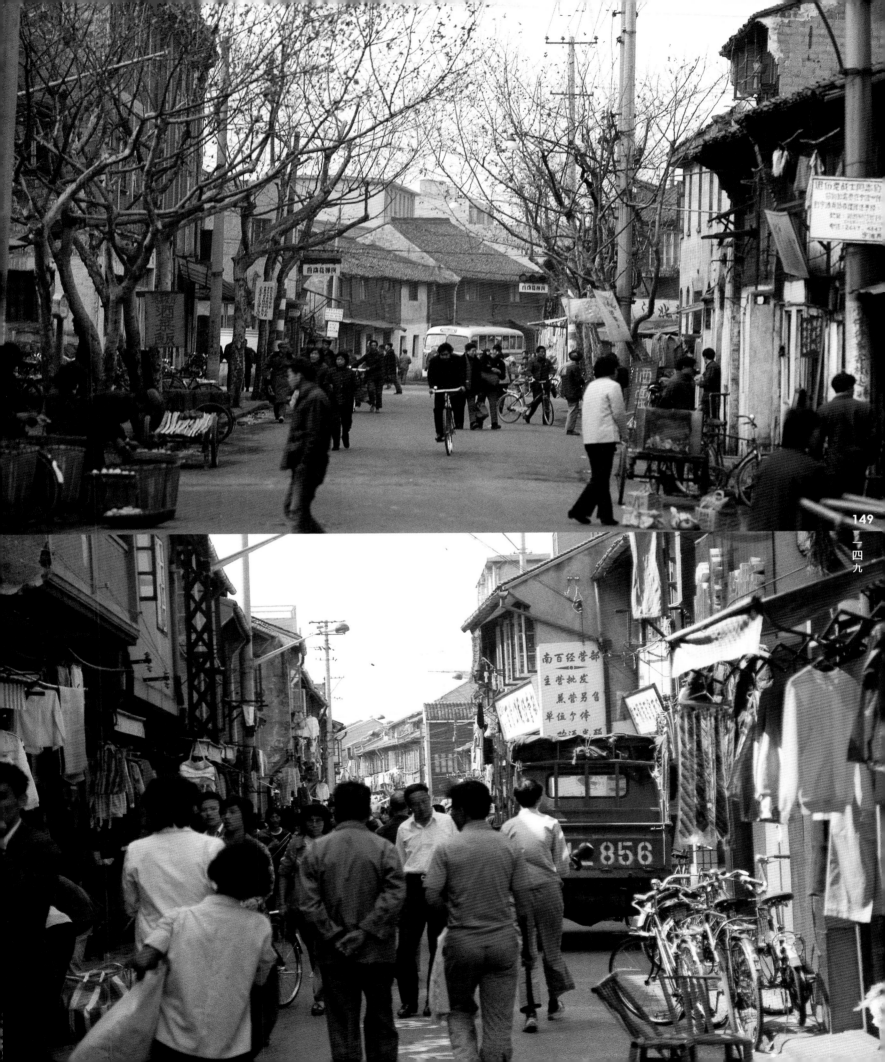

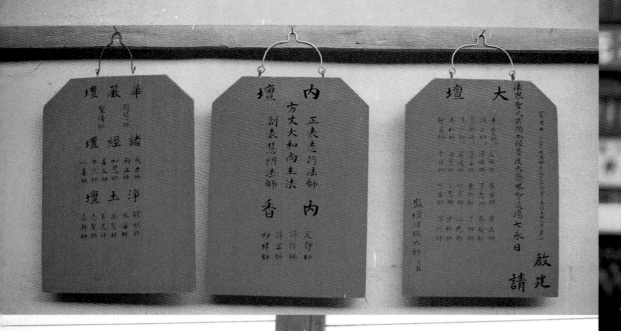

华严坛 诸经坛 土坛
内坛 正表志行法师 方丈大和尚主法 副表慧朗法师 香内
大坛 启建 请

人行道上不准停车
请就近支路临时停放
黄浦公安分局交通队

一九八七年任务
工业总产值 675万元
产量
　生丝 67吨
　坯绸 104万米
　成品绸 101万米
质量 成品绸一等品率 73%
　生丝品位 2A
　生丝正品率 93%
　坯绸一等品率 75%
税利总额 160万元

顺者侠徙顺拉娑徙顺徇你
○人的情事尝抚中徇你徙

庆祝国庆

1949—1985

（清顺治十七年）座
国为宫殿·中轴线
大门，两侧为平
天妃宫，气势宏伟
区乡红色政权
、西、南侧从
、西、南、北

县级文物
西陂

员会

THIS SPREAD
Signboards and notices

RELIGION

Under the Chinese Constitution, every citizen of the People's Public of China possesses the freedom to practice his or her choice of religious faith. While the Cultural Revolution has put a halt to the progress and spread of religious beliefs and practices in China, this freedom was enthusiastically revived following the fall of the Red Guard, creating the diverse religious environment which we see China in today.

Buddhism Introduced to China from India in the 1st century BC, Buddhism has flourished as one of the most widely-practiced religions in China. Over the centuries of development, Buddhism has branched out into various schools. The most common is Mahayana Buddhism, with other smaller divisions such as Tibetan Buddhism and Yunnan Shangzuobu Buddhism being practiced alongside. Tibetan Buddhism was introduced into Tibet in the 7th Century. There are currently about 9 million believers, most residing in Tibet and Inner Mongolia. Shangzuobu Buddhism was led from Burma into Yunnan to the minority peoples of China around mid-7th century. There are as many as 1 million believers of Shangzuobu Buddhism today. Currently, 13,000 temples operating with the Government's permission and 14 institutions dedicated towards Buddhist teaching and study are found across China. There are about 200,000 nuns and priests.

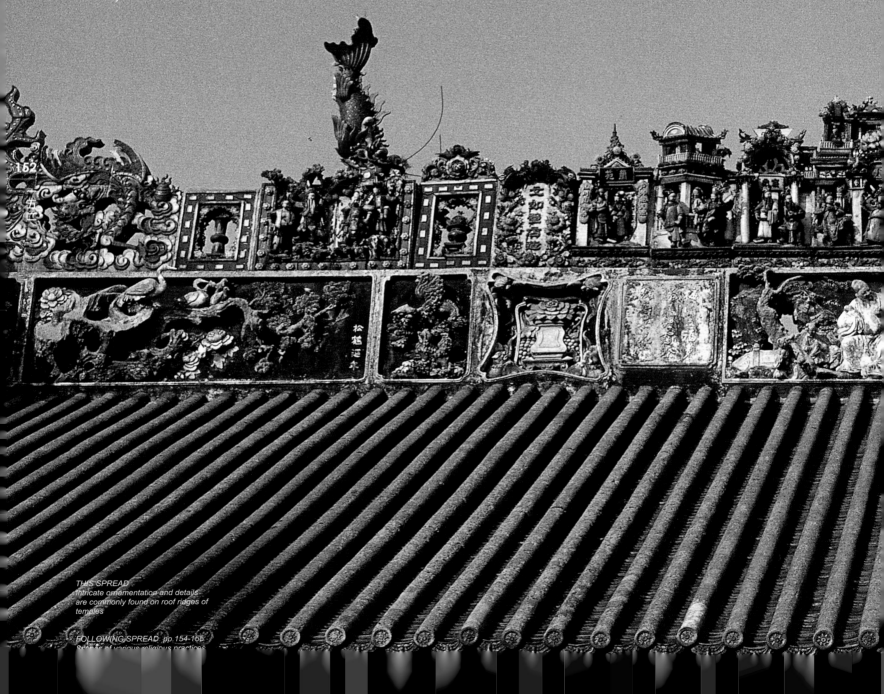

152
五二

THIS SPREAD
Intricate ornamentation and details
are commonly found on roof ridges of
temples

FOLLOWING SPREAD pp.154-155

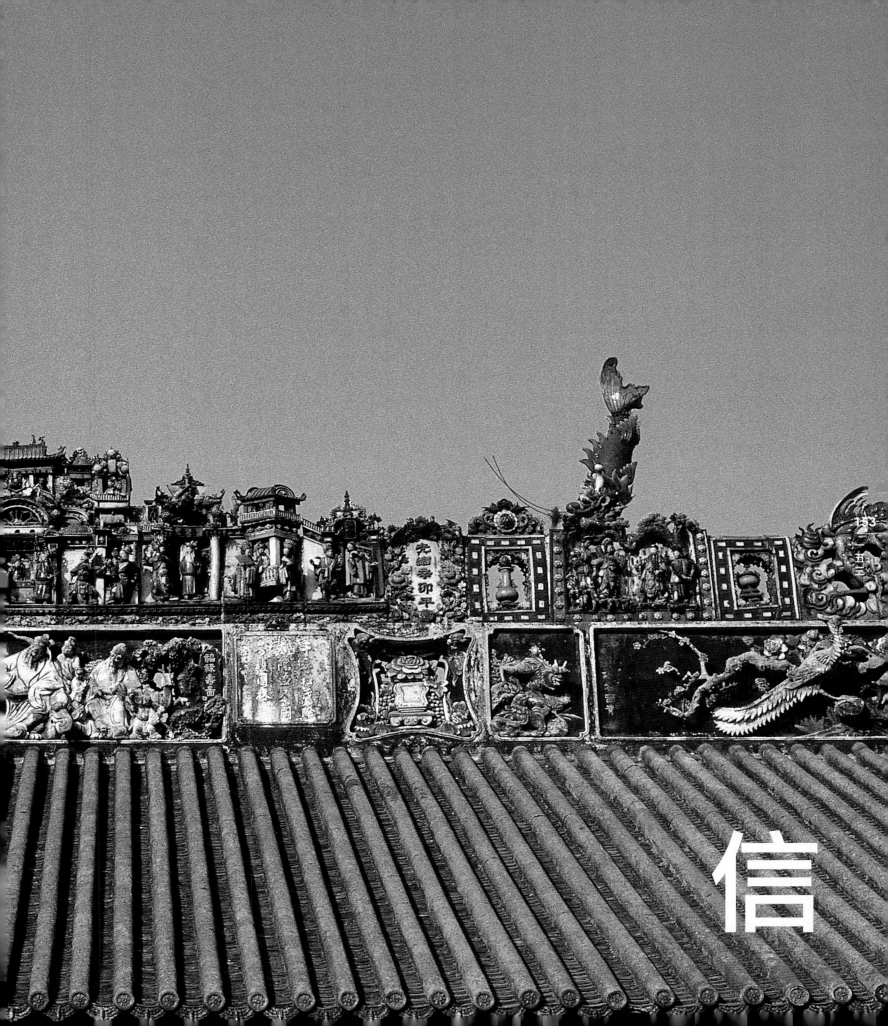

信

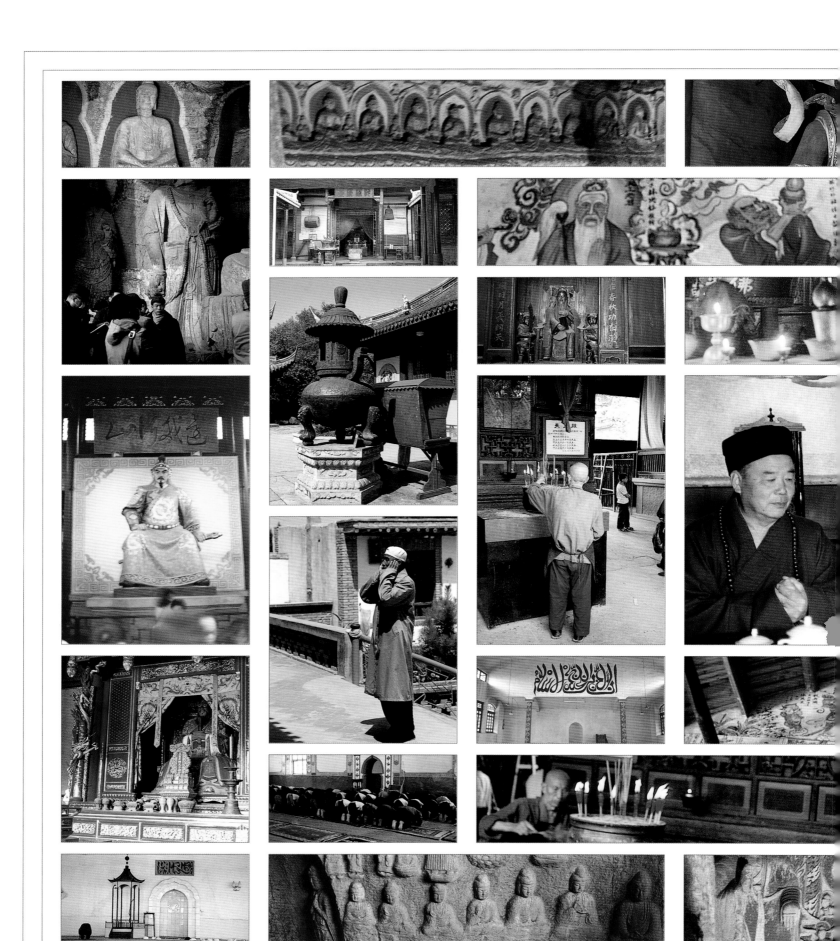

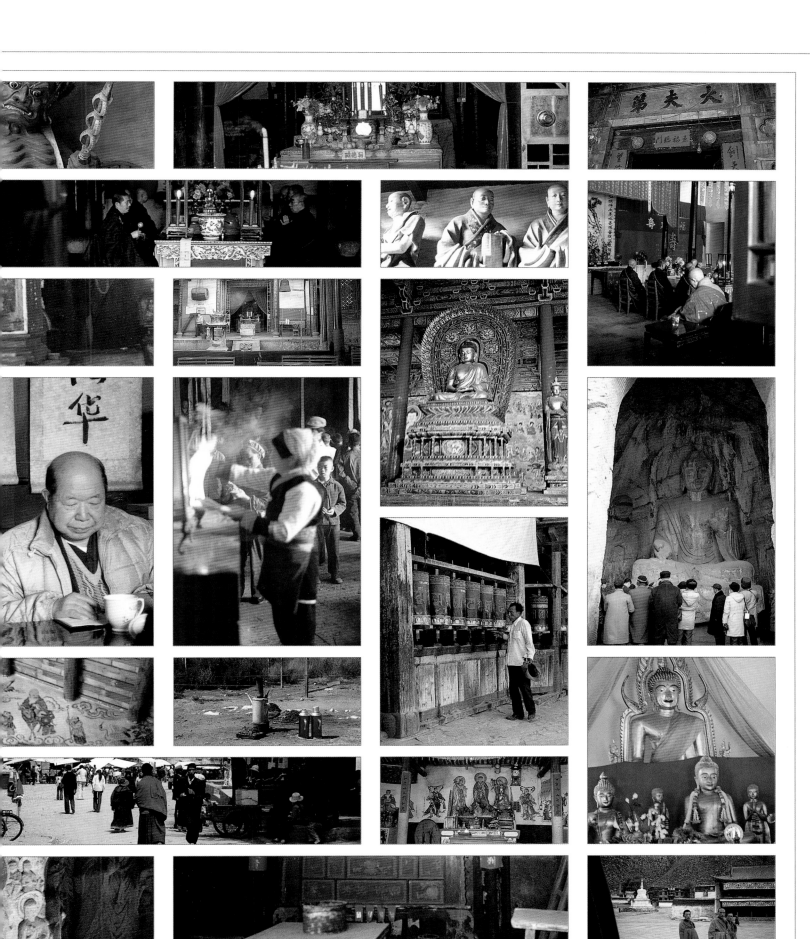

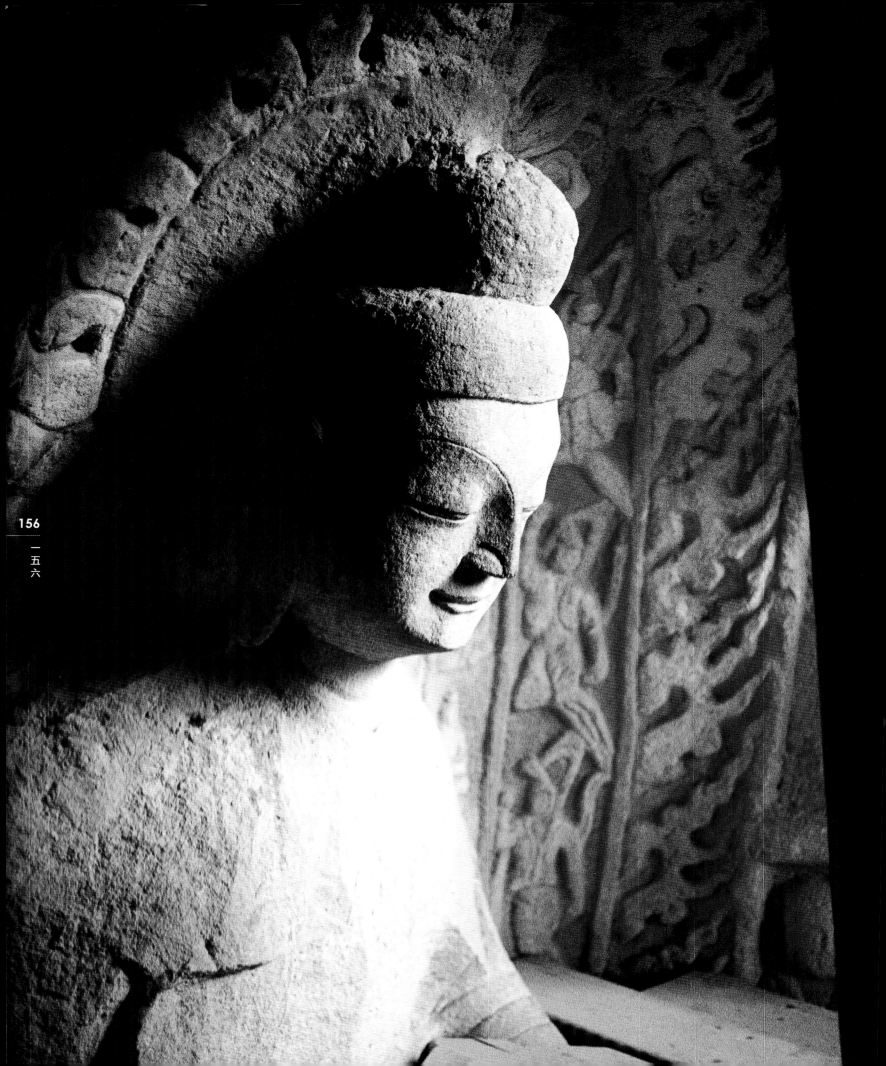

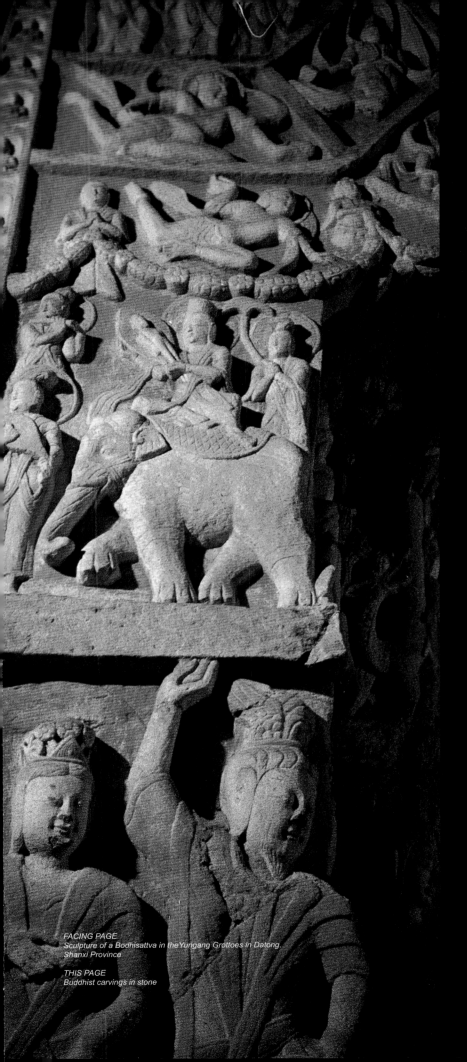

FACING PAGE
Sculpture of a Bodhisattva in the Yungang Grottoes in Datong, Shanxi Province

THIS PAGE
Buddhist carvings in stone

Taoism Originating as a native practice, Taoism was subsequently organized into a religion around the 2nd century AD. It draws together the various legends, myths, beliefs, superstitions and practices of alchemy, divination and sorcery spread throughout China. Linked intricately to the mythical first Emperor of China—Huangdi (Yellow Emperor)—the religion bases its spiritual foundation on the teachings of Lao Zi (Laotzu or "Old Sage"), as recorded in the Dao De Jing (Scriptures of the Way and Virtue). People believe in Taoism very eagerly as the religion is practiced in the daily lives of the commoners. It still very much influences the spiritual culture of Han people. Throughout China, there are presently about 1,500 Taoist temples, and approximately 25,000 full-time Taoist professional workers, priests and priestesses.

Islam Islam is believed to have been introduced into China by Arab and Persian merchants in the 7th Century. Today, we can see two types of Muslim cultures in China. The first type of culture sees Muslims who are conditioned under the Chinese culture and speak the Chinese language. On the other hand, there are some Muslims, many from the minorities including the Uigurs, Kazaks, Kirgizs, Ozbeks, Tajiks and Tartars, who retain a way of living highly specific to their cultures. These Muslims belong mainly to the Suni sect. There are currently about 30,000 mosques, 40,000 *imams* and *ahungs* (religious teachers) and 18 million Muslims in China.

Christianity Christianity (Jidujiao) first made its entrance into China during the Tang Dynasty and flourished under royal advocate. However, it suffered a decline towards the end of the Tang Dynasty. It was not until only very much later, in the years of the Opium War (1839-1842), that the various denominations of Christianity were actively preached in China once again. As a result, there was an extensive spread of Christianity after the Opium War, which helped to establish many hospitals, schools and charitable organizations. In 1950, upon Chinese liberation, the "Three-Selfs" Patriotic Movement championed by Wu Yaozong played a critical role in dispelling the imperialist associations of the religion, enabling the practice of Christianity to develop on independent grounds. Currently, the figures stand at 25,000 official assembly venues, 12,000 churches, 18,000 church workers and 10 million believers.

Catholicism The introduction of Catholicism in China is largely credited to Jesuit priest Matteo Ricci at the end of the Ming Dynasty. After the Opium War, Catholicism (Tianzhujiao) saw a sudden surge in numbers. This religion was one of the tools used by the West in its "aggression" against China. In 1946, 137 parishes were set up in China and many foreigners were appointed as bishops and Holy Orders. After the founding of the People's Republic of China, many local priests and believers clamored for more appointments. Since 1985, the local Catholic churches started to independently appoint key positions including bishops. At present, there are about 4,600 churches, 4,000 clergymen and 4 million believers in China.

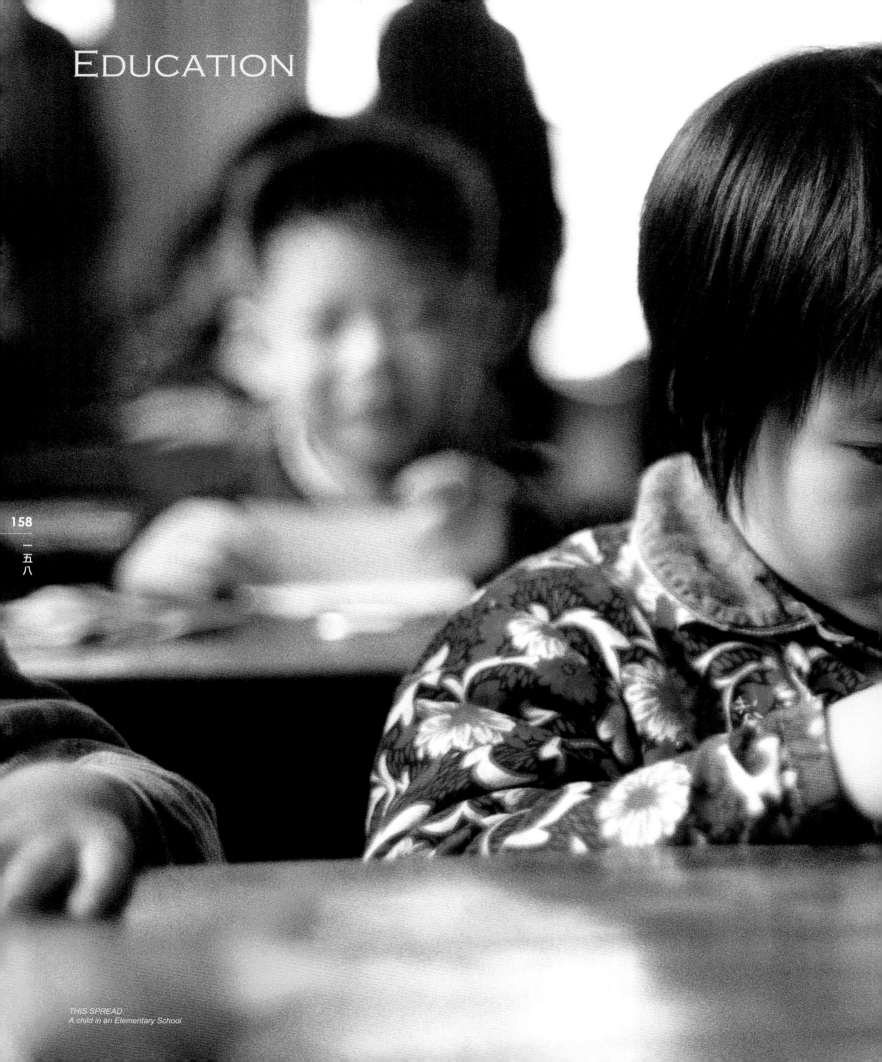

158
一五八

THIS SPREAD
A child in an Elementary School

育

In China's drive for social and economic advancement, there is now a serious interest in education. As of 1 July 1986, it is required by law for all children to undergo compulsory education for 9 years. Typically, rural schools adopt a 5-year/4-year structure, whereas schools in the cities adopt a 6-year/3-year system. While most of China appears to have caught up with the economic boom, the nationalist ideals and attitudes of Mao's communist model are far from extinct. In the Chinese curriculum, morals and ethics are not the only issues explored; nationalistic, political and patriotic principles are similarly inculcated.

In 1999, the percentage of students completing elementary education in China reached a record of 99.1%. When the People's Republic of China was founded, this figure stood at a mere 20%. While the improvement is encouraging, the problem of children, particularly girls, being unable to receive formal education still persists in the underdeveloped rural and backwater areas of China. Driven by poverty and poor awareness, the dropout rate in schools in these areas is often also high.

Elementary Education The elementary school curriculum covers 8 subjects—Moral Education, National Language, Mathematics, Social Studies, Science, Physical Education, Music and Art. Of late, there has been a debate about the overemphasis on academic performance of school children. A new form of education—Quality Education that emphasizes the comprehensive development of skills—is currently being advocated. Ultimately, Quality Education aims to cultivate the Chinese student in independent thinking, creative spirit and practical skills.

Secondary Education A full secondary education covers 3 years in Junior Secondary School and another 3 years in Senior Secondary Schools, or Specialized Secondary Schools, which provide vocational or technical education. At the end of secondary school, a fierce competition to gain entrance into the top universities ensues. The university entrance examination covers common subjects such as national language, mathematics, physics, chemistry, foreign languages and humanities courses such as politics and history.

Tertiary Education According to official figures in 1998, an estimated 1.08 million people successfully completed tertiary education, and this figure rose to 1.55 million people in the following year. As in 1999, 10.5% of the population aged between 18 to 22 years of age are enrolled in local universities. The university system in China is much like many other countries in the world; a regular bachelors course takes 4 to 5 years, while postgraduate courses are typically carried out over a duration of 2 to 3 years, of which masters or doctorate degrees are awarded upon successful completion.

Municipal Children's Palace and Municipal Youth Palace These state-owned institutions conduct for students enrichment activities falling beyond the normal curriculum from the primary, junior high and high schools. Courses include singing, dancing, instrumental music, calligraphy, table tennis, gymnastics and so on. Typically, each offers different activities and courses for the students to choose from.

THIS PAGE
TOP Painting lessons; BOTTOM Students studying at the Beijing University's library

FACING PAGE
A student doing eye-relaxing exercises that are conducted in a classroom at an Elementary School

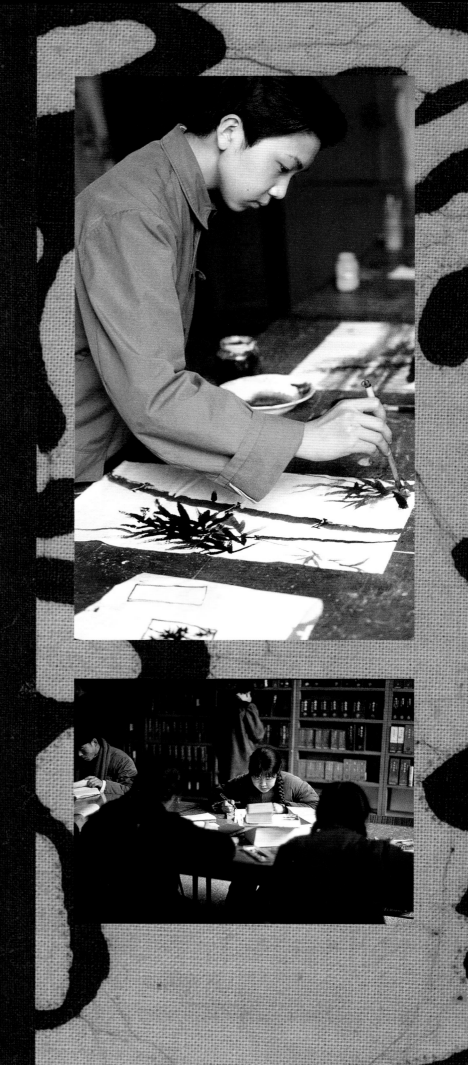

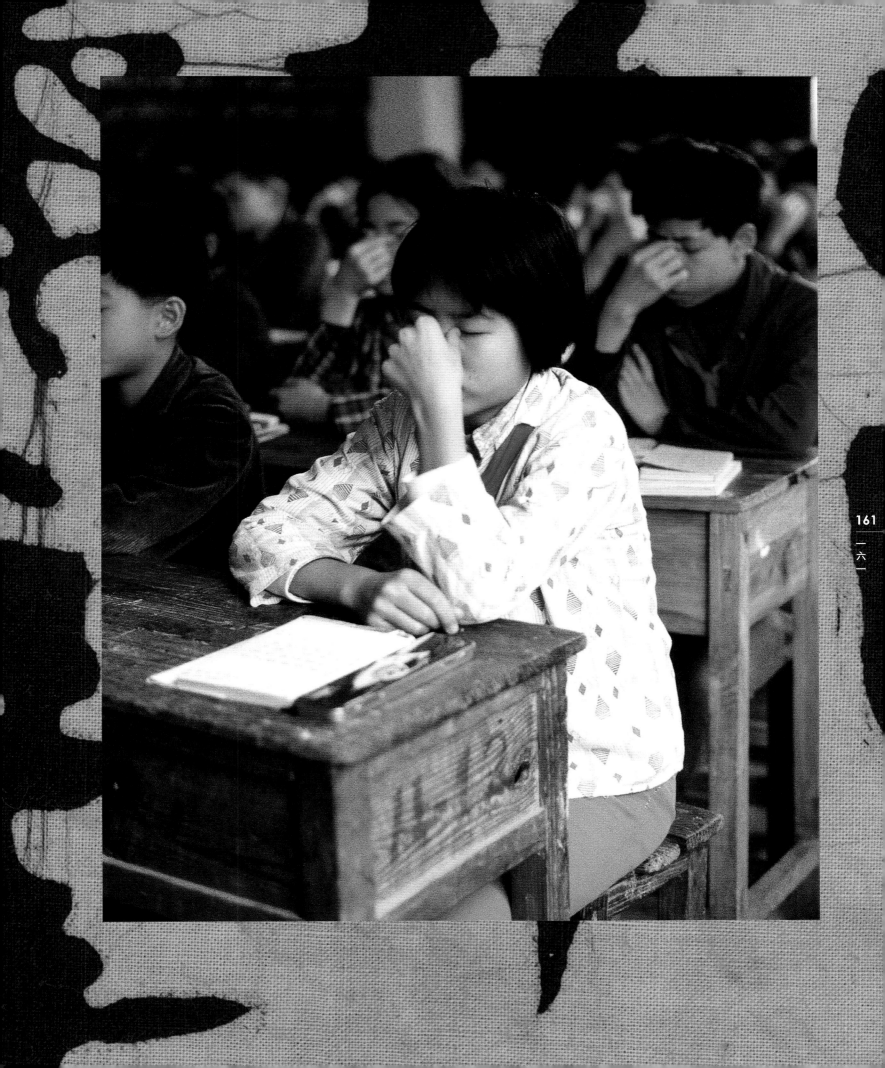

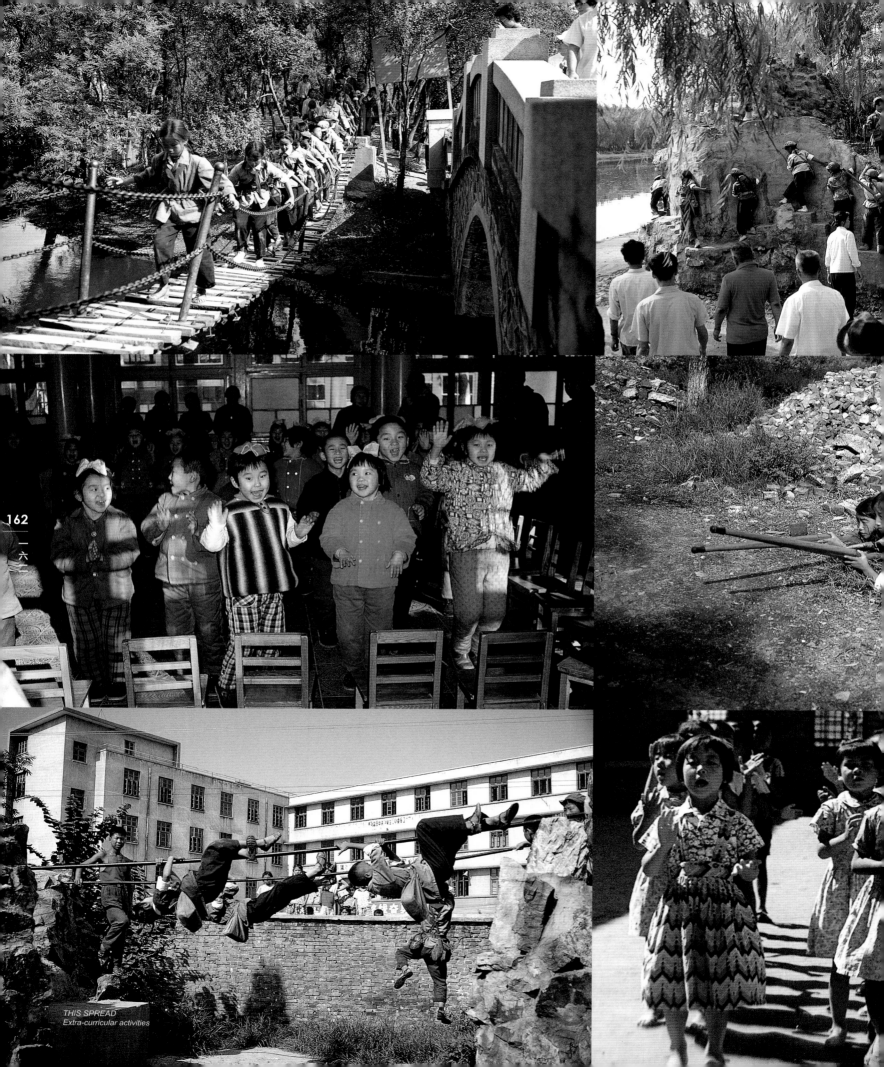

162
一六二

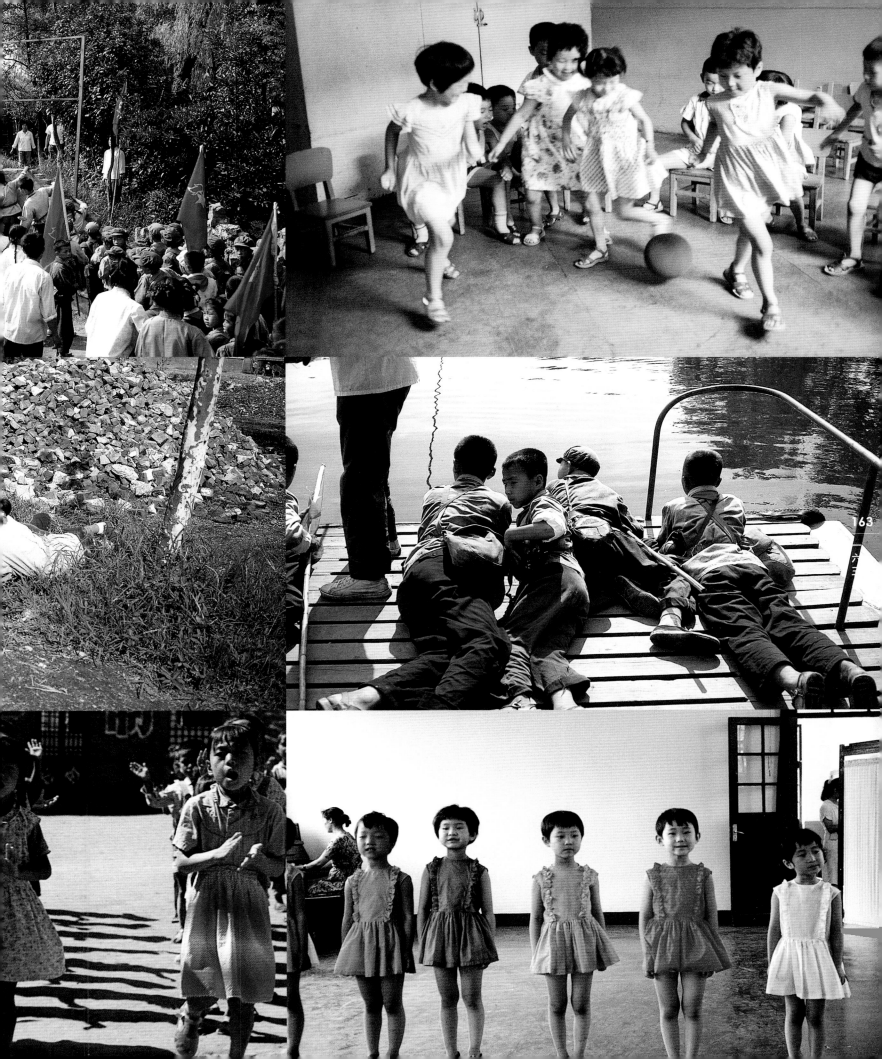

岁月

Winter

The winters of China have always fascinated me. Covered in a thick layer of snow, the Chinese landscape has never appeared more enigmatic. I like to imagine what is hidden beneath that thick blanket of white. Under the veil of snow, a complex mysteriousness shrouds this vast expanse of land that seems to stretch on endlessly.

THIS PAGE
A cold winter's morning in China

FACING PAGE
A townhouse in Shaoxing

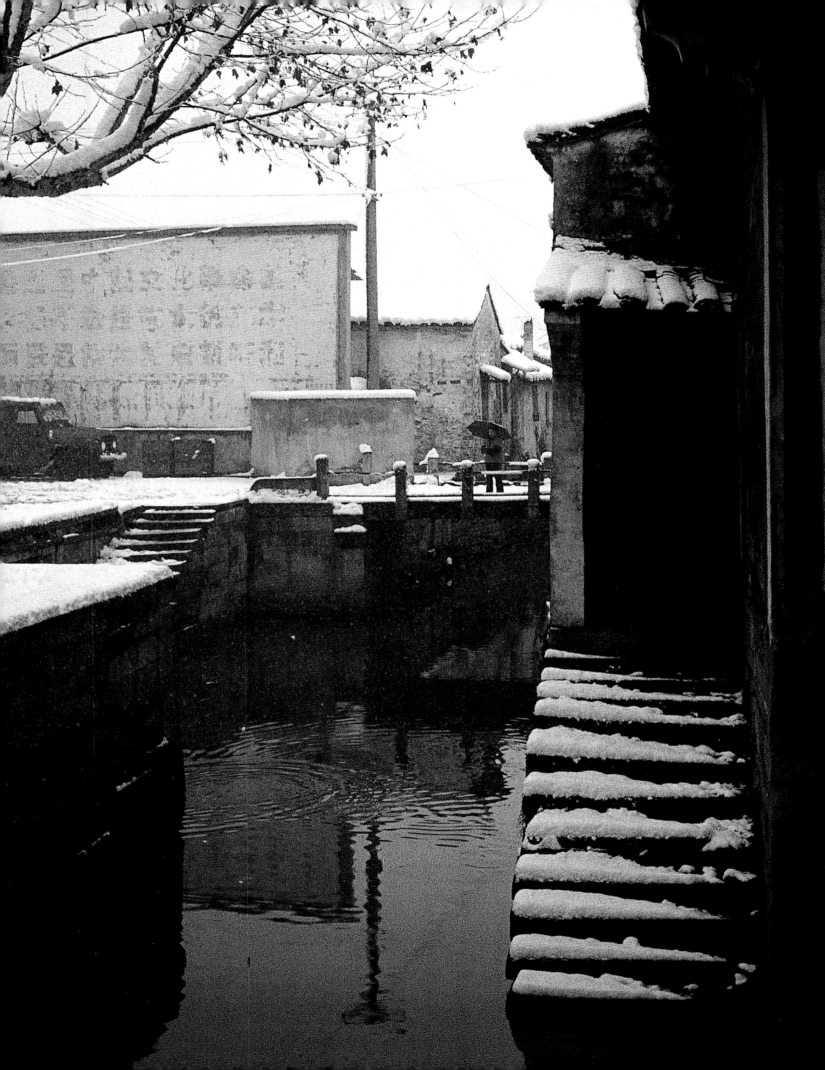

166

一六六

THIS SPREAD
Morning walks along the lake in winter

FOLLOWING PAGES pp. 168-169
p.168 (CLOCKWISE FROM TOP LEFT) A bridge built over a creek on the way
to Cold Mountain Temple; A house in Shaoxing covered with snow; A boat in a
creek near Ningbo; Taxis awaiting passangers in Guangzhou; Children playing
in a river at Tieli, Heilongjiang Province; Fishing in the Lijiang
p.169 (CLOCKWISE FROM TOP LEFT) A town in Shaoxing in soft winter light;
Three-story townhouses; The Chongqing-Changjiang Bridge; Locals cycling to
work in Yinchuan; A sculpture of a camel in the suburbs of Beijing; Locals
cycling to work in Hangzhou

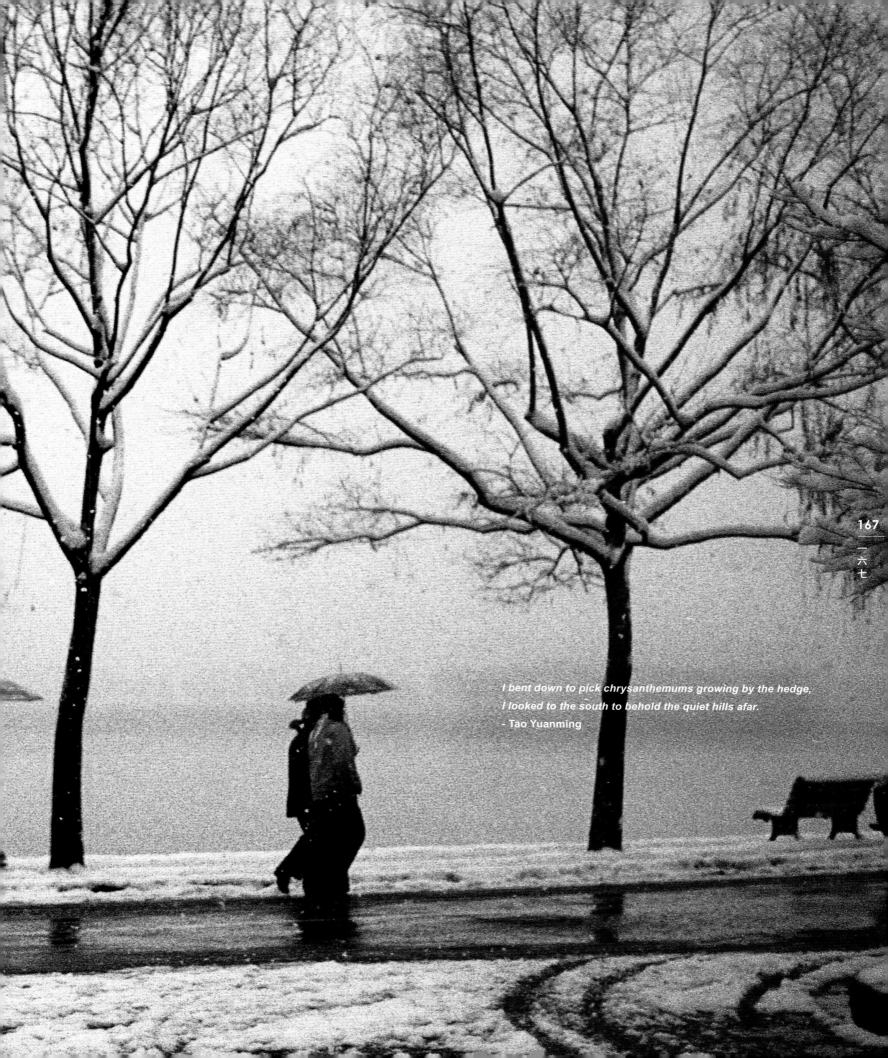

I bent down to pick chrysanthemums growing by the hedge,
I looked to the south to behold the quiet hills afar.
- Tao Yuanming

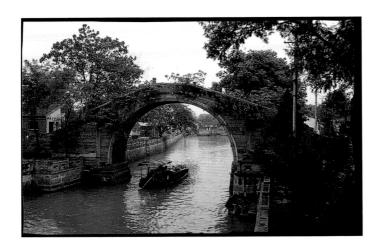

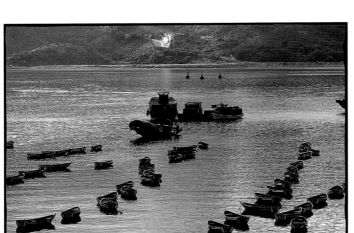

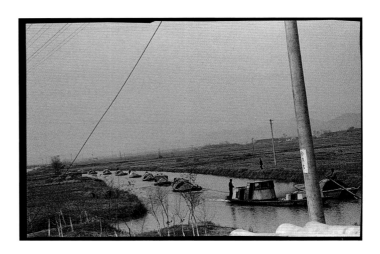

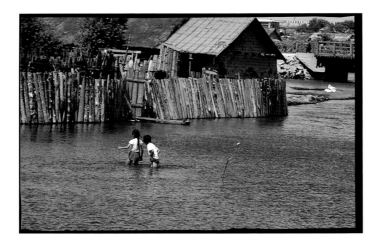

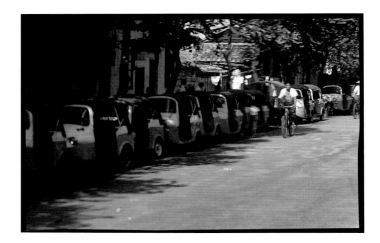

In many ways, the Chinese notion of beauty is parallel to that of the Japanese. The "beautiful" is subtle and harmonious with both heaven and earth. Unfolding slowly like painting scrolls, one is let into the beauty of Chinese landscapes only a little at a time.

In their art and literature, the Chinese often praise nature. It is no wonder that even in their built surroundings, the Chinese constantly borrow from nature to recreate these frames of natural beauty. Through arches and moon-gates, distant sceneries and views are captured to form a natural painting. These "paintings" change as the scenery changes, and such is the ephemeral quality that makes beauty so fleeting, but precious.

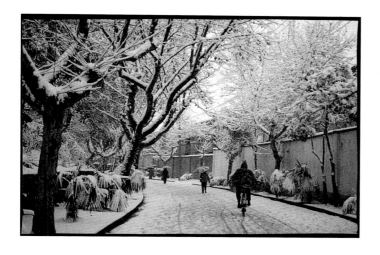

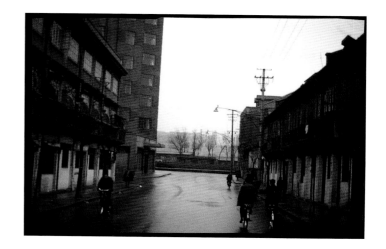

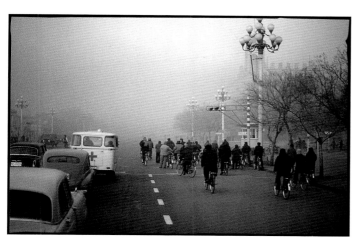

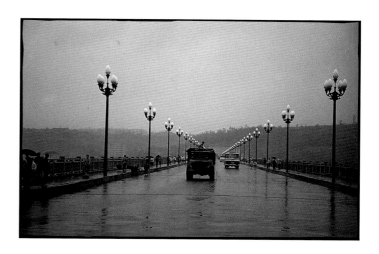

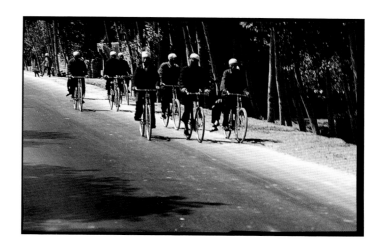

To Wang Lun

Li Po takes a boat and is about to depart
When suddenly he hears the sound of footsteps and singing on the shore.
The water in the Peach Blossom pool is a thousand feet deep
But not as deep as Wang Lun's parting love for me
- Li Bai

贈 汪 倫

李 白 乘 丹 將 欲 行

忽 聞 岸 上 踏 歌 聲

桃 花 潭 水 深 千 尺

不 及 汪 倫 送 我 情

一 李 白

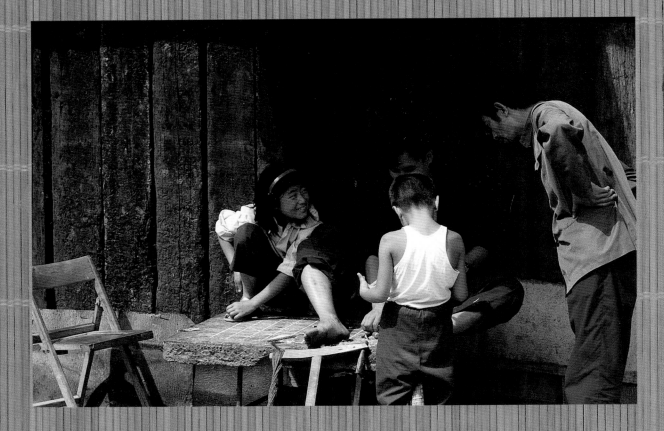

China is like a kaleidoscope that looks into many worlds. Through each and every window, we see different aspects of the people and culture of China, which can be so different from each other. Sometimes this disparity is amazing, but sometimes it is also alarming. Even with the gradually developing economy, the majority of the population continues to reside in rural and backwater areas. The way of life of most commoners is still rather simple; people wash their clothes by the river, toil in the fields with crude machinery, and cook simple meals from gathered fuel over old charred stoves.

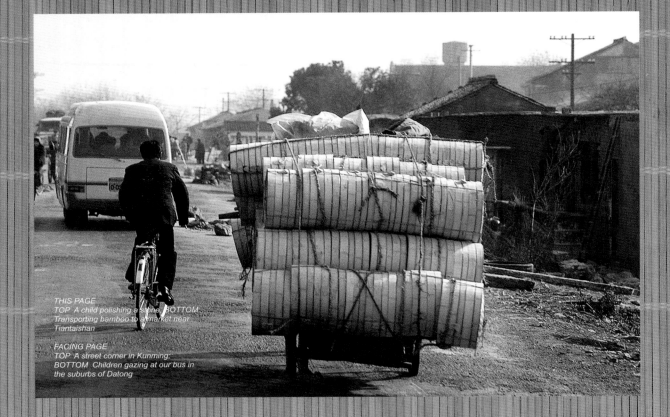

THIS PAGE
TOP A child polishing a stone. BOTTOM
Transporting bamboo to a market near
Tiantaishan

FACING PAGE
TOP A street corner in Kunming;
BOTTOM Children gazing at our bus in
the suburbs of Datong

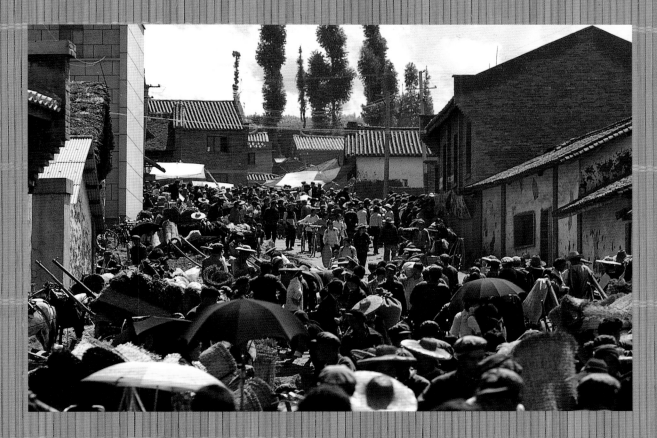

In the cities, we can see four or five-story apartment buildings separated by dark narrow alleyways where children play and hawkers sell local snacks. The marks of technology have left little imprint in some places, and in others, the poverty of the people still stands in direct contrast with the lavish lives some Chinese lead.

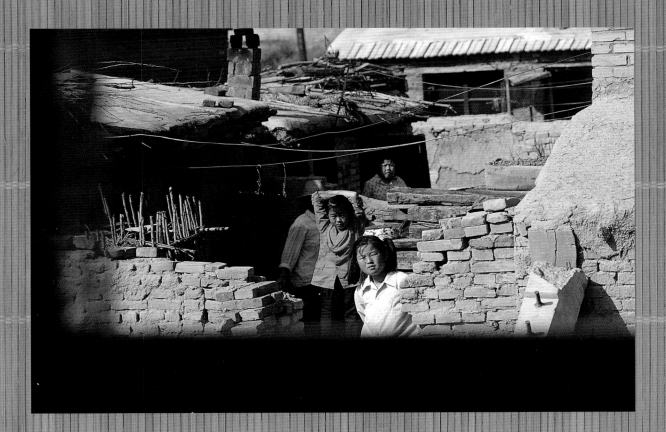

MAO SUITS & RED KERCHIEFS

With growing prosperity and Western influence, the dressing habits of many Chinese have changed to become much like those in other cities around the world. We used to see people clad in green and blue Mao-suits even on normal days, and the little children wore red kerchiefs around their necks. There was little variation in styles, not to mention trends, which were literally non-existent. China was a world of equality and the power of labor and the masses were glorified. Everyone's beliefs were conditioned to conform to the goals of the common good. Women fought for equal status and opportunities with men, and children were taught to live not for themselves, but for the country.

172

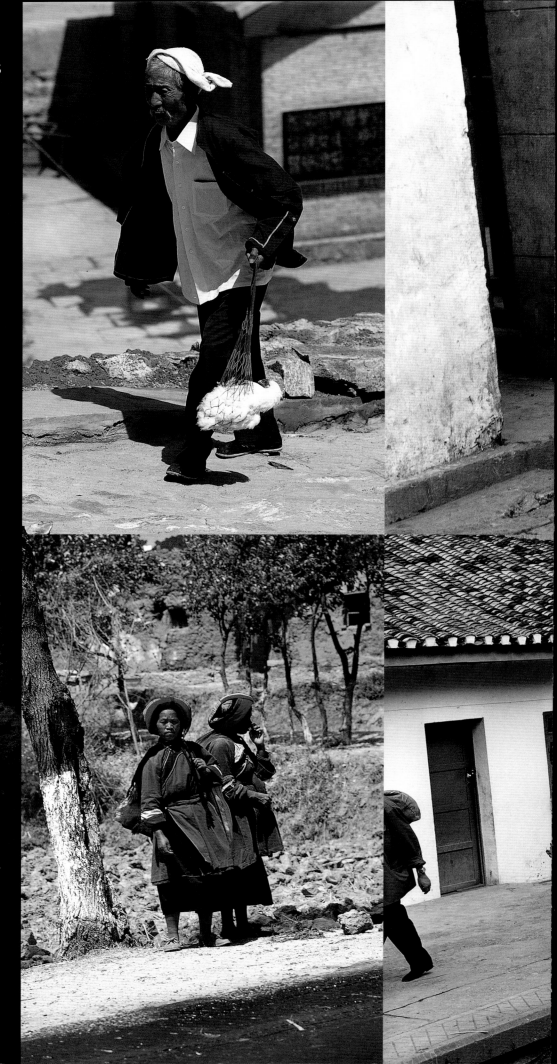

The favorite slogan was "*ren ren wei wo, wo wei ren ren,*" which literally means "Others work for the good of me; I work for the good of others." How different it is from today, where youngsters are brought up under a social climate driven by the market economy. Old-time socialism, it seems, has ceased to exist .

THIS SPREAD
People of a multi-ethnic nation

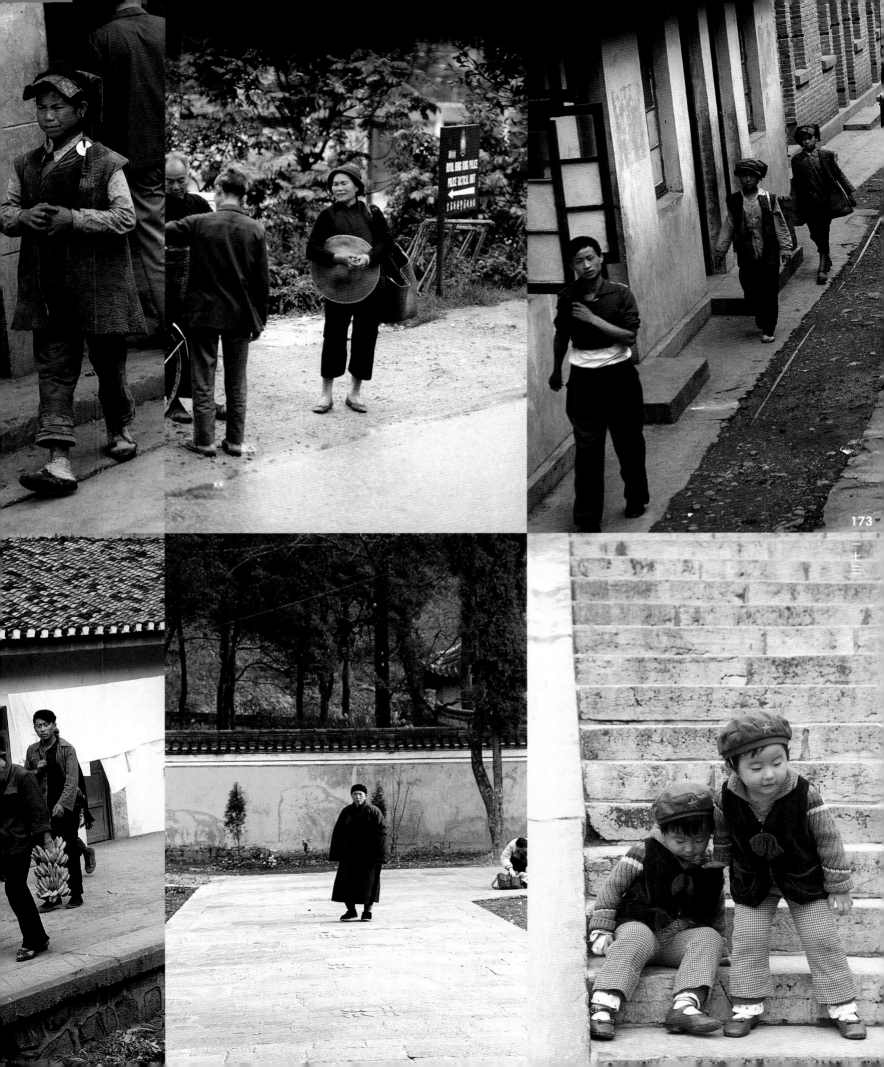

THIS PAGE
"ren ren wei wo"—literally means "Others work for the good of me"

FACING PAGE
"wo wei ren ren"—literally means "I work for the good of others."
These two phrases are usually read together in a single sentence.

In my travels to China during the 80s, the presence of old Communist China was already slowly eroding. Often, we could see peeling "big-character posters" and signs pasted forlornly around the towns or villages, beaten by rain and sun over the forgotten years of the era. In the rural areas, remnants of these images overlapped with traditional Chinese signboards and plaques that hung haphazardly on dirt-washed walls in the commoners' dwellings. Whenever I saw these, I would wonder about what the people went through in the days of the Cultural Revolution. This is something that I would only be able to imagine, but never able to understand fully.

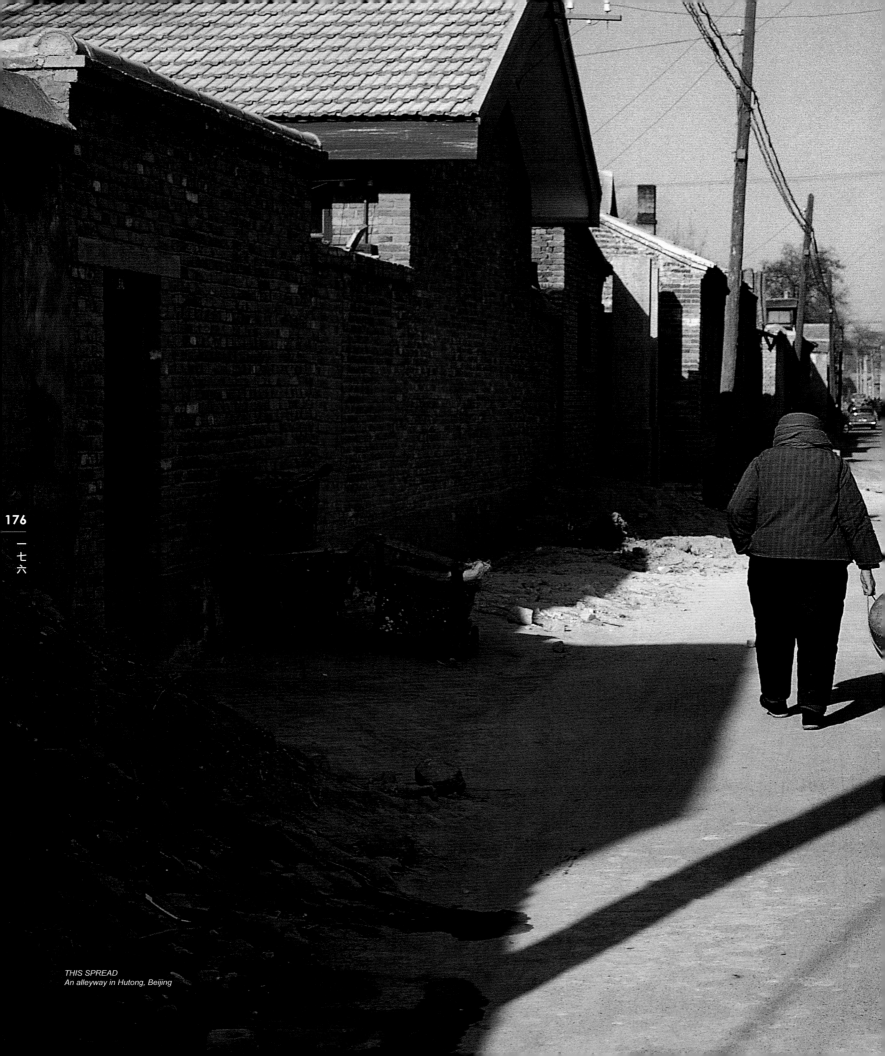

THIS SPREAD
An alleyway in Hutong, Beijing

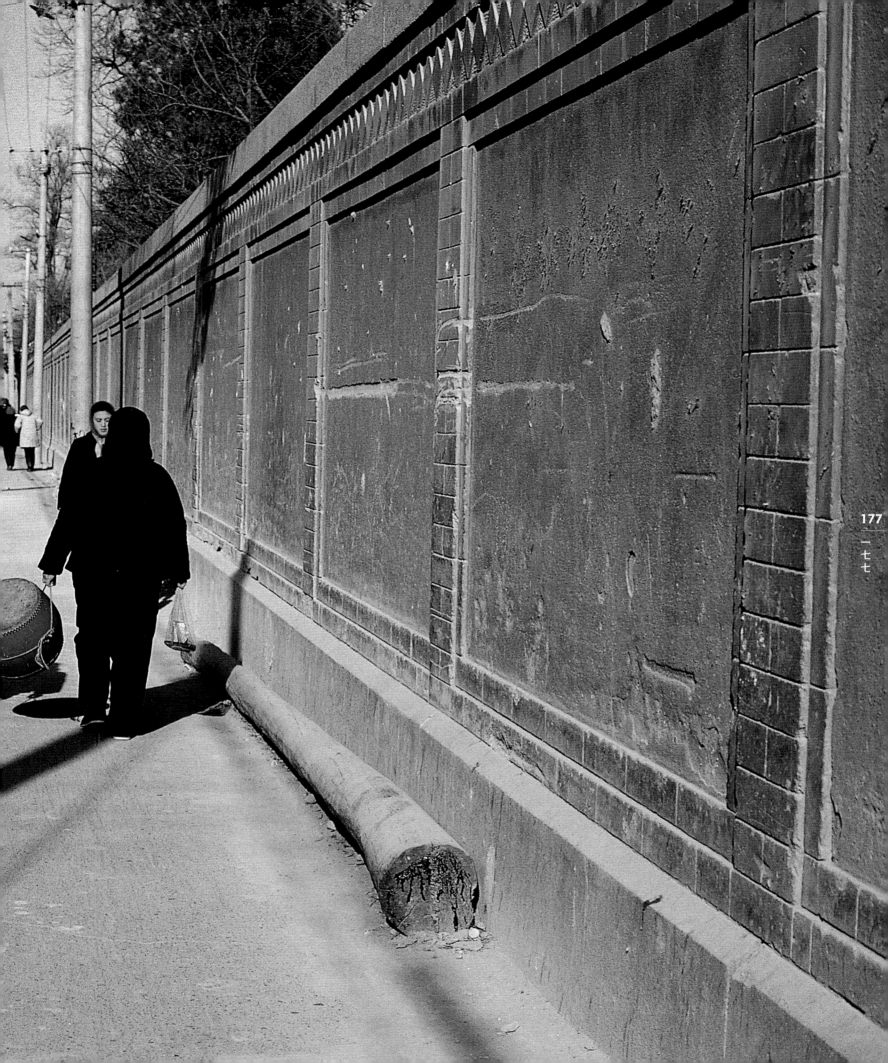

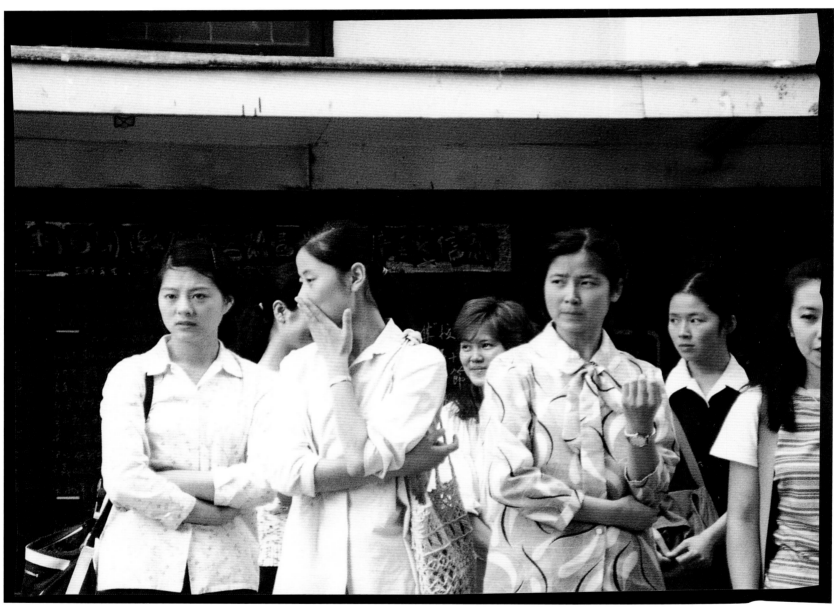

THIS PAGE and FACING PAGE
A welcome applause by the the students of Shanghai for the
students of Toko Gakuen College of Drama

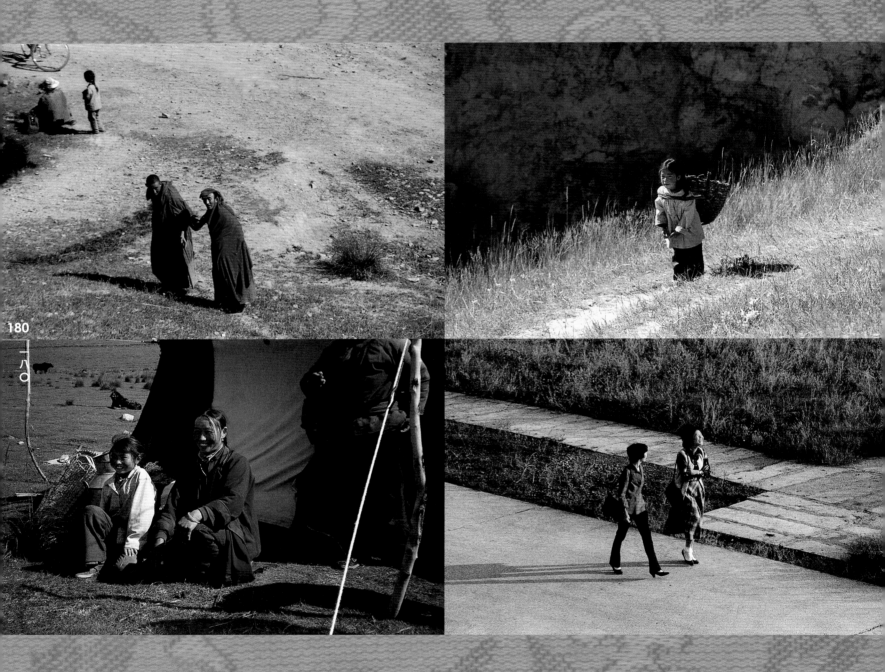

180

一八〇

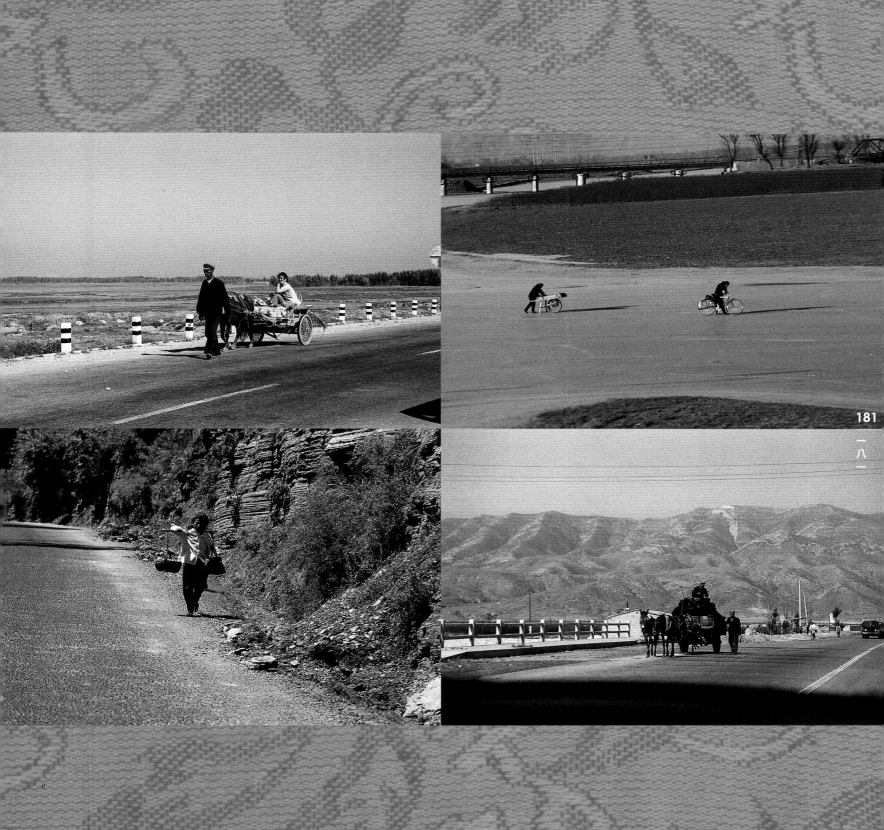

182

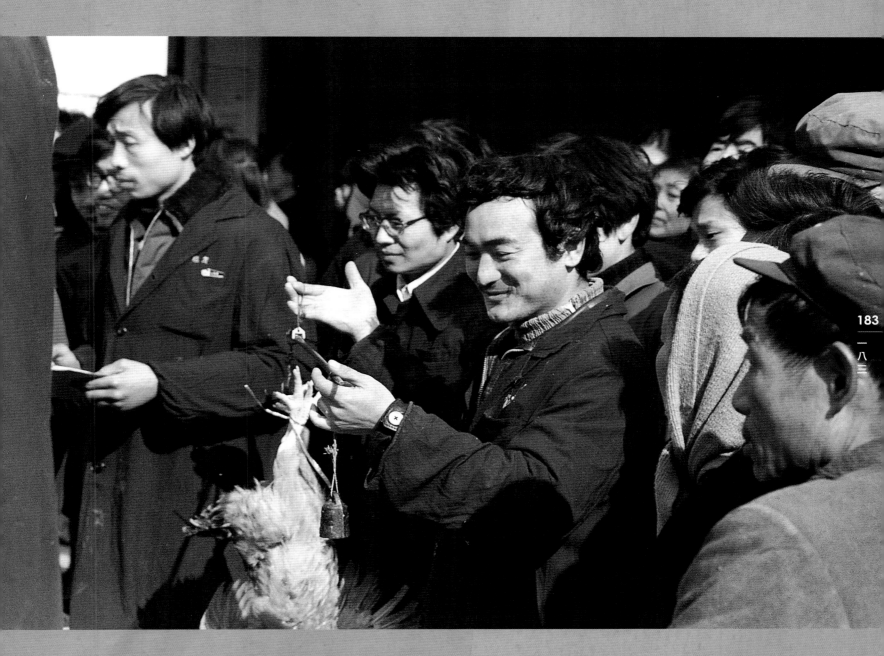

Under the direction of Premier Deng Xiaoping in the 80s, China embraced a market economy model. Slogans of "reform" (*gai ge*) and "opening up" (*kai fang*) formed the mantra of society during that period, and we began to see a different behavior take root in Chinese society. The newly-affluent were able to afford luxuries such as cars and imported electrical goods. Throughout the newly designated economic zones such as Shenzhen and Xiamen, new buildings and big bright malls began to spring up like bamboo shoots after a spring rain.

THIS PAGE
Buying and selling chickens in a market in Hangzhou

FACING PAGE
A Chinese New Year's poster in Beijing

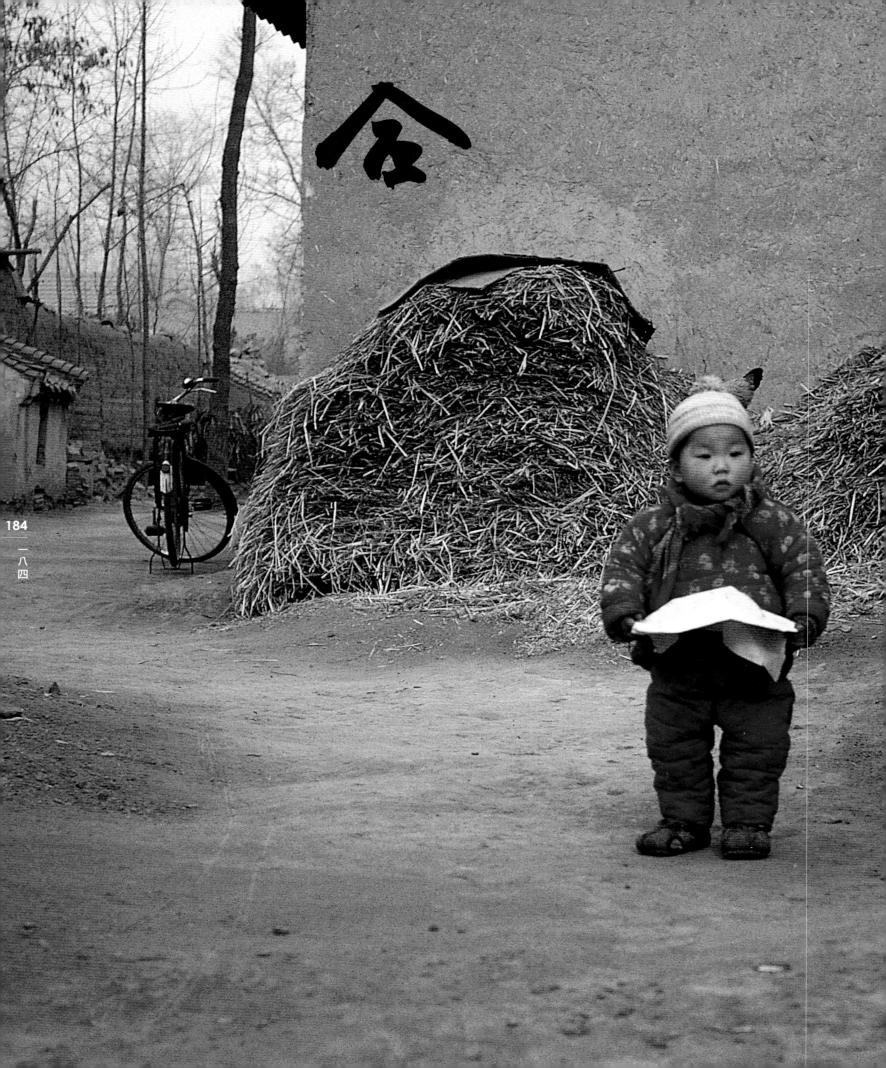

令